LONDON
MAP OF DAYS

Also by Mychael Barratt and Unicorn
The Master's Muse – Artists' Cats and Dogs

LONDON
MAP OF DAYS

Mychael Barratt

UNICORN

The Big Smoke

To Amanda,
Matilda and Freya

A LONDON MAP OF DAYS

This book is based on a map featuring 366 date-specific anecdotal references to events and people from London's history. The details range from the playful to the sublime such as 3 December 1976, Pink Floyd's inflatable pig breaks free from its moorings on Battersea Power Station to 11 November 1920, Cenotaph on Whitehall, designed by Edward Lutyens, is unveiled on Armistice Day. They are sometimes site specific as well although this was not always possible as I found that so many of the events occurred in the City and Westminster.

The original print is an eight-plate etching printed in four panels, which are then attached together at the back in the manner of an antique folding map. This print was included in the Royal Academy Summer Exhibition in 2015 and the explanation of each of the details was revealed to the purchasers on a daily basis throughout that year.

The challenges of writing backwards on a copper plate made for a few errors in typography. I hope to be forgiven for them by those who own the original etchings with errors intact, including the British Library where it is part of their permanent collection of maps.

JANUARY

SAMUEL PEPYS BEGINS WRITING HIS FAMOUS DIARY.

Pepys started the diary when he was only 26 years old and wrote it for ten years. He was a naval administrator and even though he had no maritime experience, he rose by a combination of hard work, patronage and talent for administration to be the Chief Secretary to the Admiralty under King Charles II and King James II. His diary, which was not published until the 19th century, was written in cryptic, personal shorthand and the first person to fully transcribe it did so without the benefit of Pepys' key.

It was not until 1970 that an unabridged version was published, as previous editions had omitted passages deemed too obscene to print, usually involving Pepys' sexual exploits. The diary combines personal anecdotes (often centred around drinking) with eyewitness accounts of great events such as the Great Plague of London, the Second Dutch War and the Great Fire of London. This glorious work was a constant source of inspiration for my map.

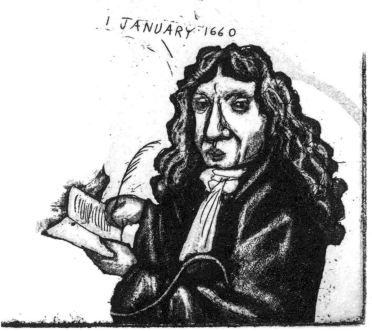

1 JANUARY 1660

PICASSO'S MASTERPIECE *GUERNICA* OPENS FOR A TWO-WEEK EXHIBITION AT THE WHITECHAPEL ART GALLERY.

The gallery was then a relatively modest art gallery in the East End of London when they pulled off this memorable coup by securing the loan of this world-class monumental painting. In January 1937, Picasso was living in Paris and had been named Honorary Director-in-Exile of the Prado Museum when the Spanish Republican government commissioned him to create a large mural for the Spanish display at the Exposition Internationale des Arts et Techniques dans la Vie Moderne at the 1937 World's Fair in Paris. When Picasso read an eyewitness account of the bombing of Guernica he immediately abandoned his initial project and started sketching the preliminary drawings for *Guernica*. The mural sized painting on canvas measures 349 x 776 cm and after the World's Fair in Paris was placed in the care of the Museum of Modern Art in New York, as Picasso had stipulated that the painting could not be sent to Spain until liberty and democracy had been restored.

On its way to the US, Picasso agreed to allow this brief exhibition at the Whitechapel Gallery. The exhibition was opened by leader of the Labour Party, Clement Attlee, and was hugely successful with more than 15,000 people passing through the doors in the first week alone. It raised much needed money for the Spanish Republican cause, as well as truckloads of working men's boots that were then sent to the Spanish front, as Picasso had decreed that this should be the price of admission.

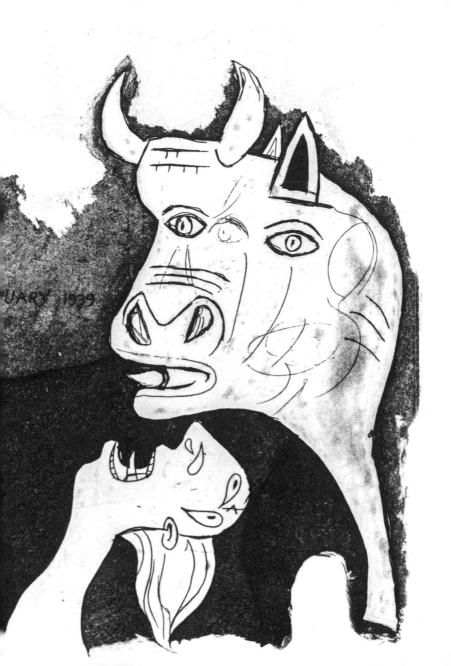

THE NOTORIOUS GUNFIGHT KNOWN AS THE SIEGE OF SIDNEY STREET OR THE BATTLE OF STEPNEY TAKES PLACE IN THE EAST END.

A politically motivated gang of burglars led by an anarchist known as Peter the Painter broke into a jewellers on Houndsditch Street, coming through buildings on a cul de sac at the back. A shopkeeper alerted the police to the banging and nine unarmed officers arrived to investigate the situation. Most of the burglars escaped, killing three policemen in the process.

When the police received information that the gang was holed up in Sidney Street in Stepney, Home Secretary Winston Churchill sent 200 armed officers and a detachment of the Scots Guard from the Tower of London. After a six-hour battle that ended with field artillery guns being deployed, the building burned down and the remains of two of the gang were found. No trace of Peter the Painter, now believed to have been Latvian far-leftist Janis Zhaklis was ever discovered.

3 JANUARY 1911

BENJAMIN FRANKLIN, ONE OF THE FOUNDING FATHERS OF THE UNITED STATES, ARRIVES FOR A VISIT TO LONDON.

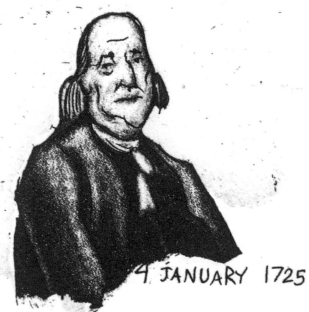

4 JANUARY 1725

A renowned polymath, Franklin was a leading author, printer, political theorist, politician, Freemason, postmaster, scientist, inventor, civic activist, statesman and diplomat. He was responsible for a number of inventions, including bifocals and the lightning rod, and became a folk hero for his experiments into electricity involving flying a kite in an electrical storm with a key at the end of the string. He visited London in 1725 and then returned to live in the city for much of the decades between 1750 and 1770. He was originally sent on a diplomatic mission but used the opportunity to further his scientific research.

KING OF ENGLAND, EDWARD THE CONFESSOR DIES.

Edward was the seventh son of Ethelred the Unready (clearly he was ready for some things) and had escaped to France to avoid conflict with the Vikings. He became king after the death of Harthacnut, restoring the crown to the Saxons. Upon his death there were four claimants to the throne: Edgar the Atheling, a Saxon prince and the nephew of Edward; Harold Godwinson, a powerful English nobleman with no links to royalty; Harald Hardrada, the King of Norway and a direct descendant of King Cnut; and William, Duke of Normandy and a distant cousin of Edward who claimed to have been promised the throne. Harold Godwinson seized the throne but William did not take the matter lying down and amassed an invading army, conquered Harold's forces and was crowned by the following Christmas.

5 JANUARY 1066

KING HENRY VIII MARRIES
HIS FOURTH WIFE, ANNE OF CLEVES.

Jane Seymour died from postnatal complications after she gave birth to Henry's only son Edward, and Thomas Cromwell set up the marriage to Anne of Cleves as both a cure for his mourning and a good political union. The painter Hans Holbein the younger was sent to Germany to paint as accurate a portrait of Anne as possible for Henry's approval. Henry was ultimately disappointed with how the real Anne measured up to her portrait and was angry with Holbein but angrier still with Cromwell whose dramatic decline from favour began from this point.

The marriage was never consummated and was annulled on 9 July 1540, although Anne received a very generous settlement and remained living in England for the rest of her life as the 'King's Beloved Sister'. Thomas Cromwell was arrested and beheaded on 28 July, on the same day as Henry married his fifth wife, 17-year-old Catherine Howard.

6 JANUARY 1540

7 JANUARY 1714

HENRY MILL OBTAINS THE FIRST PATENT FOR A TYPEWRITER.

In 1575, an Italian printmaker named Francesco Rampazetto invented a machine called a 'scrittura tattile' that pressed letters into paper, and an American named Christopher Scholes in 1867 was issued the first patent that coined the word 'typewriter', but Mill's invention is considered to be the first proper typewriter. The beautifully worded patent stated that he had 'invented and brought to perfection an artificial machine or method for impressing or transcribing of letters, one after another, as in writing, whereby all writing whatsoever may be engrossed in paper or parchment so neat and exact as not to be distinguished from print'. His original invention looked so little like what we recognise as a typewriter, however, that I opted to do a drawing resembling a 1950s vintage machine.

8 JANUARY 1734

GEORGE FRIDERIC HANDEL'S OPERA *ARIODANTE* PREMIERES AT THE COVENT GARDEN THEATRE.

Ariodante was supported and funded by the King, Queen and Princess Royal and competed successfully with a production by its rival the *Opera of the Nobility*, which was supported by the Prince of Wales. Despite its initial success when first performed, it disappeared into obscurity for over two hundred years. It has now resurfaced and is generally considered to be one of Handel's finest operas. Due to the difficulty in casting the necessary castrato, the lead in contemporary productions is now performed by a woman.

THE STATE FUNERAL OF VICE ADMIRAL HORATIO LORD NELSON TAKES PLACE AT ST PAUL'S CATHEDRAL.

Nelson was born into a relatively prosperous family in Norfolk and entered the navy through the influence of his uncle, Maurice Suckling. His personal valour and keen knowledge of tactics saw him rise rapidly through the ranks, receiving his own command by the age of 20. It was during the Napoleonic Wars that his tactical genius was truly realised. He was an inspirational leader and his brilliant gift for unconventional tactics was responsible for winning many battles, particularly against the French and Spanish. The capture of Corsica cost him the sight in his right eye and he lost his right arm in a rare defeat at the Battle of Santa Cruz de Tenerife. He quickly recuperated back in England and returned to win various decisive battles, culminating with Britain's greatest naval victory at the Battle of Trafalgar. Outnumbered by the French and Spanish fleets, Nelson's tactics saw them sink 22 enemy vessels whilst losing none themselves.

Nelson was on board the lead ship, *Victory*, and after refusing to remove his coat, which identified him as an admiral, was fatally wounded by a French sharpshooter. His famous last words 'kiss me, Hardy' were said to Thomas Hardy, captain of the *Victory*. Nelson's body was placed in a cask of brandy and lashed to the mainmast and placed under guard on its return to England. His funeral procession contained 32 admirals, over 100 captains, an escort of 10,000 soldiers and the Prince of Wales and his brothers who travelled incognito, as it was deemed inappropriate for royals to attend funerals for commoners. In his honour, Trafalgar Square was created in 1835 and Nelson's Column in 1843.

9 JANUARY 1806

THE WORLD'S FIRST UNDERGROUND RAILWAY, THE METROPOLITAN RAILWAY, OPENS TO THE PUBLIC.

The first underground trains had gas-lit wooden carriages hauled by steam locomotives. The Metropolitan line connected the mainline train stations between Paddington and the City of London using the 'cut and cover' method between Paddington and King's Cross and then deep tunnels along Farringdon Road to Smithfield, near the City. Later in its development they would employ very deep round tunnels cut through London clay, giving rise to the affectionate nickname 'the Tube'. From its humble but ambitious beginnings, London Underground has grown to be a network of 270 stations on 11 lines covering 250 miles of routes. Amongst its most innovative schemes was to extend lines and create stations in virtually uninhabited areas, then sell off the surrounding lands to property developers. This dramatically affected the development of suburban London in the 1920s and 30s.

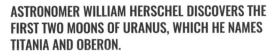

ASTRONOMER WILLIAM HERSCHEL DISCOVERS THE FIRST TWO MOONS OF URANUS, WHICH HE NAMES TITANIA AND OBERON.

Herschel was a German-born British astronomer and composer who built his first large-scale telescope in 1774, with which he studied clusters of stars and nebulae. In March 1781 he realised that the celestial body he had observed was actually a planet, the first to be discovered since antiquity. He named it Uranus and was made famous overnight. George III appointed him Court Astronomer and he was shortly thereafter elected a Fellow of the Royal Society. In total, 27 moons of Uranus have been identified and all of them have been named after characters from the works of Shakespeare and Alexander Pope.

11 JANUARY 1787

THE NATIONAL TRUST IS FORMED.

The National Trust was formed by Octavia Hill, Sir Robert Hunter and Hardwicke Rawnsley, and its primary concern was protecting open spaces and threatened buildings. It started with Alfriston Clergy House and a decorative cornice there inspired its logo, the sprig of oak.

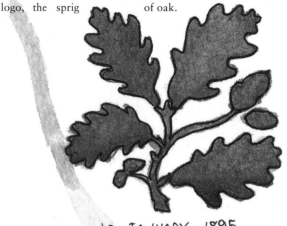

12 JANUARY 1895

The National Trust has grown to be one of the biggest charitable organisations in the country with an annual income in 2014 of £494 million raised mostly through membership and entry fees to properties. Its headquarters in Swindon is named Heelis, after the married name of Beatrix Potter, one of the biggest supporters of the trust who gave it her home in Cumbria.

On the original drawings for my map, I had references for both the formation of the National Trust and English Heritage. The National Trust detail was the only one of the two that made it to the finished etching but with a depiction of English Heritage's logo. I have corrected this here but all of the maps contained the error.

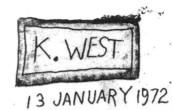

13 JANUARY 1972

THE PHOTOGRAPH OF DAVID BOWIE IS TAKEN BY BRIAN WARD ON HEDDON STREET, W1 FOR THE *ZIGGY STARDUST* ALBUM COVER.

The album's full title was *The Rise and Fall of Ziggy Stardust and the Spiders from Mars* and it was David Bowie's fifth studio album, sandwiched between *Hunky Dory* (1971) and *Aladdin Sane* (1973). It was a narrative concept album that followed the story of Bowie's alter ego Ziggy Stardust, a bisexual alien rock star who was acting as a messenger for extraterrestrials. It was a wonderful album from which *Starman* and *Suffragette City* are the most well-known singles.

The cover photo was shot on a cold and rainy night outside furriers K. West. When Bowie heard that the K. West sign had been removed he said 'It's such a shame that sign went – people read so much into it. They thought that K. West must be some sort of code for quest.' In 2012 a commemorative brown plaque was installed by Crown Estates on the same site as the sign, one of very few honouring a fictional character.

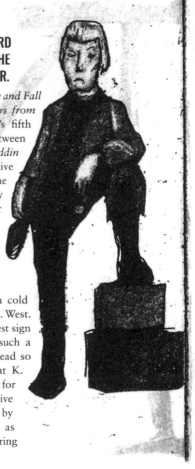

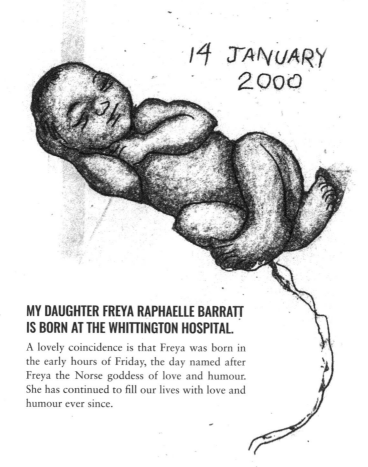

14 JANUARY 2000

MY DAUGHTER FREYA RAPHAELLE BARRATT IS BORN AT THE WHITTINGTON HOSPITAL.

A lovely coincidence is that Freya was born in the early hours of Friday, the day named after Freya the Norse goddess of love and humour. She has continued to fill our lives with love and humour ever since.

THE BRITISH MUSEUM FIRST OPENS TO THE PUBLIC IN MONTAGU HOUSE IN BLOOMSBURY.

The museum was established from items collected by Sir Hans Sloane, an Irish-born British physician and naturalist. Throughout his lifetime he had amassed an enviable collection of curiosities consisting of about 71,000 objects ranging from printed books and manuscripts to prints and drawings and antiquities. Not wanting the collection to be broken up after his death, he bequeathed it to King George II for the nation, for a sum of £20,000. It was decided to house the cabinet of curiosities in a bespoke building and the trustees of the newly formed British Museum decided on converting a residential building called Montagu House. They purchased the house from the Montagu family for £20,000 and within six years opened the first exhibition galleries and the reading room for scholars.

The building was expanded hugely between 1825 and 1850, becoming the biggest building site in Europe. The books and manuscripts were moved to the newly built British Library in 1997 and the courtyard surrounding the old reading room was converted into the largest covered square in Europe.

The original collection of curiosities has grown to 13 million objects at the British Museum, 70 million at the Natural History Museum and 150 million at the British Library (including this map). My detail is of one of the 82 beautiful Lewis chessmen that the museum owns.

15 JANUARY 1759

A HELICOPTER CRASHES INTO A CONSTRUCTION CRANE ATTACHED TO ST GEORGE WHARF TOWER IN VAUXHALL.

The helicopter was flying between Redhill Airport and Elstree Airfield to collect a single passenger to then fly on to Yorkshire. There was low cloud and freezing temperatures that dramatically affected visibility, making it impossible to land at Elstree. The pilot, Pete Barnes, was returning to Redhill when he requested permission to land at Battersea Heliport. Although the tower had been included in a NOTAM (Notice to Airmen) it was not included on the helicopter's GPS system. The crane had been in place since 7 January and was only required to be lit at night so the pilot did not see it before colliding with the jib. The pilot and one pedestrian, Matthew Wood, were killed when it struck the ground and exploded.

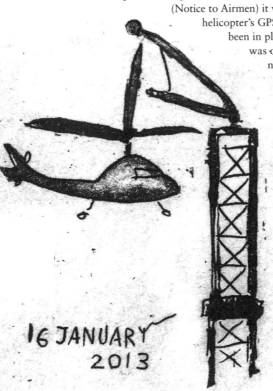

16 JANUARY 2013

17 JANUARY 1934

BATTERSEA POWER STATION IS COMMISSIONED.

It comprises two separate power stations, Battersea A Power Station that was built in the 1930s and Battersea B Power Station built in the 1950s to the east and joined to the first building. Both were built to almost identical design and specifications, so that it would look like one massive four-chimneyed structure. The exterior was designed by the architect Sir Giles Gilbert Scott, who also designed the glorious Southwark Power Station (now the Tate Modern) and the red London phone box.

The power station stopped producing electricity in 1983 but has become an iconic London landmark partly through it featuring in popular culture ranging from Pink Floyd's *Animals* album cover and in the Beatles' film *Help* to episodes of Dr Who. There have been many redevelopment plans over the years, many involving the destruction of the building. The latest will preserve the shell and many of the interior Art Deco features in a massive development that will include the creation of 3,400 homes and a new tube station on the Northern Line.

THE SCULPTOR AND WOOD CARVER GRINLING GIBBONS IS DISCOVERED BY DIARIST JOHN EVELYN IN DEPTFORD.

Gibbons was born in Rotterdam of English parents and moved to England in 1667 when he was 19 years old. Evelyn wrote of coming across the young man working by candlelight on a wooden version of Tintoretto's *Crucifixion*. He described what he had seen to his friend, the architect Christopher Wren, who sought the sculptor and introduced him to King Charles II. The king gave him his first commission, which still resides in the dining room of Windsor Castle.

Gibbons went on to become the world's most renowned carver in wood, creating works for Windsor Castle, Hampton Court and St Paul's Cathedral. Some of the finest examples of his work are to be found at Petworth House in West Sussex, which is owned by the National Trust. Gibbons' work very often includes carvings of pea pods that would be carved open once he had been paid. If the pea pod was left shut, it supposedly showed that he was never paid for the work.

18 JANUARY 1671

19 JANUARY 1661

THOMAS VENNER, REBEL LEADER OF THE FIFTH MONARCHY MEN, IS EXECUTED AFTER A FAILED COUP.

Venner was a cooper who had lived in New England for 22 years before returning to England to join the Fifth Monarchy Men, a quasi-political group of religious zealots who had tried unsuccessfully to overthrow Oliver Cromwell. After their previous leader had been killed, Thomas Venner was chosen to lead the uprising against the recently restored Charles II. At one point they drove back an army of 1,200, which was impressive as although they were reported to have been 500 men, Samuel Pepys wrote that they were actually only about 50. Their last stand was against General Monck's men at the Helmut Tavern in Threadneedle Street, where soldiers used the butts of their muskets to break though the clay roof tiles before shooting them. Although wounded 19 times, Venner was captured and able to stand trial at the Old Bailey before being hung, drawn and quartered.

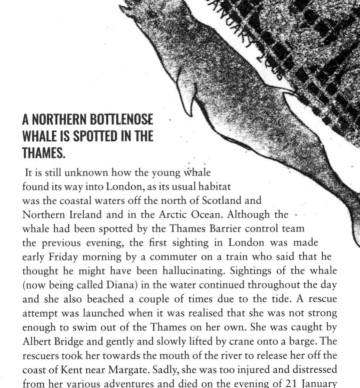

A NORTHERN BOTTLENOSE WHALE IS SPOTTED IN THE THAMES.

It is still unknown how the young whale found its way into London, as its usual habitat was the coastal waters off the north of Scotland and Northern Ireland and in the Arctic Ocean. Although the whale had been spotted by the Thames Barrier control team the previous evening, the first sighting in London was made early Friday morning by a commuter on a train who said that he thought he might have been hallucinating. Sightings of the whale (now being called Diana) in the water continued throughout the day and she also beached a couple of times due to the tide. A rescue attempt was launched when it was realised that she was not strong enough to swim out of the Thames on her own. She was caught by Albert Bridge and gently and slowly lifted by crane onto a barge. The rescuers took her towards the mouth of the river to release her off the coast of Kent near Margate. Sadly, she was too injured and distressed from her various adventures and died on the evening of 21 January before she could be released.

THE FIRST ISSUE OF THE *DAILY NEWS* IS PUBLISHED, EDITED BY ITS FOUNDER CHARLES DICKENS.

The paper, conceived by Dickens as a radical rival to the right-wing *Morning Chronicle*, was not initially a commercial success. Dickens edited the first 17 issues before handing over the editorship to his friend John Forster who was an experienced journalist. Forster ran the paper until 1870 and under him it flourished. In its heyday, George Bernard Shaw, Harriet Martineau, H.G. Wells and G.K. Chesterton were all regular contributors. It was published in some form or another until 1930.

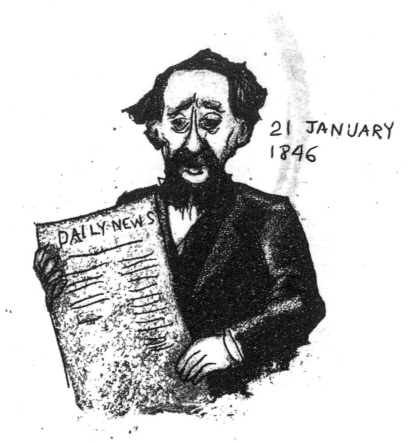

21 JANUARY 1846

22 JANUARY
1924

RAMSAY MACDONALD IS ELECTED, BECOMING THE FIRST LABOUR PRIME MINISTER IN BRITAIN.

MacDonald, a Scottish journalist, was an intellectual and a strong pacifist. The Labour Party, of which he was the leader, had only just overtaken the Liberals to become the second largest political party behind the Tories when he became Prime Minister. His first term, formed with Liberal support, lasted only nine months, when his government was punished by the electorate for its involvement in the Campbell Case where a communist newspaper went unpunished after inciting mutiny. The Conservatives won a majority but MacDonald's short term in office had shown that Labour was a viable force in British politics and he was re-elected in 1929. In 1931 he formed a National Government and was expelled from the Labour Party. He was PM until 1935 when his deteriorating health forced him to step down from office. He died on holiday on a cruise liner two years later.

THE ROYAL EXCHANGE IS OFFICIALLY OPENED BY QUEEN ELIZABETH I.

The Royal Exchange was founded to act as a centre of commerce for the City of London and the freehold is still held by the Corporation of London and the Worshipful Company of Mercers. The Queen granted them their royal title and a license to sell alcohol. The building was only used to trade goods – stockbrokers were banned due to their rude manners and were forced to use the nearby and much less salubrious Jonathan's Coffee House. The original building burned down in the Great Fire in 1666 and its replacement burned down in 1838. The third building still stands, complete with a mounted statue of the Duke of Wellington cast with bronze sourced from melted down enemy cannons.

23 JANUARY 1571

I ARRIVE IN LONDON.

I had been backpacking around the Continent before arriving in London for what was meant to be a fortnight. On that first day, I went to the Odeon Kensington to visit my friend Graham Ashmore who was working there as a cashier. He was one of the two people I knew in the country at the time, with the other being the award-winning author Moira Young, although then she was studying at a drama school in Ealing. I walked through the doors of the cinema and was greeted by a beautiful, young usherette who went off to find Graham. I have lived in London ever since and the usherette was Amanda, who was later to become my wife.

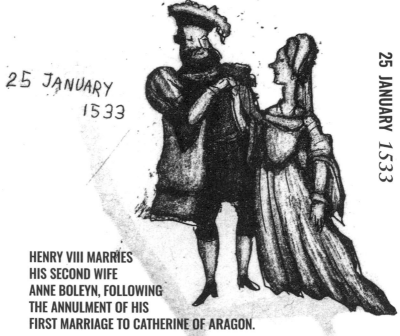

25 JANUARY 1533

HENRY VIII MARRIES HIS SECOND WIFE ANNE BOLEYN, FOLLOWING THE ANNULMENT OF HIS FIRST MARRIAGE TO CATHERINE OF ARAGON.

Henry and Anne married secretly in November 1532 but had a proper ceremony once Anne was pregnant with the baby who would turn out to be Elizabeth I. They were confidently expecting the boy that every royal physician and astrologer had forecast and were desperately disappointed. They added a hasty 's' to their birth announcement to change 'prince' to 'princes(s)' and cancelled the traditional celebratory jousting tournament which was to be held in honour of the birth of an heir. Shortly thereafter, Henry began an affair with Jane Seymour and gave her a locket with a portrait of himself. Anne was present when this gift was given and ripped the locket off Jane with such ferocity that her fingers bled. Anne was believed to have had other unsuccessful pregnancies but when she miscarried a baby that was said to have been a boy in January 1536, it marked the beginning of the end for her. Henry moved Jane Seymour into royal quarters and by May, Anne had been arrested, tried and executed at the Tower for charges ranging from adultery and treason to incest. She was either 28 or 35 at the time as there is still debate over whether she was born in 1501 or 1507.

THE MEDIEVAL LONDON BRIDGE IS DEMOLISHED.

King Henry II commissioned the bridge as a stone replacement of an older wooden one. He built it in part to atone for the murder of Thomas Becket, the Archbishop of Canterbury, and included a chapel honouring his martyrdom in the centre of the bridge. The Chapel of St Thomas on the Bridge became the official starting point of pilgrimages to his Canterbury shrine. Building work on the bridge began in 1172 and finished in 1209 at great expense. It was 26 feet wide and 900 feet long, and was supported on 19 irregularly spaced arches. There was a drawbridge in the centre to allow for the passage of tall ships and defensive gatehouses at both ends which would regularly display the heads of traitors on pikes. Famous heads include William Wallace, Thomas More and Thomas Cromwell. To cover the maintenance costs, the City of London was given control of the bridge and leased out the 138 shops and houses, and charged a toll for crossing.

By the 19th century a new bridge that had no buildings on it replaced the bridge. The old bridge was used until the new one was opened and then it was torn down, 622 years after it was completed. The new bridge lasted only until the 1960s when it needed to be replaced as it was found to be sinking. That 19th-century bridge was sold to an oil magnate in America and is now in the middle of the Arizona desert (where my parents saw it on one of their snowbird trips down south).

26 JANUARY

27 JANUARY 1926

JOHN LOGIE BAIRD DEMONSTRATES THE FIRST WORKING TELEVISION SYSTEM.

Baird was born and educated in Scotland but never completed his degree at the University of Glasgow, as it was interrupted by service in World War I. He was too unfit for active duty but worked at the Clyde Valley Electrical Company on munitions. He moved first to Hastings and then to London to work on his inventions. After successful experiments in his laboratory, he went to the *Daily Express* to try to get publicity. The news editor was terrified, saying: 'For God's sake, go down to reception and get rid of a lunatic who's down there. He says he's got a machine for seeing by wireless!'

The first public demonstration followed shortly thereafter at 22 Frith Street in Soho for members of the Royal Institution and a reporter from *The Times*. His first prototype transmitted a grey scale image of a ventriloquist's dummy named 'Stooky Bill'. He also transmitted a human face in motion. The Baird Television Development Company Ltd went on to do the first colour transmissions, the first intercontinental transmissions and to make the first television programme for the BBC.

1832

GAS LIGHTING IS DEMONSTRATED FOR THE FIRST TIME ON PALL MALL.

William Murdoch was the first person to experiment with using the flammability of gas for lighting in the 1790s and used it to light his house in Redruth, Cornwall. Frederick Albert Winsor patented its use on streetlights and demonstrated the first one on Pall Mall near Carlton House Terrace. They started to be installed around London from 1812 and there was a marked reduction of crime with the streets no longer being pitch black at night.

London was the only city in the world to have street lighting until 1816 but the obvious benefits made it spread rapidly afterwards. They started to be installed in factories, which allowed for 24 hour running, greatly desirable during the Industrial Revolution. This then spread to being used in theatres, shops and homes. By the early 20th century most cities in Europe and North America had gas street lighting but this began to give way to the new technology of electrical lighting.

There are still 1,500 gas streetlamps in London, mostly concentrated around Westminster and Covent Garden, and each one is hand lit by a team of five lamp lighters.

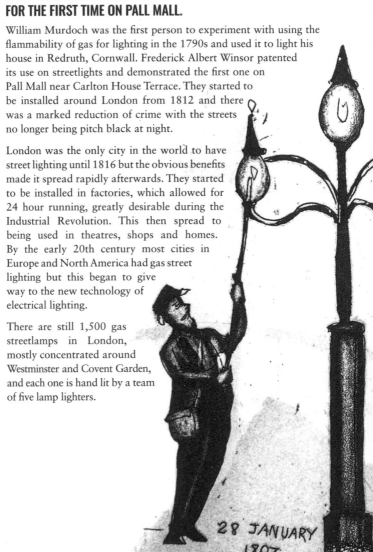

28 JANUARY 1807

29 JANUARY / 1728

THE BEGGAR'S OPERA BY JOHN GAY OPENS AT THE LINCOLN'S INN FIELDS THEATRE AND GOES ON TO HAVE THE LONGEST RUN IN THEATRICAL HISTORY UP TO THAT POINT.

The Beggar's Opera was a revolutionary piece in its day and was the first in a genre of satirical musical theatre that became extremely prevalent and is still regarded as the most popular play of the 18th century. Benjamin Britten and Vaclav Havel both did 20th-century updates and Alan Ayckbourn's *Chorus of Disapproval* is about the disastrous staging of the play.

1649 – THE EXECUTION OF CHARLES I ON WHITEHALL.

Charles I was the second son of King James VI of Scotland who became James I of England when he inherited the throne from his cousin Elizabeth I in 1603. Charles became the heir apparent when his older brother died in 1612 and became king when his father died in 1625. He believed in the divine right of kings and quarrelled badly with Parliament, who sought to curb his royal prerogative. His subjects objected to many of his policies and to his marrying a Roman Catholic, and felt that he was a tyrannical absolute monarch. He fought a civil war with the parliaments of England and Scotland and even in defeat refused to consent to a constitutional monarchy. By the end of 1648, Oliver Cromwell's New Model Army had taken control of England and Charles was imprisoned, tried and sentenced to death as a traitor. A large scaffold had been erected in front of the Banqueting House and huge crowds, gathered separated by soldiers. On the day, it was so cold that Charles asked to wear two shirts so that no one would mistake his shivers for fear. He was killed by a single clean stroke from a still unknown executioner. The crowd moaned and many dipped their handkerchiefs into the King's blood as a memento. England became a democratic republic or commonwealth until 1660 when the crown was restored to his son, Charles II.

1969 – THE BEATLES PLAY THEIR LAST PUBLIC CONCERT ON THE ROOFTOP OF APPLE LABEL'S HEADQUARTERS.

The Beatles had wanted to play a public performance for some time but only decided on the location about three days beforehand. They set up and started playing on the roof at 3 Saville Row during the lunch break of the local office workers. As news of the concert spread, the crowds on the streets below began to worry the police. When they tried to enter the building, Apple employees at first resisted but ultimately relented and let them access the roof. The Beatles kept playing for a while with the police present, Paul McCartney famously adding references to them in the lyrics of *Get Back*. When they finally stopped playing, John Lennon said, 'I'd like to thank you all on behalf of the group and hope that we've passed the audition.' Footage from the concert was used in the documentary film *Let It Be*.

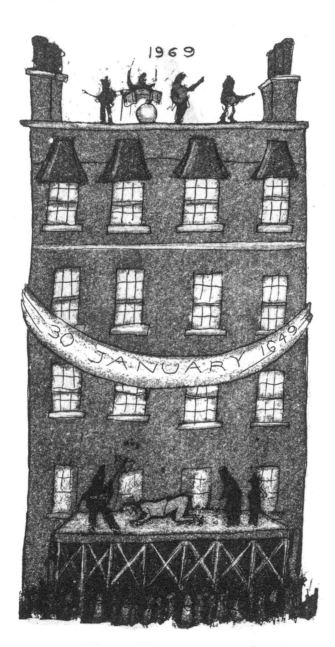

31 JANUARY
1942

FILM DIRECTOR DEREK JARMAN IS BORN IN NORTHWOOD.

Jarman was an artist, stage designer and author but it was his experimental, non-narrative films, such as *Caravaggio* and *Last of England*, for which he is most famous. He is also remembered for his seaside garden by his home built in the shadow of the Dungeness nuclear power station. The garden was created from an artful combination of flotsam washed up nearby and salt-loving plants.

I saw Derek Jarman in a framer's shop in Soho once. I didn't get a close look at the painting that he was framing except to see that it was very dark and monochromatic. He handed it to the framer saying that it was one of his that was going to be auctioned for charity while the framer commented on how exquisite it was. He asked for his 'usual frame with a nameplate at the bottom'. An awkward silence ensued before the framer gingerly asked which side was the bottom. 'Well, it's a portrait!' Jarman said, indignantly. Another awkward silence followed before he pointed at the picture and said 'oh for goodness sake man, that's the bottom, there!'

FEBRUARY

THE LAST EVER FROST FAIR IS HELD
ON THE FROZEN RIVER THAMES

The fairs were impromptu festivals that were a cross between a Christmas market and a circus that occurred whenever the Thames froze solid enough to support the weight of the revellers. The river froze solid 23 times between 1309 and 1814, and on five of these times entrepreneurial Londoners set up stalls, shops, theatres and pubs on the ice. They were mostly run by the watermen and lightermen whose livelihoods on the river were temporarily suspended, and I have depicted them dragging a boat along the ice.

During the four-day fair in 1814, they roasted an entire ox that could feed 800 people over a 24-hour period and walked an elephant from one side of the riverbank to the other. The fairs occurred between London Bridge and Blackfriars Bridge, and were made possible by a combination of extremely cold temperatures in what was a mini ice age in London and by the slow movement of the Thames due to the multiple arches of London Bridge. With a new bridge and warmer climate, that was the last time the river froze over.

2 FEBRUARY 1852

THE FIRST PUBLIC FLUSH TOILETS OPEN ON FLEET STREET.

The inventor George Jennings installed his revolutionary *monkey closets* at the Great Exhibition in 1851, where 827,280 people each spent 1p to use them. By *spending a penny* (a euphemism you still occasionally hear), each customer would receive a clean seat, a towel, a comb and a shoeshine. At the end of the exhibition the monkey closets were moved to Crystal Palace with the rest of the building, but Jennings realised that there was a huge potential market for his invention. He installed the first of his toilets at 95 Fleet Street, outside the Society of Art. This one was for men only, with the first women's convenience opening on the Strand a week later. Outside of the exhibition, the flush toilet was slow to catch on, however, and it was only when improvements were devised by Thomas Crapper that it became the ubiquitous object we now know and love.

PRIME MINISTER HAROLD MACMILLAN
MAKES HIS 'WINDS OF CHANGE' SPEECH TO THE PARLIAMENT
OF SOUTH AFRICA IN CAPE TOWN.

Macmillan's speech was foreshadowing Britain's intention to grant independence to various African nations including South Africa and contained criticism of the Apartheid system. Reaction from the Conservative government listening to the speech back in Whitehall was decidedly cool. Labour had started a process of decolonisation after the war, but this had been halted by the Tories in 1951. Despite opposition from his party, Macmillan started the ball rolling, with most of the British possessions becoming independent nations in the 1960s.

3 FEBRUARY 1960

THE FIRST CHINESE NEW YEAR LION DANCE IN SOHO.

The now familiar celebrations in London's Chinatown date back to 1973, to welcome the year of the ox. The original Chinatown was in Limehouse in the East End, where businesses catered for the Chinese sailors in the docklands. The area was very badly bombed during the Blitz, and the Chinese population scattered. They settled in the then very rundown area around Gerard and Lisle Streets in Soho in the early 70s, and this area is still the focal point for the Chinese community in Western Europe. The celebrations included the traditional lion dance, a parade and fireworks.

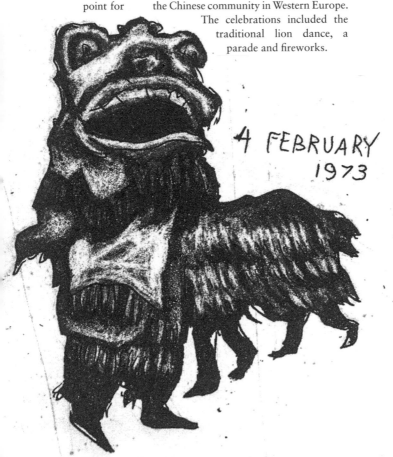

4 FEBRUARY 1973

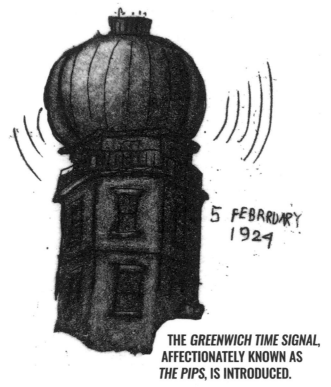

5 FEBRRUARY 1924

THE *GREENWICH TIME SIGNAL,* AFFECTIONATELY KNOWN AS *THE PIPS,* IS INTRODUCED.

The signal consists of six short tones to mark the precise start of the hour on the radio. The last pip was made longer in the 1970s when six equal length pips were found to be confusing to announcer Charles Lister. The *pips* were the idea of the Astronomer Royal, Sir Frank Watson Dyson and the head of the BBC, John Reith. Their official name came from the fact that they were originally controlled by two large mechanical clocks located in the Royal Greenwich Observatory. They mark every hour on BBC Radio 4 and the World Service except at 18.00 and 00.00 when they are replaced with the chimes of Big Ben from Westminster. They also don't sound at 15.00 on Saturdays and 11.00 and 12.00 Sundays. They are also occasionally heard on Radio 2 and even on Radio 1. They have become one of the most enduring and comforting features of the BBC.

A LAW IS PASSED GIVING WOMEN THE RIGHT TO VOTE.

Women in Britain were not explicitly banned from voting until the 1832 Reform Act. This Act made women's suffrage a political topic, although it became a national movement with the formation of the National Society for Women's Suffrage in 1872. The campaign gained momentum and became more militant in 1903, when Emmeline Pankhurst formed The Women's Social and Political Union (WSPU).

The situation escalated in 1913, when suffragettes burned down the house of Chancellor of the Exchequer David Lloyd George and Emily Davison was killed when she walked in front of the King's horse at the Epsom Derby. Also that year, Mary Richardson slashed Velázquez's *Rokeby Venus* at the National Gallery, in protest of the government force-feeding Emmeline Pankhurst and the other hunger-striking women who were political prisoners.

The declaration of war in 1914 stopped all campaigning, but directly after the war was finished in 1918, the coalition government passed The Representation of the People Act. This Act allowed women over the age of 30 to vote if they were a member or married to a member of the Local Government Register and gave about 8.4 million women the vote. In 1928, the vote was given to all women over the age of 21.

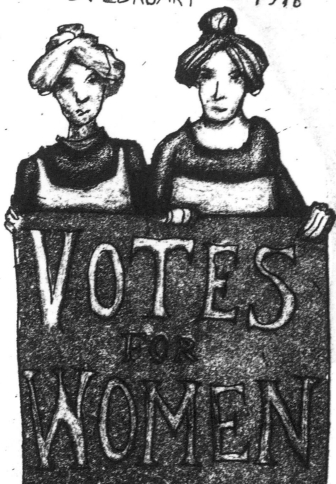

SIR THOMAS MORE IS BORN
ON MILK STREET IN THE CITY OF LONDON.

More was a bright lad and served John Morton, the Archbishop of Canterbury, as a household page. Morton recommended him to the University of Oxford, to which he went aged 14. He became a student at Lincoln's Inn and was called to the bar in 1502. After accompanying Thomas Wolsey on a diplomatic mission, More was knighted and made under-treasurer of the exchequer. He was made secretary and personal adviser to Henry VIII and became increasingly influential.

When Wolsey fell from grace and power, More succeeded him as Lord Chancellor. However after he refused to attend the coronation of Anne Boleyn or to swear an oath of supremacy of the state over the church, Henry became so disenchanted with More that he had him arrested and locked in the Tower. He was tried for high treason by a panel of judges that included Anne Boleyn's father, brother and uncle, as well as More's replacement as Lord Chancellor, Sir Thomas Audley. He was found guilty and sentenced to be hung, drawn and quartered, but Henry commuted his sentence to execution by decapitation.

More wrote an impressive history of King Richard III as well as a novel called *Utopia*, a word that has permanently entered the English language.

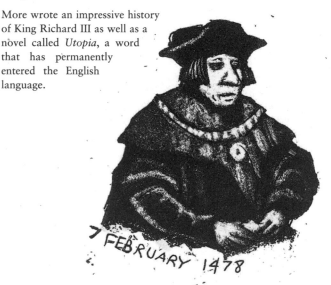

7 FEBRUARY 1478

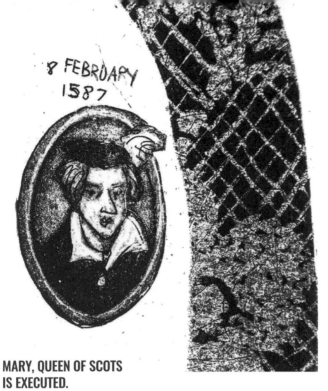

8 FEBRUARY 1587

MARY, QUEEN OF SCOTS IS EXECUTED.

Mary was the only legitimate child of King James V of Scotland and succeeded him to the throne after he died when she was only six days old. She lived most of her childhood in France, with Scotland being ruled by regents. She was briefly the Queen Consort of France after marrying Francis, the dauphin of France. After his death, she returned to Scotland and married her first cousin Henry Stuart, Lord Darnley. Although they had a child, their marriage was short and unhappy until his residence was blown up and he was found murdered in the garden. She married James Hepburn, who was widely regarded to have been responsible for the murder of Darnley. This caused an uprising against the couple, and she was forced to abdicate in favour of her and Darnley's son, who would become James VI (and later James I of England). She fled south to seek the protection of her first cousin Elizabeth I but was imprisoned by her for 18 years and then executed.

THE LAST APPEARANCE OF HALLEY'S COMET IN THE INNER SOLAR SYSTEM IN THE 20TH CENTURY.

Astronomer Royal Edmund Halley accurately calculated that the comets recorded in 1456, 1531, 1607 and 1682 were indeed a repeating 75-year orbit of the same comet. He did not live to see it return in 1758, but when it did, it was named after him. The 9 February 1986 appearance was the comet's *perihelion*, where it was closest to the sun.

QUEEN VICTORIA MARRIES PRINCE ALBERT.

Victoria became the Queen in 1837, when her father, William IV, died. It was the convention of the day that an unmarried woman, even if she was the Queen of the United Kingdom, should live with her mother. Victoria found this prospect unpalatable and realised that only marriage would rescue her. She was introduced to her first cousin Prince Albert of Saxe-Coburg and Gotha, and after their second meeting she proposed to him. They were married in the Chapel Royal of St James's Palace on a day that Victoria in her diary called 'the happiest day of my life!' She went on to say that 'his excessive love and affection gave me feelings of heavenly love and happiness I never could have hoped to have felt before!' The two were extremely happy together, and when Albert died in 1861, Victoria entered a state of mourning and wore black for the rest of her life.

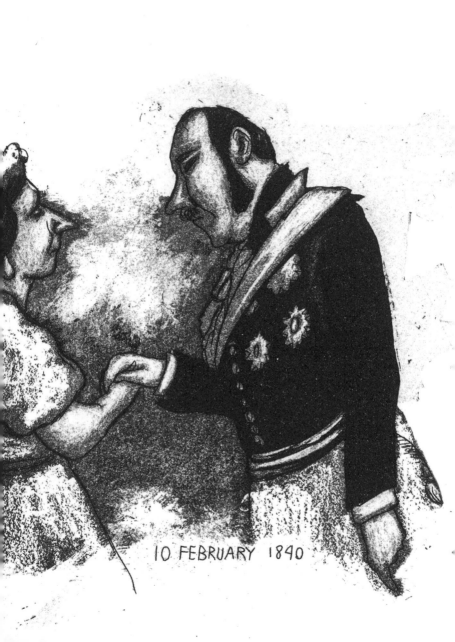

10 FEBRUARY 1840

R.U.R. (ACRONYM FOR 'ROSSUM'S UNIVERSAL ROBOTS') BY THE CZECH WRITER KAREL CAPEK IS AIRED ON THE BBC.

The play is set in a factory that makes artificial people, called *roboti* (or robots) from synthetic organic matter and is responsible for the word 'robot' entering the English language.

The play was written in 1920, and when it was shown by the BBC in 1938, it was the first television science fiction ever to be broadcast.

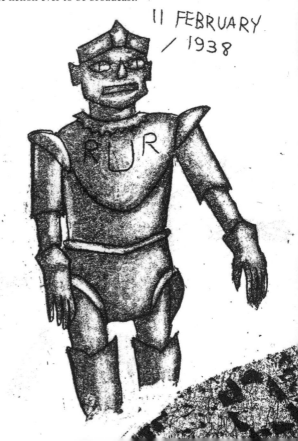

11 FEBRUARY / 1938

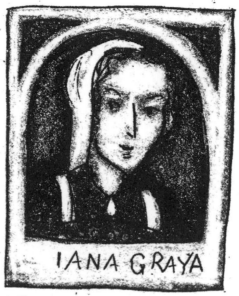

IANA GRAYA

12 FEBRUARY
1554

LADY JANE GREY IS EXECUTED AT THE TOWER OF LONDON.

Jane was the great-granddaughter of Henry VII and the first cousin once removed of Edward VI. When 15 year-old Edward lay dying he altered his will and nominated Jane as his successor rather than his half-sisters Mary and Elizabeth. Her reign of nine days ended when the Privy Council changed sides and proclaimed Mary as Queen on 19 July 1553. Jane was imprisoned in the Tower and convicted of high treason, which held a sentence of death. Although her life was initially spared, she was ultimately executed at the age of 17.

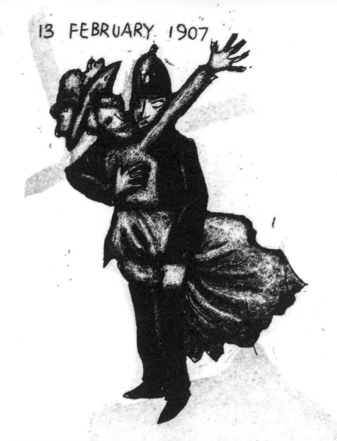

13 FEBRUARY 1907

EMMELINE PANKHURST AND MEMBERS OF THE WOMEN'S SOCIAL AND POLITICAL UNION LEAD A GROUP OF 400 SUFFRAGETTES TO MARCH ON PARLIAMENT.

The suffragettes were protesting the King's speech of the previous day that contained no mention of giving women the vote. Massed ranks of police met them on the green outside Westminster Abbey, and although 15 women got through to the lobby of the Houses of Parliament, 60 women were arrested. This was seen as a landmark event, but it was still another 11 years before women were given the vote, and even then it was not on an equal footing with men.

GREAT ORMOND STREET HOSPITAL
FOR CHILDREN IS FOUNDED.

The hospital was begun by Dr Charles West as The Hospital for Sick Children and started with only ten beds. Through the patronage of Queen Victoria and Charles Dickens, a close personal friend of Dr West, the hospital flourished to become one of the world's leading children's hospitals.

Author J.M. Barrie gave the copyright to all of the *Peter Pan* works to Great Ormond Street on the proviso that they did not disclose the income from this source. It is believed to be a huge source of funding for the hospital and when the copyright expired in 1987, 50 years after the death of Barrie, the UK Government granted the hospital perpetual rights to all publication and performance royalties.

A HUGE RETROSPECTIVE OF THE WORK OF ARTISTS GILBERT AND GEORGE OPENS AT THE TATE MODERN MUSEUM.

It was the first major survey of the pair's art and included most of their most iconic works. Gilbert Proesch and George Passmore were born in 1943 and 1942 respectively and have been working together since they first met as art students in the sculpture department of Saint Martin's School of Art in 1967. They are known as much for their distinctive and highly formal appearance as for their brightly coloured, graphic photo-based artworks. They are often seen walking about in their beloved East End of London. They are also regularly spotted eating out as, although they have restored their 18th-century Spitalfields home to its original grandeur, they claim to have never used their immaculate kitchen even to boil an egg.

15 FEBRUARY 2007

16 FEBRUARY 1895

OSCAR WILDE'S PLAY *THE IMPORTANCE OF BEING EARNEST* IS REVIEWED BY THE DAILY PRESS, INCLUDING GEORGE BERNARD SHAW IN THE *SATURDAY REVIEW*.

The play had its premiere at the St James Theatre on 14 February and although the audience response was extremely enthusiastic, the critical response was mixed. Shaw said that he went to the theatre to be moved to laughter and that Wilde's play although extremely funny, had left him unmoved. Audiences continue to love it, however, and it remains Wilde's most popular and enduring work.

17 FEBRUARY 1771

THE TEMPERATURE DROPS SO LOW THAT ALL OVER LONDON PEOPLE REPORT SEEING FROZEN BIRDS DROP FROM THE SKY.

Almanacs report that there was also heavy fog that day which must have made the sudden appearance of the frozen birds all the more alarming.

THE FIRST BENTLEY AUTOMOBILE, THE BENTLEY 3 LITRE, IS MADE ON NEW STREET MEWS, MAYFAIR, W1.

The car was hand built by Walter Owen Bentley MBE, RAF and introduced at the London Motor Show in 1919, although production and sales did not commence until 1921. Early models were owned by Prince George and the Duke of Kent, and the car was very popular with enthusiastic motorists. It won the 24 Hours of Le Mons race in 1924 and 1927.

18 FEBRUARY
1919

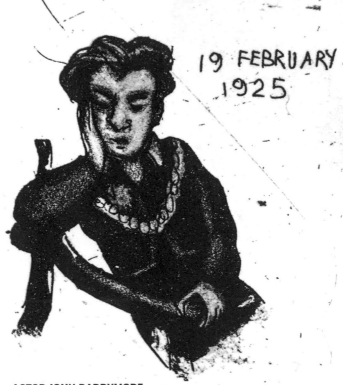

19 FEBRUARY
1925

ACTOR JOHN BARRYMORE
PREMIERES AS HAMLET AT THE HAYMARKET THEATRE.

He was already famous as a film actor and this return to the stage was met with very positive reviews. Among the audience members on that first night was 20-year-old actor John Gielgud. He wrote in his programme, 'Barrymore is romantic in appearance and naturally gifted with grace, looks and a capacity to wear period clothes, which makes his brilliantly intellectual performance classical without being unduly severe; and he has tenderness, remoteness, and neurosis all placed with great delicacy and used with immense effectiveness and admirable judgment.'

GIRO, THE 'NAZI DOG' DIES AT CARLTON HOUSE TERRACE.

Giro was a terrier that was brought to Britain by the German ambassador Leopold von Hoesch in 1932. They lived in the German Embassy at 9 Carlton House Terrace until 1934 when Giro chewed through a cable in the back garden and died from electrocution. Hoesch was so distraught at Giro's untimely death that he buried him with full honours, with a diminutive headstone that is still there. In English it reads:

'Giro – a faithful companion!
London in February 1934,
Hoesch.'

21 FEBRUARY 1848

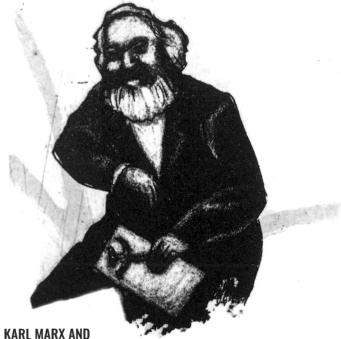

KARL MARX AND
FRIEDRICH ENGELS
PUBLISH THE COMMUNIST MANIFESTO
IN LONDON, ALTHOUGH IT IS WRITTEN IN GERMAN.

The 23-page leaflet was commissioned by the Communist League and published just as the revolutions of 1848 began to erupt. Marx and Engels were living in London when they wrote the manifesto and it contains their theories about the nature of society and politics and the history of class struggles. It quickly went on to be distributed around the world in many different languages and is recognised as one of the world's most influential political manuscripts.

22 FEBRUARY
1857

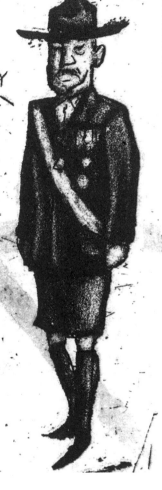

ROBERT LORD BADEN-POWELL, FOUNDER OF THE SCOUT MOVEMENT AND FIRST CHIEF SCOUT OF THE BOY SCOUTS ASSOCIATION, IS BORN IN PADDINGTON.

Baden-Powell served in the British Army from 1876 until 1910 in India and Africa. He wrote military books that became very popular with boys and went on to write *Scouting for Boys* in 1908. He held the first Scout Rally at Crystal Palace in 1909 and formed the Boy Scouts Association when he retired from the army in 1910. He made paintings and drawings almost every day of his life and was renowned for entertaining audiences with his 'ripping yarns'.

23 FEBRRUARY 1820

THE CATO STREET CONSPIRACY IS DISCOVERED AND FOILED.

Hard economic times after the end of the Napoleonic Wars created political unrest. On 22 February, George Edwards met with a group of activists who planned to exploit this situation by murdering the Prime Minister Lord Liverpool and all his cabinet ministers. One of the group at the meeting was a police informer and the plotters fell into a trap and were arrested and either executed or transported to Australia. The name comes from the meeting place near the Edgware Road where the conspirators were discovered.

CANNONS CAPTURED AT SEBASTOPOL ARE MELTED DOWN TO MAKE THE FIRST VICTORIA CROSS MEDALS.

24 FEBRUARY 1857

Queen Victoria introduced the Victoria Cross as a military decoration awarded for valour 'in the face of the enemy'. It is the highest award of the United Kingdom honours system. A single company of jewellers, Hancocks of London, has been responsible for the manufacture of every Victoria Cross ever awarded, made from two cannons seized from the Russians after the Siege of Sebastopol.

A PEDESTRIAN FAMOUSLY UNDERTAKES WALKING ACROSS LONDON BACKWARDS.

He successfully accomplished it in eight hours.

25 FEBRUARY 1838

THE BANK OF ENGLAND ISSUES THE FIRST £1 NOTE.

The note was introduced by the Bank of England following gold shortages created by the French Revolutionary Wars. The first ones were handwritten on one side only and bore the name of the payee, the date and the signature of the issuing cashier.

The end of the Napoleonic Wars in 1815 eased the gold shortage and meant that notes could be exchanged for an equivalent amount of gold when presented at the bank. This practice ended in 1931, when Britain stopped using the Gold Standard. The £1 note continued to be printed until 1984, and it was withdrawn from circulation in 1988 to be replaced by the £1 coin.

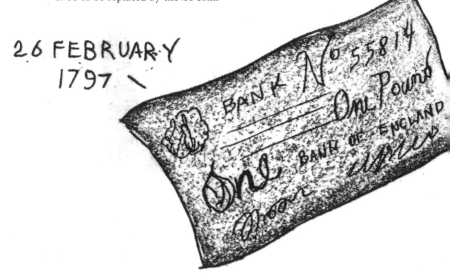

THE OFFICIAL OPENING OF THE CENTRAL CRIMINAL COURTHOUSE, KNOWN AS 'THE OLD BAILEY'.

The courthouse was built of the site of the medieval Newgate Gaol and is located on Old Bailey Street, which followed London's fortified wall (or 'bailey') that runs from Ludgate Hill to the junction of Newgate Street via Holborn Viaduct. The building was designed by E.W. Mountford in 1902 and was officially opened by King Edward VII. Above the main entrance is inscribed 'Defend the Children of the Poor & Punish the Wrongdoer'.

A bronze statue of Lady Justice, made by F.W. Pomeroy, stands on the dome above the court. She has a sword in her right hand and the scales of justice in her left, and although popular urban myth states that she represents 'blind justice', she was sculpted without a blindfold as 'her maidenly form is supposed to guarantee her impartiality'.

27 FEBRUARY 1907

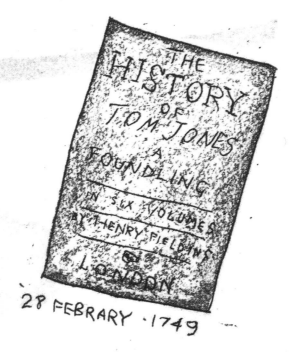

28 FEBRARY ·1749

HENRY FIELDING'S NOVEL, *THE HISTORY OF TOM JONES, A FOUNDLING*, IS PUBLISHED IN LONDON.

Tom Jones is among the earliest works of English prose works to be described as a novel. It is a comic tale following its high-spirited hero, Tom, as he rollicks through the English countryside. The book is lengthy but highly well organised and divided into 18 smaller books. Samuel Taylor Coleridge said that it had 'one of the three most perfect plots ever written'. It is generally regarded as Fielding's greatest work and was such a success that it had four editions printed in its first year alone.

ARTIST CORNELIA PARKER'S SCULPTURE, *BREATHLESS*, IS INSTALLED IN THE VICTORIA AND ALBERT MUSEUM.

The sculpture was specially commissioned to fill the oculus or open space that had been recently created between the two floors of galleries in a corner of the museum. It features 54 defunct brass band instruments found in dusty storerooms of the British Legion and Salvation Army. These instruments were squashed flat by the 22-ton accumulator in Tower Bridge's hydraulic system. The flattened objects were then hung from the ceiling with fine wire with polished sides up and tarnished sides down to resemble a Tudor rose and can be seen from below or above. It is a stunning and memorable installation whose modernism and seeming lack of respect for musical instruments caused a furore when it was installed.

MARCH

SPECTATOR

MARCH 171

THE FIRST ISSUE OF THE DAILY PUBLICATION, *THE SPECTATOR*, IS PUBLISHED.

The initial run of the paper was 555 consecutive issues, which were later collected and published in seven volumes and a later run was published as an eighth volume. *The Spectator's* stated aim was to 'enliven morality with wit, and to temper wit with morality' and it hoped to have 'brought philosophy out of closets and libraries, schools, and colleges, to dwell in clubs and assemblies, at tea-tables and coffee-houses'. In newspaper form, it was read by 60,000 Londoners and its book form was read throughout the 18th and 19th centuries.

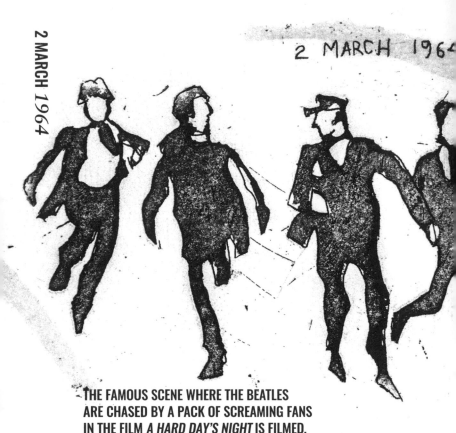

2 MARCH 1964

THE FAMOUS SCENE WHERE THE BEATLES ARE CHASED BY A PACK OF SCREAMING FANS IN THE FILM *A HARD DAY'S NIGHT* IS FILMED.

The film was directed by Richard Lester and unusually was filmed in sequential order. The opening scene was filmed at Marylebone Station, and The Beatles had only joined the actor's union, Equity, that morning. The final day of filming was in West Ealing on 24 April. The film was extremely popular in its day and is credited with being one of the most influential music films of all time, inspiring spy films, pop music videos and the Monkees' television show.

POLITICIAN MICHAEL FOOT DIES
IN HIS NORTH LONDON HOME IN HAMPSTEAD.

A fiercely intelligent man, Michael Foot began his career as a journalist and was the editor of the *Tribune* on several occasions and of the *Evening Standard* newspaper when he was only 28. He became a Member of Parliament in 1945. He was a passionate orator and an active member of the Campaign for Nuclear Disarmament, and was opposed to Britain's membership in the European Economic Community.

He was named the leader of the Labour Party between 1980 and 1983, but his affiliation with the far left of the party, combined with his outspokenness and his not particularly telegenic appearance, made him an unpopular leader, and the defeat suffered in the 1983 general election was the worst in his party's history. He resigned immediately afterwards but remained an MP until 1992.

3 MARCH 2010

4 MARCH 1969

ENGLISH GANGSTERS REGGIE AND RONNIE KRAY ARE CONVICTED OF MURDER AT THE OLD BAILEY.

The twins were the foremost perpetrators of organised crime in the East End of London during the 1950s and 1960s. Heading up a gang called 'The Firm', the Krays were involved in armed robberies, arson, protection rackets, assaults and the murders of Jack 'the Hat' McVitie and George Cornell. They became celebrities in the 1960s and socialised with prominent entertainers like Diana Dors, Frank Sinatra and Judy Garland, had their photos taken by photographer David Bailey and were even interviewed on television. They were so feared that no one would offer testimony against them. Detective Superintendent Leonard 'Nipper' Read was put on the case and decided to arrest them and hoped that with them safely in custody, evidence would follow. Eyewitnesses to the murders of both McVitie and Cornell came forward, and the Krays were sentenced to life imprisonment without the possibility of parole for 30 years, the longest sentence ever handed out at the Old Bailey.

KING HENRY VII ISSUES LETTERS PATENT TO NAVIGATOR AND EXPLORER GIOVANNI CABOTO (JOHN CABOT) AND HIS THREE SONS, GIVING THEM THE ROYAL AUTHORITY FOR A VOYAGE OF EXPLORATION TO SEEK OUT NEW LANDS.

Cabot and his sons were granted permission to 'sail to all parts, regions and coasts of the eastern, western and northern sea… to find, discover and investigate whatsoever islands, countries, regions or provinces of heathens and infidels, in whatsoever part of the world placed, which before this time were unknown to all Christians'. Cabot landed at Cape Bonavista, Newfoundland, Canada, on 24 June 1497, the first explorer to land in North America since the Vikings five centuries earlier.

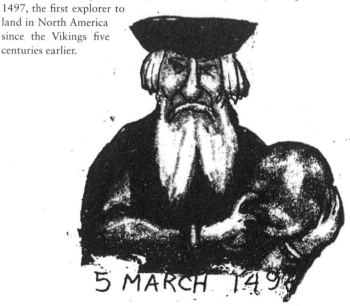

PICASSO'S PAINTING OF HIS MISTRESS DORA MAAR, TITLED *TÊTE DE FEMME*, IS STOLEN BY AN ARMED ROBBER FROM THE LEFEVRE GALLERY IN MAYFAIR.

The pony-tailed robber pulled the painting off the wall before escaping in a taxi that he asked to wait outside for him. At gunpoint, he ordered the driver to take him to Wimbledon, where he fled from the taxi, leaving behind the discarded frame and a £10 tip. The painting was recovered unharmed a week later, and Peter Scott, the thief, was captured. Scott quoted poet William Ernest Henley to his arresting officers, saying, 'Under the bludgeoning of chance, my head is bloody but unbowed.'

6 MARCH 1997

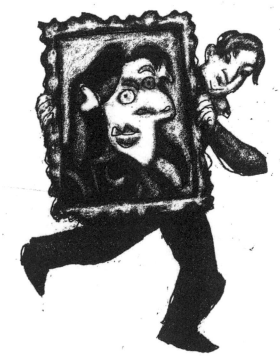

7 MARCH 1804

THE ROYAL HORTICULTURAL SOCIETY IS ESTABLISHED AT A MEETING OF SEVEN MEN AT HATCHARD'S BOOKSHOP IN PICCADILLY.

John Wedgwood (son of Josiah Wedgwood) originally suggested the formation of the society in 1800, but it took four years for the first meeting to take place. The initial aims were modest, as the founders wanted the society to hold regular meetings where its members could present papers on horticultural activities and discoveries which they would discuss and then publish the results. The society would also award prizes for gardening achievements. It has grown exponentially since its inception and now has well over 400,000 members and has four major gardens in England: Wisley Garden in Surrey; Rosemoor Garden in Devon; Hyde Hall in Essex; and Harlow Carr in Harrogate, North Yorkshire.

LONDON NIGHTCLUB, THE CAFÉ DE PARIS, IS STRUCK BY BOMBS DURING THE BLITZ.

Two bombs fell down the building's ventilation shaft to the dance floor in the cellar and exploded just in front of the stage at the start of the performance by 26-year-old bandleader Ken 'Snakehips' Johnson and his band. The band was playing 'Oh Johnny, Oh Johnny, how you can love' when the bombs struck. At least 34 people were killed, including Johnson, many of his band members, staff and diners. One survivor was cheered by the crowd outside when he was carried out on a stretcher and shouted to them, 'At least I didn't have to pay for dinner!'

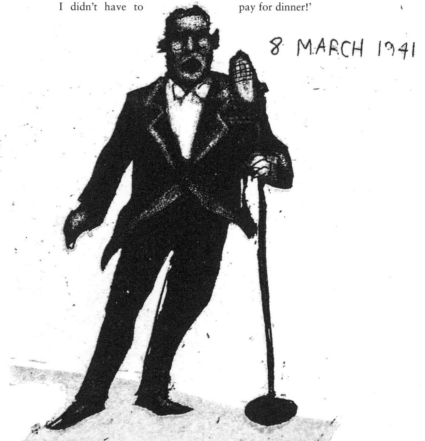

8 MARCH 1941

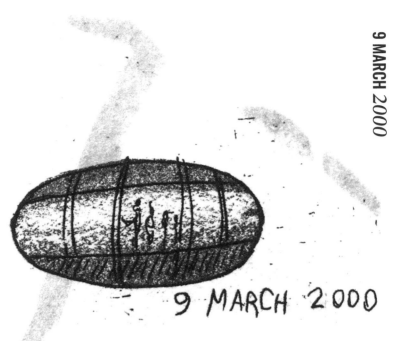

9 MARCH 2000

THE LONDON EYE – OR MILLENNIUM WHEEL – OPENS TO THE PUBLIC, THREE MONTHS AFTER ITS COMPLETION.

At 120 m high, it was the world's largest Ferris wheel until 2006, when it was surpassed by the Star of Nanchang in China. It is on the western end of Jubilee Gardens on the River Thames, between Westminster Bridge and Hungerford Bridge. It has become a popular and iconic symbol of London, with over 3.75 million visitors annually.

SUFFRAGETTE MARY RICHARDSON ENTERS THE NATIONAL GALLERY AND SLASHES THE *ROKEBY VENUS* BY DIEGO VELÁZQUEZ WITH A MEAT CLEAVER SHE SMUGGLED INTO THE GALLERY.

This was done in response to the arrest the previous day of the charismatic head of the Women's Social and Political Union, Emmeline Pankhurst. The WSPU frequently endorsed the use of property destruction to bring attention to the issue of women's suffrage. In a statement explaining her actions, she said: 'I have tried to destroy the picture of the most beautiful woman in mythological history as a protest against the Government for destroying Mrs Pankhurst, who is the most beautiful character in modern history.' The work was completely restored by the National Gallery's chief painting restorer, Helmut Ruhemann, and was very soon back on public display.

10 MARCH 1914

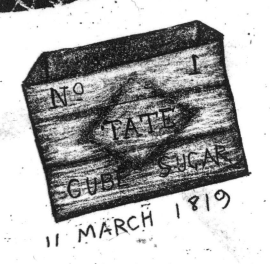

HENRY TATE, SUGAR MAGNATE
AND FOUNDER OF THE TATE GALLERY, IS BORN.

Tate started life as a grocer's apprentice when he was 13 and opened his first shop seven years later. By the time he was 35, his operation had grown to a chain of six shops, which he sold to become a partner in a sugar refinery. He opened a sugar refinery in Silvertown, London, that is still in production.

Tate was extremely philanthropic and donated 64 contemporary paintings to the country, as well as £80,000 towards the creation of the National Gallery of British Art on the site of the old Millbank Prison in Pimlico. This building is now known as the Tate Britain and has been joined by the Tate Modern at Bankside, Tate Liverpool and the Tate St Ives.

NB: Tate was actually born in Chorley, Lancashire, but made a huge and lasting contribution to life in London, the city in which he lived the last 30 years of his life. He is buried in West Norwood cemetery.

THE CHURCH OF ENGLAND ORDAINS ITS FIRST WOMEN PRIESTS.

The service was officiated by Bishop Barry Rogerson in Bristol Cathedral, and a total of 32 women were ordained. As Rogerson worked in a strictly alphabetical order, Angela Berners-Wilson is considered to be the first woman to have been ordained.

12 MARCH 1994

THE FIRST DRIVING TESTS ARE INTRODUCED IN THE UNITED KINGDOM.

Mr R.E.L. Beere of Kensington took the test voluntarily, as it did not become mandatory until 1 June 1935. He paid 7/6d to take the test, and as there were no test centres yet, he had to meet the examiner at the post office. His driving certificate was numbered 0001.

13 MARCH 1935

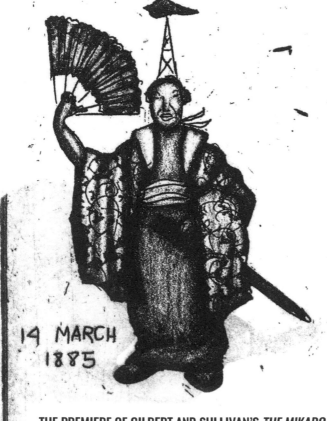

14 MARCH

1885

THE PREMIERE OF GILBERT AND SULLIVAN'S *THE MIKADO* OR *THE TOWN TITIPU* AT THE SAVOY THEATRE.

It is the ninth of fourteen collaborations that the pair created and was so popular that by the end of 1885 it was estimated that over 150 companies were producing the opera. Setting the opera in Japan allowed them to satirise British politics and institutions more freely. *The Mikado* remains the most popular of all of the Savoy Operas and one of the most frequently played musical theatre pieces in history.

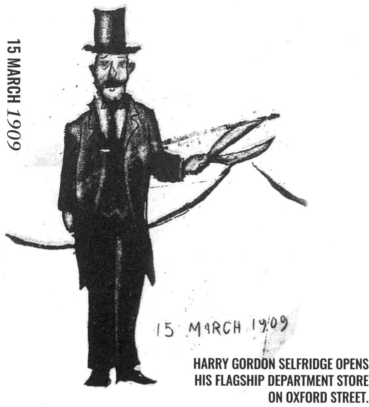

15 MARCH 1909

HARRY GORDON SELFRIDGE OPENS HIS FLAGSHIP DEPARTMENT STORE ON OXFORD STREET.

Selfridges is the second largest store in the country, after Harrods. Harry Selfridge, originally from America, was successful because of his relentlessly innovative marketing and he attempted to dismantle the idea that consumerism was strictly an American phenomenon. He tried to make shopping a fun adventure and a form of leisure rather than a chore. He placed merchandise on display so customers could examine it, moved the highly profitable perfume counter front-and-centre on the ground floor and established policies for safe and easy shopping that have been adopted by modern department stores around the world. He coined the phrase 'the customer is always right' and used it regularly in his advertising.

CONSTRUCTION BEGINS ON RENZO PIANO'S ICONIC BUILDING 'THE SHARD'.

The Shard is a 95-storey skyscraper close to London Bridge and stands 309.7 m high, making it the tallest building in the United Kingdom and the fourth tallest building in Europe. It was topped out on 30 March 2012 and inaugurated on 6 July 2012. It has 72 habitable floors with a viewing gallery and open-air observation deck on the 72nd floor at a height of 244.3 m.

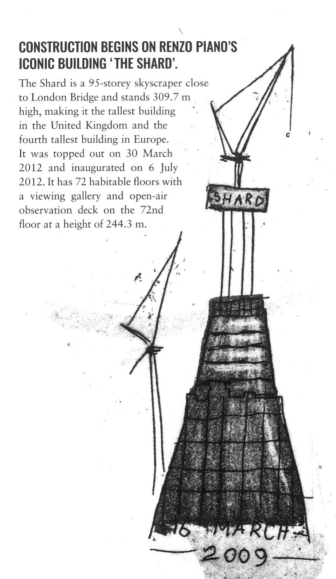

INVENTOR STEPHEN PERRY PATENTS THE RUBBER BAND.

Perry's company Messrs Perry and Co, Rubber Manufacturers of London, made early products from vulcanised rubber, a technique devised by Charles Goodyear in 1839.

17 MARCH 1845

18 MARCH
1932

THE BBC MAKES ITS FIRST RADIO NEWS BROADCAST FROM BROADCASTING HOUSE ON LANGHAM PLACE, LONDON W1.

Broadcasting House is a Grade II listed building built in Art Deco style, with a facing of Portland Stone over a steel frame. It was officially opened on 15 May 1932 and is the headquarters of the BBC.

19 MARCH
1958.

MADAME TUSSAUDS OPENS THE LONDON PLANETARIUM ON MARYLEBONE ROAD, ADJACENT TO MADAME TUSSAUDS.

Built on the site of an old cinema that was destroyed in World War II, the Planetarium had its necessary projecting equipment imported from Western Germany at a cost of £50,000. Inside a horizontal dome, an opto-mechanical star projector offered an audience of 330 people a show based on a view of the night sky as seen from earth. It was used to teach students from University College London's astronomy department the complexity of the Celestial coordinate system, allowing for practical lectures delivered by a team of planetarium and UCL staff. It closed in 2006 and the building now houses the Marvel Superheroes 4D attraction. The only remaining planetarium in London is the Peter Harrison Planetarium in Greenwich.

THE JULES RIMET WORLD CUP TROPHY IS STOLEN.

The trophy was being displayed in a case at a rare stamp exhibition in the Central Methodist Hall, Westminster, prior to England staging the World Cup. Guards doing their noon round noticed that the back door of the hall was ajar, and that the case had been forced open and that someone had made off with the trophy, ignoring more than £3 million worth of rare stamps. A ransom demand for £15,000 in £1 notes was received but was never paid. A week after the theft, a black and white collie named Pickles found the trophy wrapped in paper and tied with string tucked under a hedge in Beulah Hill, southeast London. Pickles was the guest of honour at a World Cup celebration banquet and went on to star in the film *The Spy with the Cold Nose*.

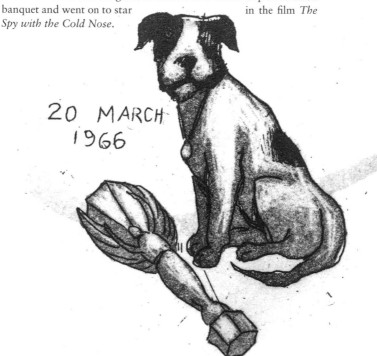

20 MARCH 1966

THE EPISODES OF THE AMERICAN SIT-COM *FRIENDS*, THAT FEATURE ROSS'S ILL-FATED WEDDING TO EMILY, BEGIN FILMING IN LONDON.

There were some scenes shot on location, but the bulk of the filming was in specially constructed sets at The Fountain Studios, Wembley. It was one of the most popular episodes of the series thus far but aired to lukewarm response in the UK, where it was deemed to have given very one-dimensional portrayals of Britain and the British.

TOMMY THUMB'S PRETTY SONG-BOOK, THE FIRST ANTHOLOGY OF ENGLISH NURSERY RHYMES, IS PUBLISHED.

This anthology contains the oldest printed texts of many well-known and popular rhymes plus a number that have dropped out of the canon of rhymes for children. It includes versions of 'Baa Baa Black Sheep', 'Hickory Dickory Dock', 'Oranges and Lemons', 'London Bridge is Falling Down', 'Mary Mary Quite Contrary' and 'Sing a Song of Sixpence'.

22 MARCH 1774

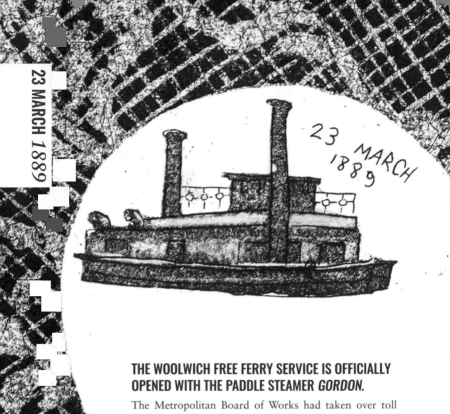

23 MARCH 1889

THE WOOLWICH FREE FERRY SERVICE IS OFFICIALLY OPENED WITH THE PADDLE STEAMER *GORDON*.

The Metropolitan Board of Works had taken over toll bridges in West London and made them free for public use, and it was suggested that they do the same in East London with the ferry. They enlisted the services of chief engineer Sir Joseph Bazalgette to lead design and construction. Two days before the first service, the Metropolitan Board of Works was replaced by the London County Council, and the opening ceremony was conducted by Lord Roseberry instead of the expected Bazalgette. There had been a connection between the two sides of the river since the Norman Conquest, and records show a ferry service operating since 1308.

THE UNION OF THE CROWNS OF ENGLAND, IRELAND AND SCOTLAND UPON THE ACCESSION OF JAMES VI, KING OF SCOTS.

The Union of Crowns followed the death of Elizabeth I of England, the last monarch of the Tudor dynasty, who was James's unmarried and childless first cousin twice removed. Despite James's best efforts to create a new imperial throne of Great Britain, the two countries remained distinct and separate sovereign states until the Acts of Union of 1707 during the reign of the last Stuart monarch, Queen Anne.

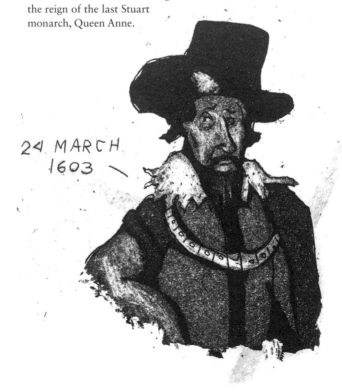

24 MARCH 1603

REGINALD KENNETH DWIGHT, AKA SIR ELTON JOHN, IS BORN IN PINNER.

Elton John learned to play the piano at a very young age and in 1962 formed the band Bluesology, the name a homage to the Django Reinhardt album *Djangology*. John met his long-term songwriting partner Bernie Taupin in 1967, after they both answered an advert for songwriters. For the next two years they wrote songs for other artists, including Lulu, and John also worked as a session musician for the Hollies and the Scaffold. He started recording his own songs in 1969 and by 2016 had released a total of 30 albums.

John has received five Grammys and five Brit Awards, as well as a number of other honours. He is also an avid music fan with an extensive collection of albums. It may be an urban myth, but I heard that at the height of his record purchasing in the 70s, he was buying so many records that he was responsible for 2% of record purchases in the UK.

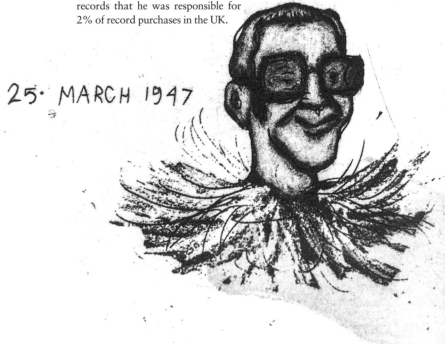

25· MARCH 1947

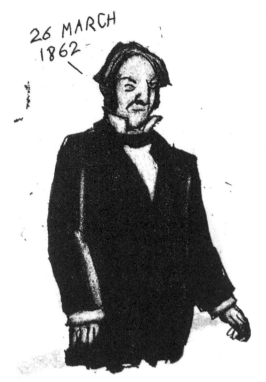

26 MARCH
1862

AMERICAN LONDON-BASED BANKER GEORGE PEABODY CREATES THE PEABODY TRUST, ONE OF THE WORLD'S LARGEST AND MOST SUCCESSFUL PHILANTHROPIC HOUSING ASSOCIATIONS.

Peabody started the Peabody Donation Fund with a donation of £150,000 with the aim to 'ameliorate the condition of the poor and needy of this great metropolis, and to promote their comfort and happiness'. Shortly before his death in 1869, he increased the amount of his donation to £500,000. His legacy is one of London's largest housing associations, with around 29,000 properties. It is also a community benefit society and urban regeneration agency, a developer with a focus on sensitive regeneration and a provider of an extensive range of community programmes.

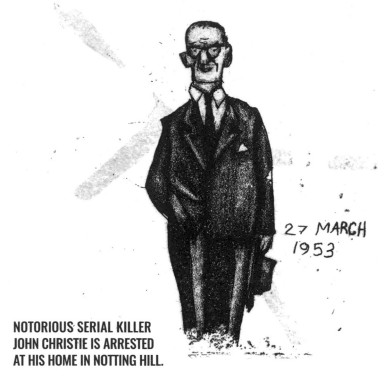

27 MARCH 1953

NOTORIOUS SERIAL KILLER JOHN CHRISTIE IS ARRESTED AT HIS HOME IN NOTTING HILL.

Christie murdered at least eight people, including his wife Ethel, by strangling them in his flat at 10 Rillington Place. Christie moved out of his flat during March 1953, and soon afterwards the bodies of three of his victims were discovered in an alcove in the kitchen. Two further bodies were discovered in the garden, and his wife's body was found beneath the floorboards of the front room. Christie was arrested and convicted of his wife's murder, for which he was hanged at Pentonville Prison. BBC Radio London DJ Robert Elms' parents almost rented a room from Christie but decided against this as Mrs Elms found their potential landlord a bit creepy.

MY DAUGHTER MATILDA IS BORN AT THE WHITTINGDON HOSPITAL ON HIGHGATE HILL.

One of the happiest personal daily details on my map.

28 MARCH 1996

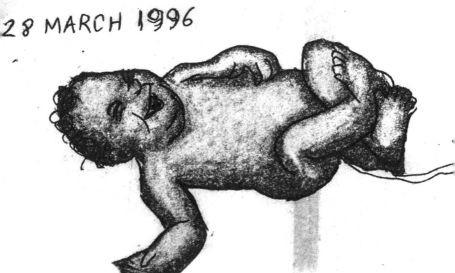

THE FIRST LONDON MARATHON TAKES PLACE.

Previous marathons had occurred in London, with the Polytechnic Marathon in 1909 following the Olympic Games in 1908, which gave us the standardised marathon length of 26 miles and 385 yards. This seemingly arbitrary length was set as it was the exact distance between the starting point outside the nursery of Windsor Castle (so that the royal children could watch) and the finishing line inside the Olympic Stadium in Shepherds Bush, West London. It was founded by athletes Chris Brasher and John Disley, who were inspired by the New York Marathon.

The first London Marathon finished in a tie as American Dick Beardsley and Norwegian Inge Simonsen crossed the finish line holding hands in 2 hours, 11 minutes and 48 seconds.

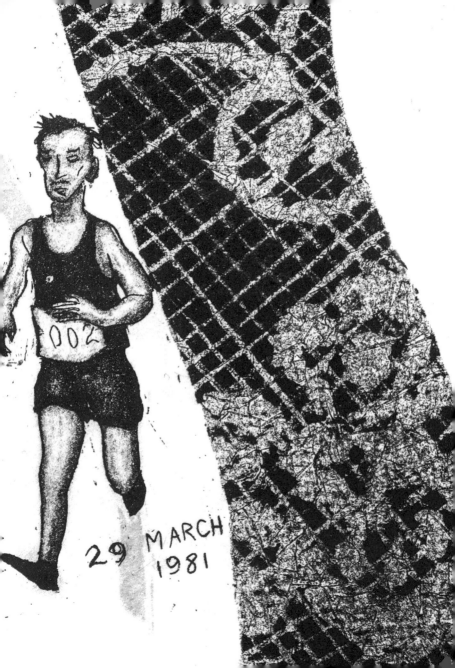

29 MARCH
1981

THE ROYAL ALBERT HALL OF ARTS AND SCIENCES OPENS.

London had staged the Great Exhibition in 1851, and it had been such a success that it led Prince Albert, the Prince Consort, to propose the creation of a permanent series of facilities in Hyde Park to enlighten the public. Gore House and its grounds were purchased, but development was so slow that little progress had been made by 1861, when Prince Albert died. Queen Victoria decided to build a monument to her husband in Hyde Park with a Great Hall opposite.

The building was inspired by ancient amphitheatres and designed by civil engineers Captain Francis Fowke and Major-General Henry Y.D. Scott. The dome was made of wrought iron and then glazed. The design was so revolutionary that during construction only volunteers remained inside the building in case it collapsed. At the opening ceremony, Prince Edward, the Prince of Wales, gave a welcoming speech as Queen Victoria was too overcome to speak.

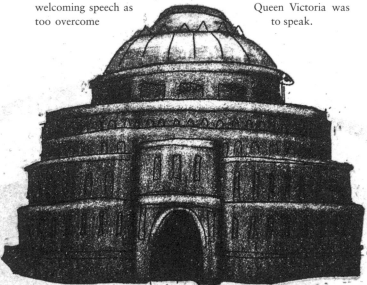

30 MARCH 1871

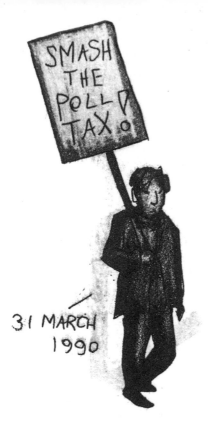

A MARCH AGAINST THE POLL TAX OR COMMUNITY CHARGE CONVERGES ON TRAFALGAR SQUARE.

What started off as a peaceful protest turned into a riot, culminating in the worst violence in the city for a century. A total of 340 people were arrested after widespread destruction and looting occurred around the West End. The demonstrations led ultimately to the reversal of the community charge and the downfall of Prime Minister Margaret Thatcher, who was forced to resign in November 1990.

APRIL

KEW GARDENS IS OFFICIALLY FOUNDED FROM LORD CAPEL OF TEWKESBURY'S EXOTIC GARDEN, WHICH HAD BEEN ENLARGED AND EXTENDED IN 1759.

The origins of Kew can be traced to the merging of the royal estates of Richmond and Kew in 1771. William Chambers designed many garden structures, including the Chinese Pagoda, built in 1761, which is the oldest remaining building. In 1841 the gardens were adopted as a national botanical garden due to the efforts of the Royal Horticultural Society and William Hooker was appointed its director. Today Kew has the largest and most diverse collection of living and preserved botanical specimens in the world and is a UNESCO World Heritage Site.

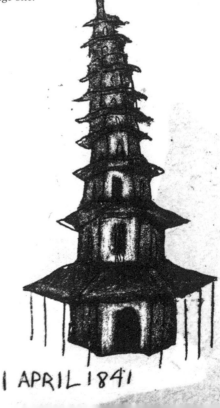

I APRIL 1841

THE WHITECHAPEL ART GALLERY ORGANISES THE FIRST MAJOR EXHIBITION OF ARTIST DAVID HOCKNEY.

Hockney had his first solo exhibition in 1963, when he was 26, but the Whitechapel organised the first retrospective. The show contained many iconic early works, such as *The Bigger Splash* and *The Rake's Progress* series of etchings.

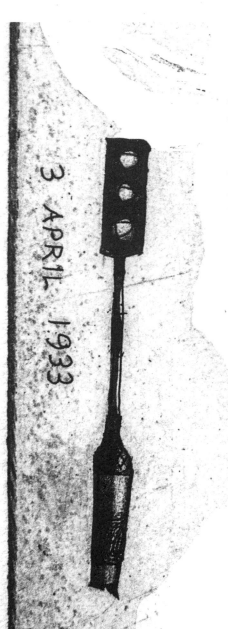

THE FIRST ELECTRIC TRAFFIC LIGHTS IN THE UK ARE INSTALLED IN PICCADILLY CIRCUS.

The world's first manually operated gas-lit traffic signal was short lived. Installed in London in December 1868, it exploded less than a month later, seriously injuring its policeman operator.

FRANCIS DRAKE, THE VICE-ADMIRAL, SEA CAPTAIN, PRIVATEER, SLAVER AND POLITICIAN, RECEIVES A KNIGHTHOOD AT DEPTFORD ON BOARD HIS SHIP *THE GOLDEN HIND*.

4 APRIL 1581

Although Queen Elizabeth I was present, the dubbing was actually performed by a French diplomat, Monsieur de Marchaumont, who was negotiating for Elizabeth to marry the King of France's brother, Francis, Duke of Anjou. By involving the French diplomat in the knighting, Elizabeth gained the implicit political support of the French for Drake's actions.

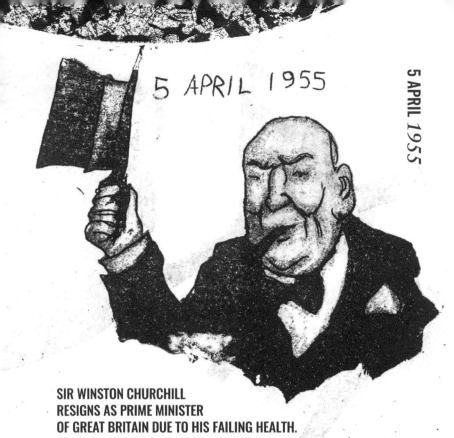

5 APRIL 1955

SIR WINSTON CHURCHILL RESIGNS AS PRIME MINISTER OF GREAT BRITAIN DUE TO HIS FAILING HEALTH.

Churchill made the announcement after a dinner party at 10 Downing Street attended by the Queen and the Duke of Edinburgh. Tributes to the 80-year-old premier poured in from around the world. Churchill first became Prime Minister in 1940 and led the wartime Coalition Government during World War II. He inspired courage throughout the war, promising nothing more than 'blood, toil, tears and sweat'. He lost the election in 1945 but returned again in 1951 at the age of 77. In 1953 he was made a Knight of the Order of the Garter in recognition of his services to his country.

WRITER OSCAR WILDE IS ARRESTED AFTER LOSING A LIBEL CASE AGAINST THE MARQUESS OF QUEENSBURY.

Wilde had been engaged in an affair with the marquess's son since 1891 but when the marquess denounced him as a homosexual, Wilde sued the man for libel. He lost the case as the evidence that came up strongly supported the marquess's allegations. Homosexuality was classified as a crime in England at the time, so Wilde was arrested, found guilty and sentenced to two years hard labour. After his release, he moved to Paris, where he wrote *The Ballad of Reading Gaol* about his experiences.

6 APRIL 1895

EMPRESS MATILDA BECOMES THE FIRST FEMALE RULER OF ENGLAND.

Matilda's father, Henry I, had no legitimate children and so named his eldest daughter Matilda as his heir. After he died, there was much conflict over the throne, and it ended up in the hands of her cousin Stephen of Blois. Matilda brought an army from France, seized the throne and captured Stephen after the Battle of Lincoln. She was titled Lady of the English but failed to be crowned Queen of England at Westminster due to dramatic opposition from the London crowds. After the Rout of Winchester, she exchanged Stephen for her half-brother Robert, and she and Stephen fought for overall control of a divided England. She gave up her title in 1148, and the country was once again ruled by Stephen until 1154 when her son Henry II became the King of a united England.

AFTER 151 CONTINUOUS WEEKLY PUBLICATIONS, THE SATIRICAL MAGAZINE *PUNCH* PUBLISHES ITS LAST ISSUE.

Punch was founded on 17 July 1841 by Henry Mayhew and engraver Ebenezer Landells from an initial investment of £25. It was subtitled *The London Charivari* in homage to Charles Philipon's French satirical magazine *Le Charivari*. The magazine featured articles and coined the word 'cartoon' in its modern sense as a humorous illustration. Its circulation peaked in the 1940s, and then it began a long decline. It was revived in 1996 but closed again in 2002.

THE NATIONAL GALLERY OPENS IN TRAFALGAR SQUARE.

The Gallery was originally founded in 1824 on Pall Mall from an original government purchase of 38 paintings from the heirs of John Julius Angerstein, an insurance broker and patron of the arts. After the initial purchase, the Gallery's collection was shaped by its early directors, notably Sir Charles Lock Eastlake, and by private donations, which comprise two-thirds of the collection. Its collection is small in scale compared with those of many European national galleries but encyclopaedic in scope, with most major developments in Western painting from Giotto to Cézanne represented with major works.

The present building is the third to house the National Gallery and was designed by William Wilkins. Only the façade onto Trafalgar Square remains unchanged from its opening, as the building has been expanded many times throughout its history, most notably the Postmodernist Sainsbury Wing in 1991.

9 APRIL 1838

THE BRIXTON RIOT BEGINS.

Tensions in the area had been mounting between the Afro-Caribbean community and the police since the January of that year, when a suspicious house fire that killed a number of black youths was not deemed to have been properly investigated by the police.

On 10 April, a policeman saw an injured black youth running from his attackers. The man ran into a flat on Atlantic Road and was found to have a four-inch stab wound. The constable and the inhabitants of the flat tried to help the man into a police car to get him to the hospital, but a gathering crowd misinterpreted this as an attempt to arrest the man and pulled him from the car. When the man died, violent demonstrations quickly escalated, and a full-scale riot ensued.

The main riot on 11 April resulted in injuries to 280 police and 45 members of the public, 82 arrests and damage to 150 buildings, 30 of which were burned. I have depicted one of the 56 police cars that were set alight.

10 APRIL 1981

11 APRIL 1633

THE FIRST BANANAS SEEN IN ENGLAND ARE PUT ON SALE IN THE WINDOW OF THOMAS JOHNSON, 'CITIZEN AND APOTHECARYE', ON SNOW HILL, EC1.

Johnson's bananas were possibly from Bermuda, where there was a British naval base, although it is unknown how they managed to reach London in a fit state to eat.

ANDREW LLOYD WEBBER'S MUSICAL *CATS*, BASED ON *OLD POSSUM'S BOOK OF PRACTICAL CATS* BY T.S. ELLIOT, BEGINS REHEARSALS AT THE NEW LONDON THEATRE, DRURY LANE.

The play opened on 12 May 1981 in the West End and on Broadway in 1982. It won numerous awards, including Best Musical at both the Laurence Olivier Awards and the Tony Awards. The London production ran for 21 years and the Broadway one for 18 years, both setting new records.

ELIZABETHAN PLAYHOUSE, THE THEATRE, OPENS IN SHOREDITCH JUST OUTSIDE THE WALLS OF THE CITY OF LONDON.

Built by actor-manager James Burbage near his family home, it is considered to be the first theatre built in London for the sole purpose of theatrical productions. It became the home of the Lord Chamberlain's Men, which included William Shakespeare as an actor and playwright.

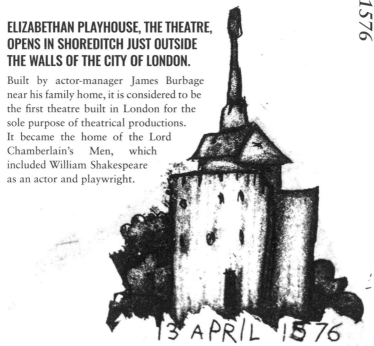

In late December 1598, a dispute with the owners of the land prompted Burbage to covertly dismantle The Theatre and transport the timbers to Bankside where they were used to construct the Globe Theatre.

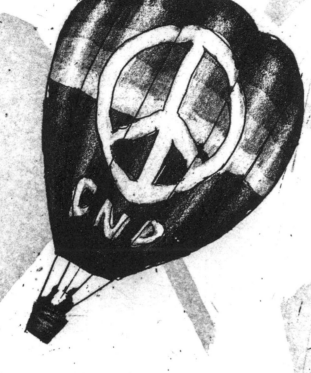

A HOT AIR BALLOON LANDS IN HYDE PARK DURING A CND RALLY.

The Campaign for Nuclear Disarmament, formed in 1957, advocates unilateral nuclear disarmament by the United Kingdom and tighter international arms regulation through agreements such as the Nuclear Non-Proliferation Treaty. It has been at the forefront of the peace movement since its formation and is Europe's largest single-issue peace campaign. Picture research done at the time the map was made gave 14 April as the date, but I have subsequently found that the rally was held on 25 April 1987.

COMEDIAN TOMMY COOPER COLLAPSES AND DIES MIDWAY THROUGH HIS ACT ON THE VARIETY SHOW *LIVE FROM HER MAJESTY'S*, WHICH WAS BEING BROADCAST LIVE FROM HER MAJESTY'S THEATRE.

Cooper was a physical comedian who was a member of the Magic Circle and used magic acts as part of his act. He had his debut on the BBC talent show *New To You* in 1948 and remained very popular with television audiences throughout his career.

Alcohol had started to erode his professionalism, with club owners regularly complaining about him turning up late or rushing his act. On 15 April, he was doing an act in which he would appear to pull props from under his gown that were actually being passed to him from behind a curtain. He collapsed during the act, and the audience mistook this for part of the act. He was moved backstage, where we was found to have had a heart attack. They carried on the show, quickly moving on to the next act, and reported his death only much later.

15 APRIL 1984

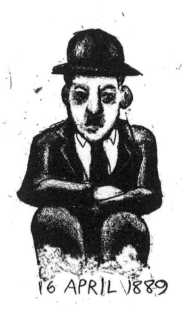

16 APRIL 1889

COMIC ACTOR AND FILMMAKER CHARLIE CHAPLIN IS BORN.

The exact site of Chaplin's birthplace is disputed but is generally regarded to have been near East Street Market in Walworth. His childhood was one of great poverty, and he started acting on stage at a very young age. He was taken to America with the prestigious Fred Karno Company and was quickly scouted by a film company. His first film appearance was in 1914, and he introduced his iconic character The Tramp later that year. Chaplin went on to star in and then direct a number of highly regarded films that successfully bridged the transition from silent films to talkies. He is arguably the single most important artist produced by the cinema, and a number of his films, including *Modern Times*, *The Great Dictator* and *Limelight*, are consistently ranked in the top 100 films of all time.

17 APRIL 1397

17 APRIL 1397

GEOFFREY CHAUCER GIVES THE FIRST PUBLIC RECITATION OF *THE CANTERBURY TALES*, A COLLECTION OF 24 STORIES TOLD BY FICTIONAL PILGRIMS ON THE ROAD TO CANTERBURY CATHEDRAL.

This recitation was done before ladies and gentlemen of the court to promote the acceptance of English as a courtly language. The widespread use of the Middle English vernacular in place of French and Latin can be traced back to that day. Chaucer is known as the Father of English literature and was the first poet to be buried in Westminster Abbey in what is now called Poets' Corner.

THE SPEAKER'S MACE IS DAMAGED DURING POLL TAX DEBATES IN THE HOUSE OF COMMONS.

Ron Brown MP grabbed the mace and angrily threw it to the floor. He agreed to read out a pre-written apology in the Commons but attempted to add comments of his own. He was suspended from Parliament for 20 days, suspended from the Labour Party for 30 days and ordered to pay £1,500 damages to pay for the repair.

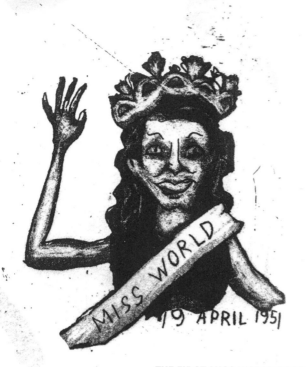

THE FIRST MISS WORLD PAGEANT
IS HELD AT THE LYCEUM BALLROOM.

Eric Morley originally organised a bikini contest as part of the Festival of Britain celebrations that he called the Festival Bikini Contest. The event was extremely popular with the press, who dubbed it Miss World. It was won by Sweden's Kersten 'Kiki' Hakansson, who was controversially crowned wearing a bikini. Bikinis had only recently been introduced onto the market and were still considered immodest. Morley registered Miss World as a trademark and made the pageant an annual event. Kiki Hakansson remains the only winner to have been crowned wearing a bikini.

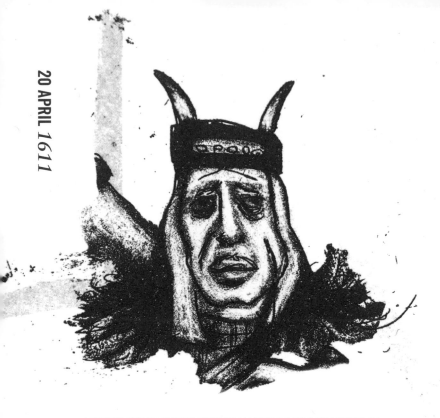

THE FIRST RECORDED PERFORMANCE OF *THE TRAGEDY OF MACBETH* AT THE GLOBE THEATRE IN BANKSIDE.

The play dramatises the psychological effects of political ambition on those who seek power for its own sake. Shakespeare wrote the play in 1606 based on Macbeth, King of Scotland, in Holinshed's *Chronicles*, 1587. Written early in the reign of James I, the patron of Shakespeare's theatrical company, it is the play that most clearly reflects the playwright's relationship with his sovereign. The events of the tragedy are usually associated with the execution of Henry Garnet for his complicity in the Gunpowder plot of 1605.

THE FAMOUS SURGEON'S PHOTOGRAPH OF THE LOCH NESS MONSTER IS PUBLISHED IN THE *DAILY MAIL*.

The photograph has since been discovered to have been an elaborate hoax masterminded by Marmaduke Wetherell, a renowned big game hunter who had been hired to find proof of the existence of the monster. He came back with evidence, including footprints of Nessie that later were found to have been made by a hippopotamus-foot umbrella stand. After Wetherell was publicly ridiculed by the editors of the *Daily Mail*, he decided to take his revenge on them. With some co-conspirators, he fashioned the monster from a toy dinosaur and a model submarine that was floated in the loch for the photograph. It was supposedly taken by Robert Kenneth Wilson, a London gynaecologist, but when he was reluctant to have his name attached it became known as the Surgeon's Photograph.

21 APRIL 1934

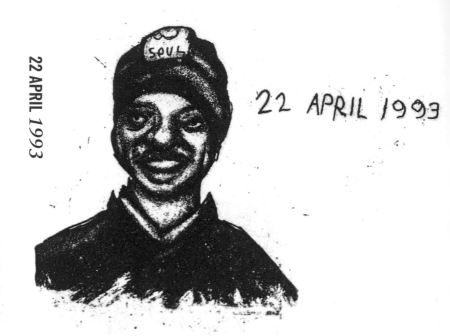

22 APRIL 1993

STEPHEN LAWRENCE IS KILLED IN A RACIALLY MOTIVATED ATTACK WHILE WAITING FOR A BUS IN ELTHAM.

After the initial investigation, five suspects were arrested but not convicted. During the course of the investigation, it was suggested that the attack had been racially motivated, but issues of race affected the handling of the case by the police and the Crown Prosecution Service. The case became a *cause célèbre* and one of the highest profile racial killings in UK history; its fallout included profound cultural changes to attitudes on racism, the police and legal practice. It helped to bring about a revocation of the double jeopardy law, and two of the previously exonerated suspects were retried and convicted 20 years later. The Royal Institute of British Architects (RIBA) established an annual architectural award, the Stephen Lawrence Prize, and the Stephen Lawrence Charitable Trust was established as a national education charity committed to the advancement of social justice.

WILLIAM SHAKESPEARE SPENDS
THE FIRST OF HIS BIRTHDAYS IN LONDON.

Little is known of Shakespeare's early days in London, and it is speculated that he began his life in theatre by holding the horses of wealthy patrons while they attended performances. Initially he was employed as an actor in Burbage's company, the Lord Chamberlain's Men, at The Theatre and by 1592 was its main playwright. When The Theatre was dismantled and its timbers were used to build the Globe Theatre in Bankside in 1598, Shakespeare was one of the six shareholders.

23 APRIL
1585

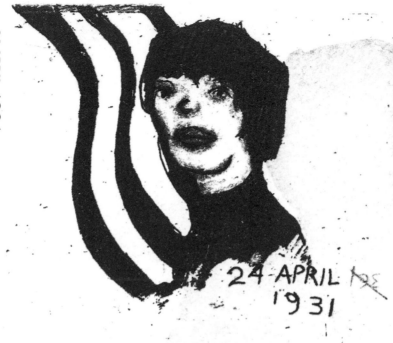

24 APRIL 1931

ENGLISH PAINTER BRIDGET RILEY IS BORN IS NORWOOD.

Famous for her iconic and hypnotic black and white paintings, Riley is one of the foremost exponents of the optical illusion art movement known as Op Art.

DANIEL DEFOE'S NOVEL *ROBINSON CRUSOE* IS PUBLISHED.

The first edition credited the work's protagonist, Robinson Crusoe, as its author, leading many readers to believe that the book was an autobiographical travelogue of true incidents. The book's hero is a castaway who spends 27 years on a remote tropical desert island near Trinidad, encountering cannibals, captives and mutineers before being rescued. The book was well received in literary circles and marked the beginning of realistic fiction as a genre. It is often cited as the first English novel.

25 APRIL 1719

26 APRIL 1928

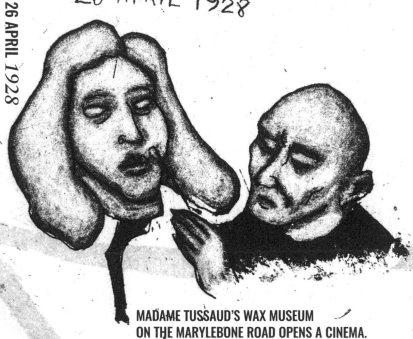

MADAME TUSSAUD'S WAX MUSEUM ON THE MARYLEBONE ROAD OPENS A CINEMA.

Madame Tussaud was a French wax sculptor who settled in Baker Street and opened her first museum in 1835. She coined the expression 'Chamber of Horrors' and included waxworks of victims of the French Revolution, and murderers and other criminals. Some of the sculptures made by Madame Tussaud herself still exist, although many were damaged by a fire in 1925 and German bombs in 1941.

JOHN MILTON, BLIND AND IMPOVERISHED, SELLS THE PUBLICATION RIGHTS FOR HIS MAGNUM OPUS, THE BLANK-VERSE EPIC POEM *PARADISE LOST*, FOR £5 PLUS A FURTHER £5 TO BE AWARDED WHEN EACH EDITION OF BETWEEN 1,300 AND 1,500 COPIES SOLD OUT.

Upon publication, *Paradise Lost* immediately established Milton's stature as an epic poet, and he is still regarded as one of the greatest writers in the English language, on par with Chaucer and Shakespeare. Milton was a poet and man of letters and worked as a civil servant in the government of Oliver Cromwell. After Cromwell's death, Milton was linked to the republicans, and after the Restoration in May 1660 a warrant was issued for his arrest, all his writings were burnt and he went into hiding for his life. He re-emerged after a general pardon was issued and lived the final decade of his life in London, only retiring to Chalfont St Giles briefly during the Great Plague of London to Milton's Cottage, his only extant home.

27 APRIL 1667

THE FA CUP FINAL IS THE FIRST MATCH PLAYED AT THE ORIGINAL WEMBLEY STADIUM.

Bolton Wanderers beat West Ham United 2-0. Wembley was known as the Empire Stadium and hosted annual FA Cup finals, five European Cup finals, the 1948 Summer Olympics and the World Cup Final. Great Brazilian footballer Pelé once said, 'Wembley is the cathedral of football. It is the capital of football and it is the heart of football.' It was replaced by the new Wembley Stadium in 2007, and the debris from the old stadium was used to make the artificial hills of Northala Fields in Northolt.

28 APRIL 1923

30 ST MARY AXE, AFFECTIONATELY KNOWN AS 'THE GHERKIN', OPENS.

The Gherkin is a commercial skyscraper in the City of London designed by Sir Norman Foster and Arup Group. The relatively modest 41-storey building was built after plans to build a 92-storey Millennium Tower were dropped. It is widely regarded as one of the best examples of modern architecture in London.

29 APRIL 2004

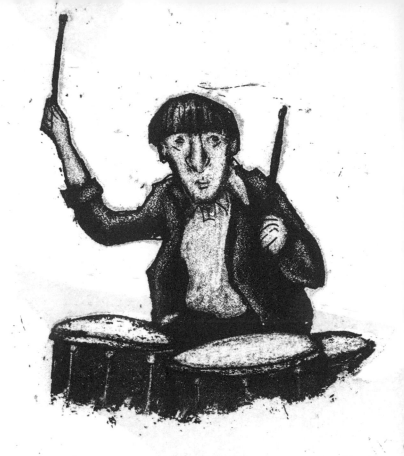

THE WHO'S DRUMMER KEITH MOON IS BORN IN ALPERTON, A SUBURB OF WEMBLEY.

Moon was as famous for his eccentric and self-destructive behaviour as for his unique drumming style. He joined The Who in 1964 before they recorded their first single. Moon developed a reputation for smashing his drum kit on stage and destroying hotel rooms on tour, including blowing up toilets with cherry bombs and dropping televisions out of windows. He died at 32 and was posthumously inducted into the Modern Drummer Hall of Fame.

MAY

STATUE OF PETER PAN IS ERECTED IN KENSINGTON GARDENS.

J.M. Barrie, author of *Peter Pan in Kensington Gardens*, commissioned Sir George Frampton to sculpt the work as a gift to children. After his death, Barrie left the royalties from *Peter Pan* to be anonymously donated to Great Ormond Street Hospital for Sick Children.

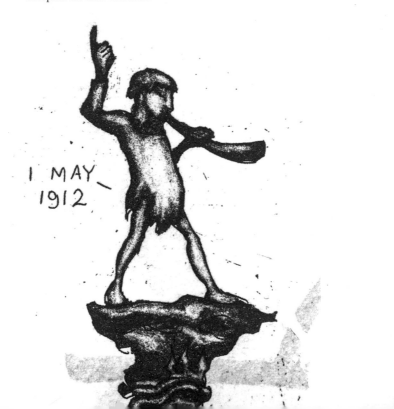

I MAY
1912

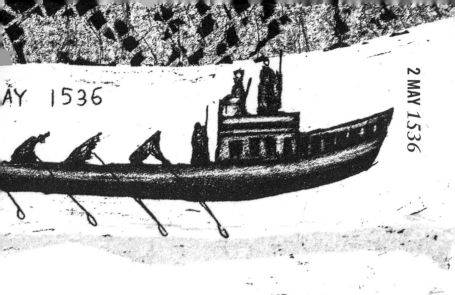

ANNE BOLEYN IS FORMALLY CHARGED WITH HIGH TREASON, ARRESTED AND TAKEN FROM GREENWICH TO THE TOWER OF LONDON BY BARGE.

Anne entered through the Court Gate in the Byward Tower rather than the Traitors' Gate. In the Tower, she collapsed, demanding to know the location of her father and 'swete broder', as well as the charges against her. She was accused of adultery, incest and high treason, as adultery on the part of a queen was a form of treason because of the implications for the succession to the throne. Her marriage to Henry was declared null and void, and she was found guilty and sentenced to be executed. Henry commuted her sentence from burning to beheading, and this was carried out on Tower Hill on 19 May 1536.

3 MAY 1951

THE ROYAL FESTIVAL HALL IS OFFICIALLY OPENED.

The hall is a 2,500-seat concert, dance and talks venue built on the south bank of the Thames close to Hungerford Bridge. It was built as the permanent centrepiece of the Festival of Britain.

Designed in the modernist style, it was made out of reinforced concrete alongside beautiful hardwood and Derbyshire fossilised limestone. The original sketch by chief architect Leslie Martin shows the design of the concert hall as the egg in a box. The strength of the design, however, was the arrangement of interior space: the central staircase has a ceremonial feel and moves elegantly through the different levels of light and air. The designers realised that the scale of the project demanded a monumental building, but its great success is the series of wide-open foyers intended as meeting places for all. It was the first post-war building to achieve a Grade I listing.

THE SULTAN'S ELEPHANT
APPEARS IN LONDON.

This was a large-scale public performance spectacle created by the Royal de Luxe theatre company and involved a huge moving mechanical elephant, a giant marionette of a girl and other related public art installations. In French it was called *La visite du sultan des Indes sur son éléphant à voyager dans le temps* (literally 'Visit from the Sultan of the Indies on His Time-Travelling Elephant').

The show was commissioned by the French cities of Nantes and Amiens to commemorate the centenary of Jules Verne's death. Its procession around London lasted for four days, and it travelled to various other major cities around the world between 2005 and 2006.

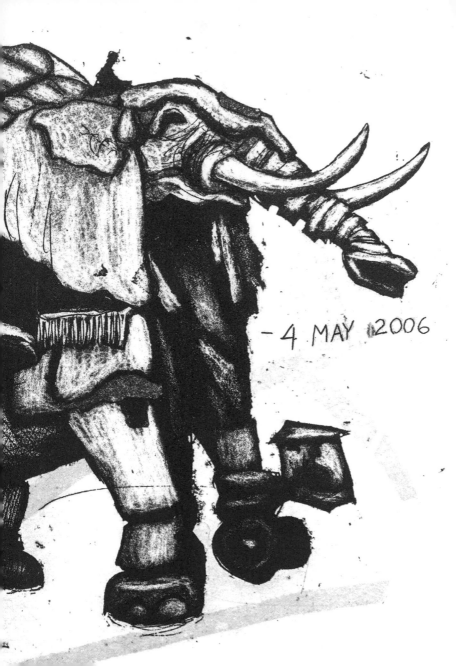

- 4 MAY 2006

5 MAY 1967

THE KINKS' SONG,
WATERLOO SUNSET, IS RELEASED.

The Terry and Julie mentioned in the lyrics refers to Terence Stamp and Julie Christie, who had a passionate affair in London during the filming of *Far From the Madding Crowd*. Written by Muswell Hill's own Ray Davies, it is widely regarded as one of the greatest songs ever written. When asked about his emotions when he wrote it, Davies said that he felt depressed because he was aware that he would never write a better song.

OPENING OF A MAJOR RETROSPECTIVE OF THE ABSTRACT PAINTINGS OF VICTOR PASMORE AT THE MARLBOROUGH GALLERY.

Pasmore started showing at the Zwemmer Gallery in 1934 with figurative paintings based on Monet and Cézanne. He pioneered the development of abstract art in Britain, doing work that was inspired by the work of Piet Mondrian and Paul Klee.

Pasmore represented Britain in 1961 at the Venice Biennale and was a trustee of Tate Gallery, donating a number of works to the collection.

JAN VERMEER'S EXQUISITE PAINTING, *THE GUITAR PLAYER*, IS RECOVERED.

Vermeer's painting was part of the permanent Iveagh Bequest at Kenwood House in Hampstead Heath. On 23 September 1974, it was stolen from Kenwood and held for a ransom of over $1,000,000 in food to be distributed on the Caribbean island of Grenada, or else the painting would be destroyed. It was recovered by Scotland Yard in the cemetery of St Bartholomew-the-Great in the City of London. Apart from slight dampness, the painting was mercifully undamaged.

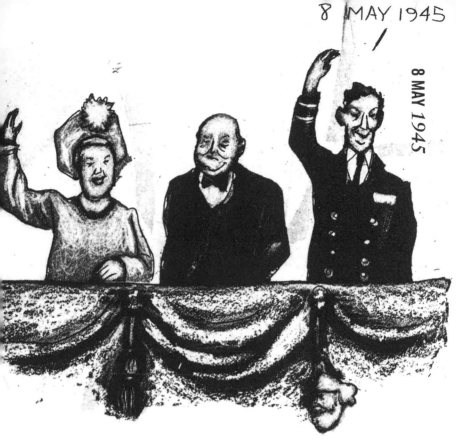

8 MAY 1945

8 MAY 1945

VE DAY IS CELEBRATED IN THE UNITED KINGDOM.

The act of military surrender was signed on 7 May in Rheims and 8 May in Berlin. Over a million people celebrated on the streets of London from Trafalgar Square and up the Mall to Buckingham Palace where King George VI, Queen Elizabeth and Prime Minister Winston Churchill appeared on the balcony of the palace. Princess Elizabeth (the future Queen Elizabeth II) and Princess Margaret were allowed to wander incognito among the crowds and take part in the celebrations.

THE FIRST RECORDED PERFORMANCE OF PUNCH AND JUDY IN COVENT GARDEN.

The Punch and Judy show has roots in the 16th-century Italian *commedia dell'arte*. The figure of Punch is derived from the Neapolitan stock character Pulcinella, which was anglicised to Punchinello. His wife was originally called Joan. His first recorded performance is on what is regarded as Punch's UK birthday. The diarist Samuel Pepys was in Covent Garden on the day and described it as 'an Italian puppet play, that is within the rails there, which is very pretty'.

9 MAY 1662

WINSTON CHURCHILL BECOMES
PRIME MINISTER OF GREAT BRITAIN.

The government was in disarray, and the Germans had just invaded France by a lightning advance through the Low Countries. Parliament had lost faith in Chamberlain's prosecution of the war, and so he resigned. Lord Halifax was the first possible replacement, but he turned down the post as he felt that he could not govern effectively as a member of the House of Lords.

Chamberlain recommended Churchill, and George VI asked him to be Prime Minister.

My detail is taken from the cartoon 'All behind you, Winston' by David Low that was run in the *Evening Standard* on 14 May.

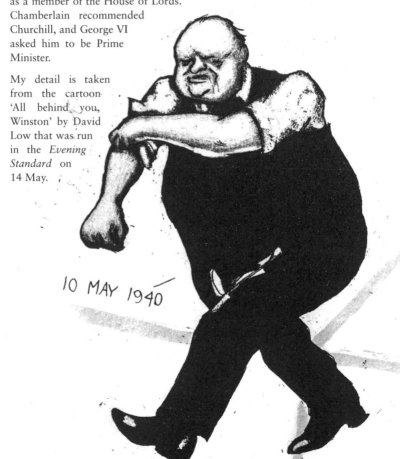

10 MAY 1940

BUFFALO BILL CODY'S WILD WEST SHOW OPENS AT THE EARL'S COURT EXHIBITION CENTRE.

Buffalo Bill was one of the most colourful figures of the American Old West, and his legend began to spread by the time he was only 23 years old. Shortly thereafter, he performed in shows celebrating cowboy themes and adventures from the frontier and Indian Wars. He founded Buffalo Bill's Wild West show in 1883 and toured to London as part of the American Exhibition to coincide with the Golden Jubilee of Queen Victoria. The Prince of Wales requested a private preview and was impressed enough to arrange a command performance for Queen Victoria. Jubilee guests included Kaiser Wilhelm II and the future kings Edward VII and George V. The London run that followed this endorsement sold 2.5 million tickets.

11 MAY 1887

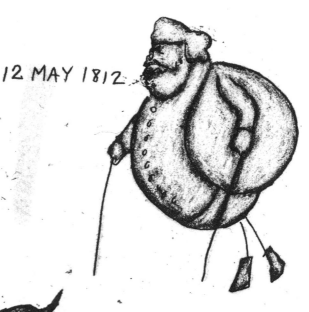

12 MAY 1812

ARTIST AND POET EDWARD LEAR IS BORN IN UPPER HOLLOWAY.

Lear was a musician and an author of nonsense poetry and prose, especially in the form of limericks. He was an accomplished watercolour artist and painted landscapes of his travels and of the animals that he encountered, including the Lear's macaw, which was named after him. His illustrated books of nonsense poetry were very popular in his lifetime.

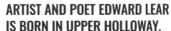

DAME DAPHNE DU MAURIER IS BORN IN HAMPSTEAD.

Du Maurier was an author whose bestselling works were initially not taken seriously by the critics but have since earned an enduring reputation for their moody and resonant storytelling craft. Many of her works have been successfully adapted into films, such as the novels *Rebecca* and *Jamaica Inn*, as well as the short stories *The Birds* and *Don't Look Now*. She lived much of her life in relative isolation in Fowey, Cornwall, where many of her works are set. The first class stamp I have referenced was commissioned in 1996 as part of the Women of Achievement series.

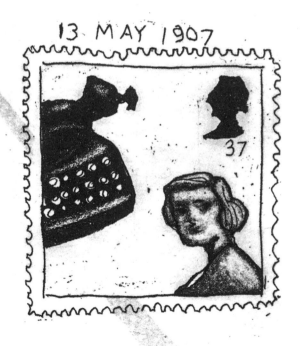

ARTIST BEN WILSON, WHO IS RENOWNED FOR HIS STREET PAINTING ON DISCARDED BITS ON CHEWING GUM, IS FEATURED AT THE 'BAROQUE THE STREETS' EVENT IN DULWICH.

Wilson is from Muswell Hill, and the area is peppered with his minute little gems on the pavements. He has also created a large number at the south end of the Millennium Bridge in front of the Tate Modern.

ARSENAL FOOTBALL CLUB COMPLETES A SEASON IN WHICH IT IS UNBEATEN IN THE LEAGUE WITH A 2-1 VICTORY OVER LEICESTER CITY AT HIGHBURY.

This victory had the club dubbed 'The Invincibles' and capped off a season in which it won the league title. I have depicted a post-match moment between Dennis Bergkamp and Thiery Henry.

BIOGRAPHER AND DIARIST JAMES BOSWELL
MEETS LITERARY FIGURE SAMUEL JOHNSON IN A CHANCE
ENCOUNTER IN DAVIES BOOKSHOP IN COVENT GARDEN.

Their resulting friendship resulted in Boswell writing *The Life of Samuel Johnson*, which was published in 1791. It was unique at the time as instead of creating the expected respectful and dry record of Johnson's public life, Boswell painted a vivid and entertaining portrait of the whole man, complete with personal details, and incorporated conversations that he had noted down in his diary. It is widely acknowledged to be one of the greatest biographical works in the English language.

16 MAY 1763

THE FIRST BRITISH COMIC BOOK, *COMIC CUTS*, IS PUBLISHED.

This comic was created by reporter Alfred Harmsworth through his company Amalgamated Press. It was published from 1890 to 1953, lasting 3006 issues. It held the record for selling the most issues of a British weekly comic for 46 years, until *The Dandy* overtook it in 1999.

18 MAY 1873

18 MAY 1873

VINCENT VAN GOGH ARRIVES IN LONDON.

Van Gogh lodged in a house in Brixton (87 Hackford Road) for a year and worked as an apprentice art dealer at Goupil's Gallery on Southampton Street in Covent Garden. It is speculated that while he lived there, he fell in love with his landlady Ursula Loyer's daughter Eugenie.

In 1973 Loyer's granddaughter, Kathleen Maynard, found a drawing of 87 Hackford Road by Van Gogh in a box of old family photographs. The drawing was authenticated and lent to the Van Gogh Museum in Amsterdam but in 2005 was returned to the family.

WORLD STRONGMAN DAVE GAUDER PULLS A BOEING 747 THREE INCHES ALONG A RUNWAY AT HEATHROW AIRPORT.

Gauder went on to become a motivational speaker and in 2009 pulled his thousanth bus.

THE FIRST CHELSEA FLOWER SHOW IS HELD IN THE GROUNDS OF THE ROYAL HOSPITAL, CHELSEA.

The Royal Horticultural Society's Great Spring
Show had taken place since 1862, but in ever-
changing venues. The Flower Show has remained
at Chelsea ever since, taking place every year
except 1917 and 1918 and for the duration
of World War II.1913 was also the year
the bonsai tree appeared in the UK.

20 MAY
1913

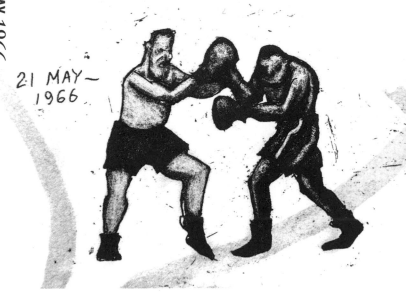

21 MAY —
1966

HENRY COOPER LOSES TO 24-YEAR-OLD WORLD HEAVYWEIGHT CHAMPION MOHAMMED ALI.

Ahead on the judges' scorecards, Cooper lost to Ali in a technical knockout in six rounds in a bout held at Arsenal's football ground in Highbury. It was the second time the two had fought, and although Ali also won the first bout, he claimed that Cooper had 'hit me so hard that my ancestors in Africa felt it'.

THE BLACKWALL TUNNEL UNDERNEATH THE RIVER THAMES IS OPENED BY THE PRINCE OF WALES.

This is a road tunnel in East London linking Tower Hamlets with Greenwich along the A102 road. It was built as a single tunnel handling traffic in both directions, but a second tunnel was added in 1967. The old tunnel, known as the western bore, is now used exclusively for northbound traffic and has several sharp bends in it, intended to stop horses bolting when they saw daylight.

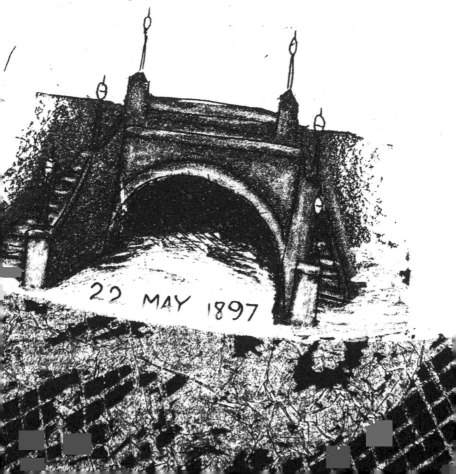

22 MAY 1897

THE BBC COMMISSIONS AN INITIAL SERIES OF SIX EPISODES FROM A NEW COMEDY TROUPE CALLED MONTY PYTHON'S FLYING CIRCUS.

The shows were structured as a sketch show, but with an innovative stream-of-consciousness approach. The troupe had complete creative control, which allowed them to experiment wildly with form and content, disregarding rules of television comedy. Their name was a product of a number of random inside jokes, and some other names in the running were 'Whither Canada?' and 'The Toad Elevating Moment'. For the image I have chosen the foot of cupid from Bronzino's *Venus, Cupid, Folly and Time* that has become a trademark icon for the troupe. It was either this or a naked man playing an organ.

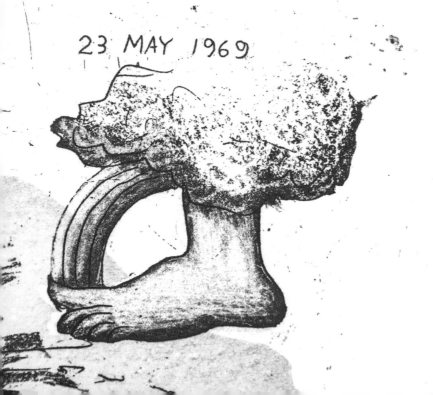

24 MAY 1906

SWISS HOTELIER CESAR RITZ OPENS THE RITZ HOTEL LONDON, EIGHT YEARS AFTER ESTABLISHING THE HÔTEL RITZ PARIS.

The building was built in a Franco-American style, designed to resemble a stylish block of Parisian flats. The interior was designed in the Louis XVI style, which is consistent throughout. After a slow beginning, the hotel began to gain popularity towards the end of World War I, becoming a regular haunt for politicians, writers and actors of the day. Noel Coward was a regular habitué during the 1920s and 1930s.

25 MAY 1850

OBAYSCH ARRIVES AT LONDON ZOO, THE FIRST HIPPOPOTAMUS SEEN IN GREAT BRITAIN SINCE PREHISTORIC TIMES AND THE FIRST IN EUROPE SINCE THE ROMANS.

Obaysch was captured on an island on the White Nile when he was less than one year old. His name is derived from the name of the island. He created such a sensation that it caused an outbreak of 'Victorian Hippomania'.

THOMAS GAINSBOROUGH'S PAINTING OF GEORGIANA CAVENDISH, THE DUCHESS OF DEVONSHIRE, IS STOLEN FROM AGNEW'S ON BOND STREET.

The painting mysteriously vanished from Chatsworth House but was discovered in the 1830s in the home of an elderly schoolmistress who had cut it down to fit over her fireplace. She sold it to a picture dealer in 1841 for £56, who in turn to a friend, the art collector Wynn Ellis. When Ellis died, it went into a Christies auction in 1876, where it was bought by the Bond Street art dealer William Agnew for the astounding sum of 10,000 guineas, an astronomical amount at the time. It was stolen from Agnew's gallery three weeks later by the notorious 'Napoleon of Crime', Adam Worth, who took it back to his home in the United States.

In 1901, the detective agency Pinkerton's negotiated the return of the painting to Agnew's for a ransom of $25,000. Agnew sold the painting at auction to Wall Street financier J.P. Morgan for $150,000. The painting remained in the Morgan family until 1994, when it was purchased in an auction at Sotheby's for $408,870 by the 11th Duke of Devonshire, who returned it to its original home in Chatsworth House.

26 MAY 1876

27 MAY 1199

THE CORONATION
OF KING JOHN IS HELD AT WESTMINSTER ABBEY.

John was the youngest of five sons of King Henry II and Duchess Eleanor of Aquitaine. His three eldest brothers, William, Henry and Geoffrey, died young, and on the death of Henry, Richard I was crowned. John unsuccessfully attempted a rebellion against Richard's administrators while his brother was participating in the Third Crusade. Despite this, John was proclaimed king upon Richard's early death. The baronial revolt at the end of John's reign led to the sealing of the Magna Carta at Runnymede, a document considered to be the first step in the evolution of the constitution of the United Kingdom.

THE MERMAID THEATRE OPENS ON THE SITE OF PUDDLE DOCK AND CURRIERS' ALLEY AT BLACKFRIARS IN THE CITY OF LONDON.

28 MAY 1959

The theatre was the life's work of actor Bernard Miles and his wife Josephine Wilson, and the most recently built in the City since the time of Shakespeare. The original Mermaid Theatre was a large barn at their house in St John's Wood, but they were encouraged to build a permanent theatre on the site of a warehouse on the Thames. In recent years, the theatre has sadly fallen into disuse, and the site is up for redevelopment.

THE FIRST FOUNDER'S DAY AT THE ROYAL HOSPITAL CHELSEA.

Founder's Day is an annual celebration commemorating the escape of the future King, Charles II, from Parliamentary forces after the Battle of Worcester in 1651. It is held as close to 29 May as possible, as this was Charles' birthday and the date of his restoration as King. On Founder's Day, in-pensioners of the Royal Hospital, known as Chelsea Pensioners, are reviewed by a member of the British Royal Family.

PLAYWRIGHT AND POET CHRISTOPHER MARLOWE IS KILLED IN A TAVERN OWNED BY THE WIDOW ELEANOR BULL IN DEPTFORD.

Exact details of Marlowe's death remain largely mysterious. Witnesses testified that Ingram Frizer and Marlowe had argued over the payment of the bill (now famously referred to as 'The Reckoning'), exchanging 'divers malicious words'. The two struggled over a dagger, and Marlowe was stabbed over the right eye, killing him instantly.

Conspiracy theories about possible motives for Marlowe's murder have abounded ever since, including professional jealousy, charges of blasphemy and even spying, as he was possibly working as a spy in the employ of Elizabeth I. What is incontrovertible is that he was a remarkably intelligent and talented man who hugely influenced the career of Shakespeare and the development of Elizabethan theatre. The two playwrights were born in the same year, and at the time of Marlowe's death, Shakespeare had written only eight of his 39 plays.

30 MAY 1593

31 MAY 1915

THE FIRST GERMAN ZEPPELIN RAID
OF WORLD WAR I IN LONDON.

The raid happened in Stoke Newington, killing 28 and injuring a further 60. Germany had been reluctant to bomb London previously as Kaiser Wilhelm had close ties with the British Royal family and did not want to be held responsible for destroying their cultural heritage.

JUNE

LESS LUST
FROM LESS
PROTEIN
LESS FISH
BIRD EGG
CHEESE
MEAT BEANS
AND NUTS

1 JUNE 1968

STANLEY GREEN, KNOWN AS THE PROTEIN MAN, STARTS HIS CAMPAIGN TO EDUCATE THE PUBLIC ON THE PERILS OF PROTEIN.

Green was a human billboard who marched up and down Oxford Street for 25 years advocating 'less passion from less protein'. His placard read, 'Less passion, by less protein: meat fish bird; egg cheese; peas beans nuts' and then later as an addendum: 'and sitting'. He was a familiar and much loved character, and upon his death in 1993, his placards and pamphlets became part of the permanent exhibition at the Museum of London.

THE CORONATION OF QUEEN ELIZABETH II
IN WESTMINSTER ABBEY.

Elizabeth had frequently stood in for her father, King George VI, as his health declined and at the time of his death was on an official visit to Kenya. When she was told of her immediate accession to the throne, she was asked to choose a regnal name and said, 'Elizabeth, of course'. The coronation occurred more than a year after the accession, as it was the tradition to avoid a celebratory festival during the period of mourning for the previous monarch.

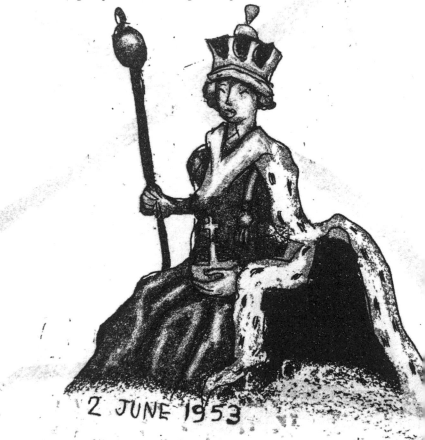

2 JUNE 1953

VIOLIN VIRTUOSO NICCOLO PAGANINI HAS HIS LONDON DEBUT AT THE KING'S THEATRE.

The most celebrated violinist of his time, he left his mark as one of the pillars of modern violin technique.

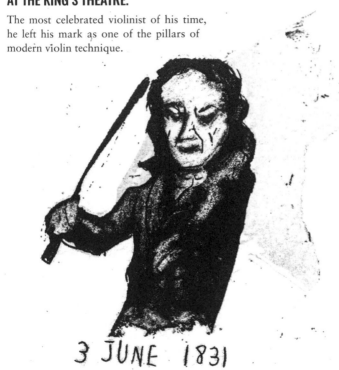

3 JUNE 1831

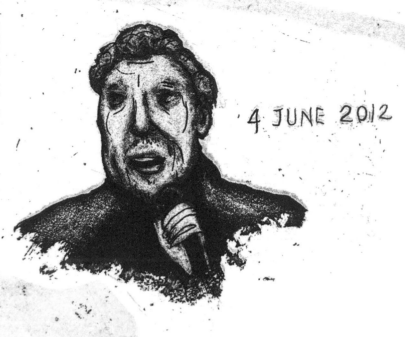

4 JUNE 2012

THE DIAMOND JUBILEE CONCERT IS HELD ON BANK HOLIDAY MONDAY IN FRONT OF BUCKINGHAM PALACE.

This was a free concert for which 10,000 ticket holders were drawn at random from 1.2 million applications. Concert ticket holders were given access to the Palace Gardens for an afternoon picnic before the main event. They were served cold hampers of British-themed food designed by chef Heston Blumenthal and royal chef Mark Flanagan.

The Queen and members of the Royal Family attended the concert, which included performances by Take That, Sir Tom Jones, Sir Elton John, Sir Paul McCartney, Dame Shirley Bassey and Stevie Wonder.

THE PROFUMO AFFAIR CULMINATES IN THE PUBLICATION OF JOHN PROFUMO'S LETTERS AND HIS RESIGNATION.

Profumo was the Secretary of State for War in Harold Macmillan's government and was found to have been having a relationship with 19-year-old would-be model Christine Keeler while she was simultaneously seeing a Soviet naval attaché, creating a security risk.

5 JUNE
196?

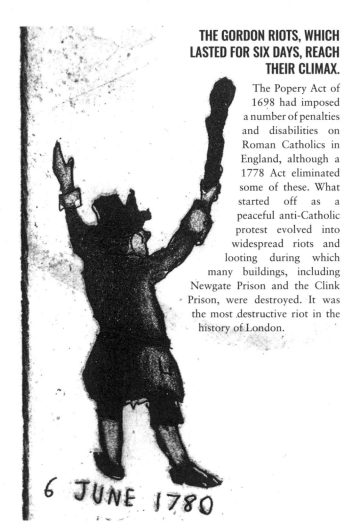

THE GORDON RIOTS, WHICH LASTED FOR SIX DAYS, REACH THEIR CLIMAX.

The Popery Act of 1698 had imposed a number of penalties and disabilities on Roman Catholics in England, although a 1778 Act eliminated some of these. What started off as a peaceful anti-Catholic protest evolved into widespread riots and looting during which many buildings, including Newgate Prison and the Clink Prison, were destroyed. It was the most destructive riot in the history of London.

6 JUNE 1780

KING HAAKON VII OF NORWAY ESCAPES TO LONDON.

Norway had been holding out against Germany until April 1940, when Luftwaffe bombers destroyed Nybersgund, the small town where the Government was staying. The King and his ministers took refuge in the snow-covered woods near Molde on Norway's west coast. The situation worsened, and on 7 June the King fled to London and established a Norwegian government in exile for the duration of the war.

-7 JUNE 1940

8 JUNE 1042

EDWARD THE CONFESSOR BECOMES KING OF ENGLAND.

The son of Etehlred the Unready and Emma of Normandy, Edward succeeded Cnut the Great's son Harthacnut, restoring the House of Wessex to the throne. His name reflects the traditional image of him as unworldly and pious. His long rule ended when he died in 1066, and he was succeeded by Harold Godwinson, who was killed later that year by the Normans under William the Conqueror at the Battle of Hastings. Edward was among the last Anglo-Saxon kings of England and is generally regarded as the last king of the House of Wessex. My image of him comes from his depiction on the Bayeux Tapestry.

THE GUTENBERG BIBLE, REGARDED AS THE WORLD'S MOST VALUABLE PUBLISHED BOOK, IS SOLD IN LONDON FOR $2,400,000.

This was the first major book to be printed using mass-produced movable metal type in Europe. It marked the start of the Gutenberg Revolution and the age of the printed book in the West, and has achieved truly iconic status. Only 49 copies of the bible exist, and only 21 of those, including this one, are complete copies.

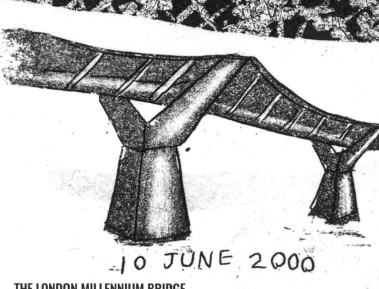

10 JUNE 2000

THE LONDON MILLENNIUM BRIDGE BRIEFLY OPENS.

Early users noticed a disconcerting wobble (or what the engineers referred to as 'an unexpected lateral vibration'), which prompted the bridge to be closed two days later. Extensive work was carried out to reduce the movement, and it reopened to the public on 22 February 2002.

While it was closed, my studio mates and I climbed over the hoardings late one night and walked across it and back. We were with a quite large group of fellow trespassers and were greeted by the police on our return. They were kind and just told us to hop it.

11 JUNE 1763

ITALIAN ADVENTURER, AUTHOR
AND LOTHARIO GIACOMO CASANOVA ARRIVES IN LONDON.

Casanova was hoping to sell his idea of a state lottery to English officials. Through his connections, he managed to get an audience with King George III, using most of the valuables he had stolen from the Marquise d'Urfé. While working the political angles, he also spent much time in the bedroom. As he could not speak English, he ran an advertisement to rent an apartment to the right person. He returned to Venice when his plan to sell the idea of a lottery ended in failure and his incessant womanising had left him penniless and ill with venereal disease.

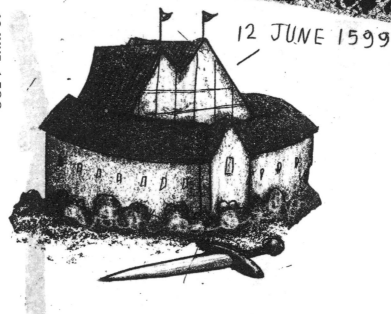

12 JUNE 1599

THE FIRST GLOBE THEATRE OPENS ON BANKSIDE.

The theatre was built from the timbers of The Theatre in Shoreditch by the theatrical company the Lord Chamberlain's Men, which included Richard Burbage and William Shakespeare. They owned The Theatre but not the land it stood on, and their landlord planned to take over ownership of the building following a dispute over the lease.

On 28 December, while the landlord was in the country celebrating Christmas, they covertly dismantled the building and transported the timbers to a warehouse on the banks of the Thames. Once the weather improved, they moved the timbers to Bankside and constructed the Globe. This building burned down during a performance of Henry VIII, when a cannon used during the play set fire to the thatched roof.

AMERICAN ENTREPRENEUR H.J. HEINZ TAKES A WHEELBARROW FULL OF TINS OF HIS BAKED BEANS TO FORTNUM & MASON.

When Fortnum & Mason bought the entire stock of five cases, they became the first store in Britain to stock Heinz baked beans.

13 JUNE 1886

14 JUNE 1822

MATHEMATICIAN, PHILOSOPHER, INVENTOR AND MECHANICAL ENGINEER CHARLES BABBAGE FIRST PROPOSES A 'DIFFERENCE ENGINE' IN A PAPER TO THE ROYAL ASTRONOMICAL SOCIETY.

Designed to aid navigational calculations, his mechanical computer was the first stage that ultimately led to the invention of the more complex digital programmable computer.

My drawing is of the difference engine no. 2 that was built to his specifications and is displayed in the Science Museum.

WALTER 'WAT' TYLER, LEADER OF THE PEASANTS' REVOLT, IS KILLED.

Tyler marched a group of rebels from Canterbury to the capital to oppose the institution of a poll tax and demand economic and social reforms. The rebellion enjoyed brief success and Tyler was invited to Smithfield to enter negotiations with officers loyal to King Richard II. Tyler was killed, however, and the King revoked all promises of compromise.

15 JUNE 1381

THE SOCIETY FOR THE PREVENTION OF CRUELTY TO ANIMALS (LATER TO RECEIVE ITS ROYAL CHARTER TO BECOME THE RSPCA) IS FOUNDED BY 22 REFORMERS, LED BY RICHARD MARTIN MP, WILLIAM WILBERFORCE MP AND REVEREND ARTHUR BROOME, IN OLD SLAUGHTER'S COFFEE HOUSE NEAR THE STRAND.

16 JUNE 1824

In its first year, the society brought 63 offenders before the court, but its first successful case was the prosecution of Bill Burns for cruelty to his donkey. The society was the first animal welfare charity in the world and remains one of the most active and effective.

7 JUNE 1239

EDWARD I OF ENGLAND IS BORN
IN THE PALACE OF WESTMINSTER, AS HEIR TO
THE THRONE OF KING HENRY III AND ELEANOR OF PROVENCE.

A tall and temperamental man, Edward was said to be quite intimidating to his contemporaries. He held the respect of his subjects for the way he perfectly embodied the medieval ideal of kingship, as a soldier, an administrator and a man of faith. He restored royal authority that had diminished during his father's reign and is credited with establishing Parliament as a permanent institution.

SAMUEL JOHNSON MEETS A GROUP OF LONDON BOOKSELLERS AND SIGNS THE CONTRACT FOR 1,500 GUINEAS TO WRITE A DICTIONARY.

Johnson promised to deliver the manuscript in three years, but *A Dictionary of the English Language* was published on 15 April 1755, nine years after receiving the commission. However, when you consider that it took 40 scholars at the Academie Francaise 40 years to produce their dictionary, Johnson's feat ranks as one of the greatest single achievements of scholarship. Until the completion of the *Oxford English Dictionary* 173 years later, Johnson's was regarded as the pre-eminent English dictionary.

18 JUNE 1746

JULIAN ASSANGE, THE HEAD OF THE INTERNATIONAL NON-PROFIT WHISTLEBLOWER ORGANISATION WIKILEAKS, SEEKS ASYLUM IN THE ECUADORIAN EMBASSY IN ORDER TO AVOID EXTRADITION TO SWEDEN FOR ALLEGED SEXUAL ASSAULT CHARGES.

19 JUNE 2012

Assange founded the organisation in 2006 and continues to run it from the Ecuadorian Embassy. He maintains his innocence, but any attempt to leave the embassy will result in his immediate arrest and extradition. Wikileaks publishes secret information, news leaks and classified media from anonymous sources.

QUEEN VICTORIA SUCCEEDS TO THE BRITISH THRONE, AGED 18, AFTER HER UNCLE KING WILLIAM IV DIES LEAVING NO LEGITIMATE HEIRS.

The United Kingdom was a constitutional monarchy where the sovereign held very little direct political power. However, Queen Victoria attempted to influence governmental policy and ministerial appointments and became a national icon identified with strict standards of personal morality. Her 63-year reign is known as the Victorian era and was a period of great industrial, cultural, political, scientific and military change within the United Kingdom.

My picture is of Victoria on the Penny Black of 1840, the world's first adhesive postage stamp used in a public postal system.

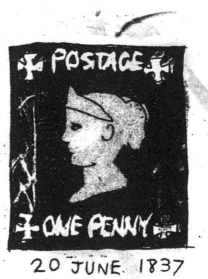

THE CHAMPIONSHIP, WIMBLEDON, COMMONLY KNOWN SIMPLY AS WIMBLEDON, IS TELEVISED FOR THE FIRST TIME.

21 JUNE 1937

Wimbledon is the world's oldest tennis tournament and widely considered to be the most prestigious. The winners of the singles tournament in 1937 were American Don Budge and Brit Dorothy Round Little.

HMT *EMPIRE WINDRUSH* ARRIVES IN LONDON FROM JAMAICA, CARRYING THE FIRST GROUP OF WEST INDIAN IMMIGRANTS.

The ship was originally MV *Monte Rosa*, a German passenger liner that was operated by the German navy as a troopship during World War II. At the end of the war, she was a prize of war and renamed. She carried 492 passengers and one stowaway from Jamaica, on a journey that has resulted in British Caribbean people being referred to as the Windrush generation.

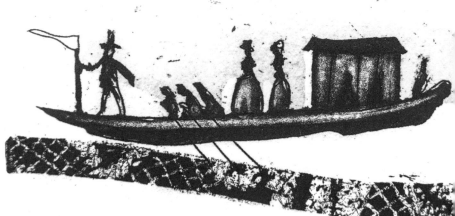

THE FIRST REGATTA
IS HELD ON THE THAMES.

The regatta copied the Venetian model and included rowing races by professional boatmen alongside more sedate social boating, and was preceded by a grand ball. This gathering was only a few weeks before the first race by the Royal Thames Yacht Club, where gentlemen competed for a silver cup donated by the Duke of Cumberland. The Cumberland Cup has run every year ever since.

24 JUNE
1882

JOSEPH MERRICK (OFTEN WRONGLY CALLED JOHN) ARRIVES AT LIVERPOOL STREET STATION FROM BRUSSELS AFTER A DISASTROUS TOUR IN EUROPE.

Merrick was born in Leicester and had severe deformities that began to appear when he was five years old. He came to London and was discovered by a theatrical agent, who dubbed him the Elephant Man and first displayed him as a freak in a shop on the Whitechapel Road. While there, he was seen by a surgeon named Frederick Treves, who brought Merrick to live at the London Hospital so that he could try to help him.

The appetite for freak shows in Britain was waning, so Merrick's manager convinced him to go on a tour of continental Europe. The Elephant Man did no better in Europe, and he was hounded out of a succession of towns before being robbed and abandoned by his manager. Arriving back in London, he had nowhere to go but happened to still have Frederick Treves' card in his pocket. He was delivered to Treves at the London Hospital, where he lived the rest of his days, dying at the age of 27.

ARTIST LUKE JERRAM INSTALLS UPRIGHT PIANOS ALL OVER LONDON, PAINTED TO REPRESENT THEIR SPECIFIC LOCATIONS, AS PART OF HIS 'PLAY ME; I'M YOURS' PUBLIC ART PROJECT.

The project was rolled out to cities all over the world. Two have remained at St Pancras International Station, one near the Eurostar arrivals gate and the other in the main shopping arcade. These pianos are regularly repaired and retuned courtesy of the station management team.

25 JUNE 2009

RICHARD III BEGINS HIS REIGN AFTER HIS CLAIM TO THE THRONE IS APPROVED BY AN ASSEMBLY OF LORDS AND COMMONERS.

Richard's brother, King Edward IV, had two young sons who were the rightful heirs to the throne, but Richard locked them up in the Tower of London and they were never seen in public again. His reign was beset with strife and ended in the second rebellion, when he was killed in the Battle of Bosworth Field. He was the last sovereign in the Plantagenet line and the last king to die in battle on home soil (the first since Harold Godwinson). Henry Tudor ascended the throne as Henry VII.

26 JUNE 1483

F I R S T
S C R A B B L E

27 JUNE 1971

THE FIRST UK NATIONAL SCRABBLE TOURNAMENT IS HELD IN LONDON.

The tournament was organised by Giles Brandreth, and the first winner was Stephen Haskell, with an aggregate score of 1,345 over three games. It has now become an annual event.

THE CORONATION OF QUEEN VICTORIA IS HELD AT WESTMINSTER ABBEY, JUST OVER A YEAR AFTER SHE SUCCEEDS TO THE THRONE.

The procession was watched by unprecedented crowds of 400,000 as new railways made it possible for spectators to come from huge distances. The ceremony cost £79,000, which exceeded the £30,000 spent on her predecessor William IV in 1831 but was far less than the £240,000 spent on his brother George IV in 1821.

The road route taken by the gold Coronation Coach was extended to allow for the increased numbers of spectators, following a circular route from Victoria's new home Buckingham Palace via Hyde Park Corner, Piccadilly, St James's Street, Pall Mall, Charing Cross and Whitehall.

The weather was fine, and the day was generally considered to have been a huge success.

28 JUNE 1838

ALFRED GILBERT'S STATUE OF EROS IS ERECTED IN PICCADILLY CIRCUS.

Actually called the Shaftesbury Memorial Fountain, it was commissioned to commemorate Lord Shaftesbury, a famous Victorian politician and philanthropist. The winged sculpture at the top is actually Eros's brother Anteros, the God of Selfless Love but was wrongly identified as Eros by the public from the beginning.

30 JUNE 1894

TOWER BRIDGE OFFICIALLY OPENS.

Increased commercial development in the East End necessitated a new crossing downriver from London Bridge but had to allow for the tall-masted ships to access the pool of London. A Special Bridge or Subway Committee was formed in 1877 to find a solution to the river-crossing problem. It opened the design of the crossing to public competition and had over 50 designs to consider over a seven-year period. The evaluation of the submissions was surrounded by controversy until 1884, when Horace Jones put forward the idea of a bridge with a drawbridge in the middle. The drawbridge was originally opened by huge steam-powered engines in the base of the two towers, but these have since been replaced by much smaller and more efficient hydraulic engines. Artist Cornelia Parker used the mechanism to crush the brass band instruments that she used to create her sculptural installation *Breathless* in the Victoria and Albert Museum.

JULY

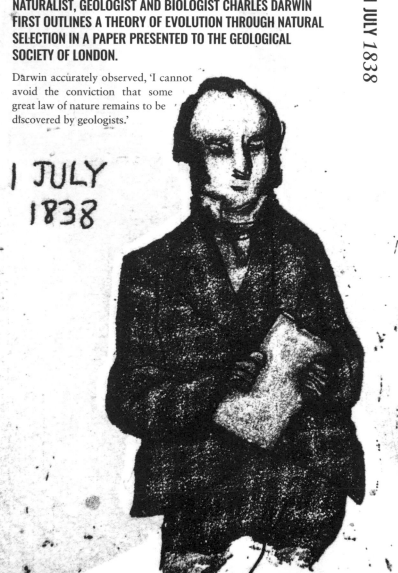

NATURALIST, GEOLOGIST AND BIOLOGIST CHARLES DARWIN FIRST OUTLINES A THEORY OF EVOLUTION THROUGH NATURAL SELECTION IN A PAPER PRESENTED TO THE GEOLOGICAL SOCIETY OF LONDON.

Darwin accurately observed, 'I cannot avoid the conviction that some great law of nature remains to be discovered by geologists.'

I JULY
1838

THE BRYANT AND MAY FACTORY IN BOW
SEES THE START OF THE MATCHGIRLS' STRIKE.

Poor working conditions, including fourteen-hour workdays, low pay and excessive fines, and the extreme health complications due to the use of white phosphorous were making the workers very discontented. It was the unfair dismissal of one of the workers that sparked the strike. Bryant and May received such bad publicity that they agreed to stop the use of white phosphorous and to move to the safer red phosphorous. Production costs were so much higher, however, that it necessitated the continued use of child labour. In 1908, the British House of Commons passed an Act prohibiting the use of white phosphorous in the production of matches after 31 December 1910.

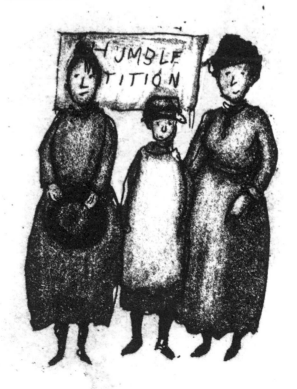

WOLFGANG AMADEUS MOZART, THEN AGED 8, PLAYS A PRIVATE HARPSICHORD CONCERT FOR KING GEORGE III.

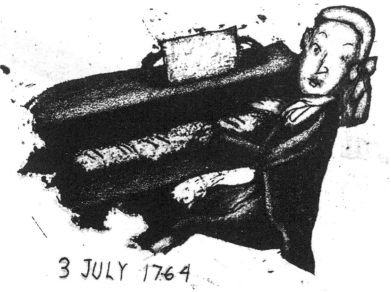

3 JULY 1764

Mozart's family was on a long concert tour, spanning three and a half years, taking the family to the courts of Munich, Mannheim, Paris, London, The Hague, again to Paris and then home to Salzburg via Zurich, Donaueschingen and Munich.

While he was in London, Mozart and his older sister Nannerl played concerts for a number of wealthy patrons, and he became acquainted with Johann Christian Bach, son of J.S. Bach, who greatly influenced him. Mozart wrote his first symphony that year, probably transcribed by his father Leopold.

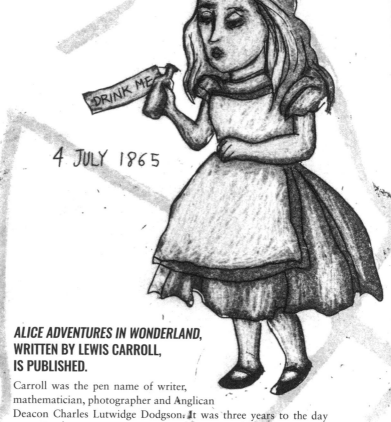

4 JULY 1865

DRINK ME

ALICE ADVENTURES IN WONDERLAND, WRITTEN BY LEWIS CARROLL, IS PUBLISHED.

Carroll was the pen name of writer, mathematician, photographer and Anglican Deacon Charles Lutwidge Dodgson. It was three years to the day since the 'golden afternoon' when Dodgson and Reverend Robinson Duckworth rowed a boat up the Isis in Oxford with Dean Henry Liddell of Christ Church College and his three young daughters. During a picnic on the banks of the river, Dodgson made up a series of stories which featured Liddell's middle daughter, Alice, then aged ten. Alice begged him to write the stories down, and he eventually presented her with a handwritten, illustrated manuscript entitled *Alice's Adventures Under Ground* in November 1864.

THE ROLLING STONES PLAY A FREE CONCERT IN HYDE PARK FOR SOMEWHERE BETWEEN 250,000 AND 500,000 PEOPLE.

The concert was just two days after the death of guitarist and founder member Brian Jones and introduced Mick Taylor. Other acts that performed on the day were Roy Harper, Marianne Faithful and King Crimson. The Stones had not played live for two years and were a bit rusty, but their 14-song set went down extremely well. It finished with an 18-minute-long rendition of 'Sympathy for the Devil', for which a number of African tribal drummers joined them on stage.

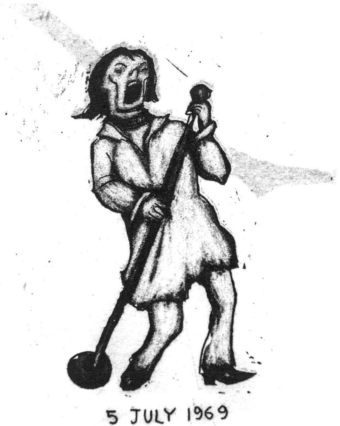

5 JULY 1969

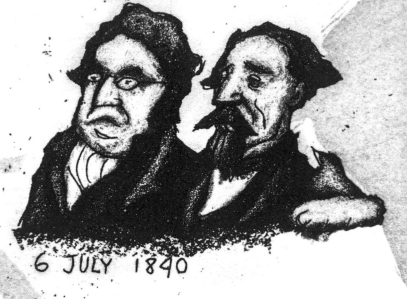

6 JULY 1840

WILLIAM MAKEPEACE THACKERAY BUMPS INTO CHARLES DICKENS AT A PUBLIC EXECUTION OF A MURDERER NAMED COIRVOISIER AT NEWGATE PRISON.

Thackeray later wrote an attack on capital punishment called 'Going to see a man hanged'. He said of the experience of witnessing an execution, 'I fully confess that I came away down Snow Hill that morning with a disgust for murder, but it was for the murder I saw done.'

A SERIES OF COORDINATED TERRORIST SUICIDE BOMB ATTACKS TARGETING CIVILIANS OCCURS IN CENTRAL LONDON ON THE PUBLIC TRANSPORT SYSTEM DURING MORNING RUSH HOUR.

Four Islamist extremists separately detonated three bombs aboard London Underground trains and a fourth on a double-decker bus in Tavistock Square. Fifty-two people were killed and over 700 were injured, making it the worst terrorist incident in London's history. It came the day after London had won the honour of hosting the 2012 Olympic Games with a bid that stressed the city's proud multicultural reputation.

COMEDIAN AND ACTOR MARTY FELDMAN IS BORN IN THE EAST END.

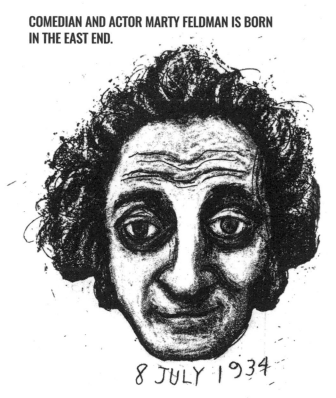

8 JULY 1934

The son of Jewish Ukrainian immigrants, Feldman left school at the age of 15 with dreams of becoming a jazz musician. Joking that he was the 'world's worst trumpet player', he decided instead to pursue in comedy acting and writing. He became the chief writer and script editor on *The Frost Report* and very soon after got his own sketch comedy show called simply *Marty*, which had all of the future members of Monty Python's Flying Circus amongst its writers. He was a wonderful physical comedian and is at his absolute best in *Young Frankenstein*.

THE FIRST LAWN TENNIS TOURNAMENT AT WIMBLEDON IS HELD AT THE ALL ENGLAND CROQUET AND LAWN TENNIS CLUB.

There was initially only a men's singles championship, the rain-delayed final of which was held on Thursday 19 July and watched by 200 people, each of whom had paid a shilling to enter. The winner, Spencer Gore from Wandsworth, won 12 guineas and a silver challenge cup valued at 25 guineas. Analysis afterwards altered the size of the court to its current dimensions.

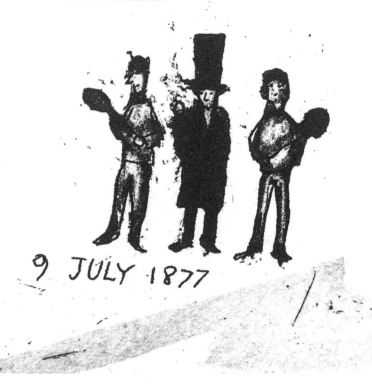

9 JULY 1877

THE FIRST PARKING METER IN BRITAIN IS INSTALLED IN WESTMINSTER, NEAR THE US EMBASSY IN GROSVENOR SQUARE.

10 JULY 1958

At the time, parking for one hour cost 6 shillings, compared with £4 in the same location in 2015. Those who overstayed or neglected to pay at all received a £2 penalty, compared with the £120, reduced to £60 for prompt payment that you would be charged today.

THE WESTMINSTER GREAT BELL, AFFECTIONATELY KNOWN AS 'BIG BEN', CHIMES FOR THE FIRST TIME.

The bell is located behind the clock in the Elizabeth Tower, which was called St Stephen's Tower in Victorian times, at the north end of the Palace of Westminster. The original was a 16-ton bell, but it cracked beyond repair during testing. The Whitechapel Bell Foundry was commissioned to make the 13.5-ton replacement, which was named after Sir Benjamin Hall, who oversaw the later stages of the rebuilding of the House of Parliament. The second bell also has a slight crack in it, but has been turned so that the hammer strikes away from the damaged section.

11 JULY 1859

THE ROLLING STONES PLAY THEIR FIRST GIG IN THE BASEMENT OF THE MARQUEE CLUB AT 165 OXFORD STREET.

The Stones were offered a slot on BBC Radio's *Jazz Club* programme and were booked by the Marquee's owner Harold Pendleton. They needed to come up with a name, and Brian Jones came up with 'Mick Jagger and the Rollin' Stones', after a song by their hero Muddy Waters. At the time of this gig, both Jagger and Keith Richards were 18 years old and still lived with their parents in Dartford.

12 JULY · 1962

RUTH ELLIS BECOMES THE LAST WOMAN TO BE EXECUTED IN THE UNITED KINGDOM, AFTER BEING CONVICTED OF THE MURDER OF HER LOVER, DAVID BLAKELY.

Ellis was the manager of a nightclub called The Little Club, where she met Blakely, a racing car driver, who was three years her junior. Blakely quickly moved into Ellis's flat above the club, even though he was engaged to another woman. The two had a very violent and tempestuous relationship, and Ellis shot Blakely on Easter Sunday, 10 April 1955, outside the Magdala public house in Hampstead. She immediately gave herself up to the police and took full responsibility for the murder at her trial. She was hanged by Albert Pierrepoint at HM Prison Holloway.

HENRY PURCELL IS APPOINTED CHIEF ORGANIST AT THE CHAPEL ROYAL IN WHITEHALL.

Purcell was already the chief organist at Westminster Abbey and carried on in the two posts after his appointment. Although he incorporated Italian and French stylistic elements into his compositions, Purcell's music was quintessentially English Baroque. He is generally considered, alongside Edward Elgar, Ralph Vaughan Williams and Benjamin Britten, to be one of the greatest English composers. /

14 JULY 1682

15 JULY 1660

THE ROYAL SOCIETY, OR MORE PROPERLY KNOWN AS 'THE PRESIDENT, COUNCIL AND FELLOWS OF THE ROYAL SOCIETY OF LONDON FOR IMPROVING NATURAL KNOWLEDGE' RECEIVES ITS ROYAL CHARTER FROM KING CHARLES II.

Originally founded in 1660, it is the oldest such society still in existence. It promotes science and its benefits, and is still the scientific advisor to the government.

KING HENRY VI ISSUES A PROCLAMATION BANNING KISSING, IN AN ATTEMPT TO STOP THE SPREAD OF GERMS.

As it was not deemed to be particularly effective or easy to enforce, this proclamation was remarkably short-lived.

GEORGE FRIDERIC HANDEL'S *WATER MUSIC* PREMIERES FOR KING GEORGE I ON A BARGE ON THE THAMES.

The *Water Music* is a collection of orchestral movements in three suites, specifically commissioned by the King in part as a display of his ability to stage grand events, as he was becoming quite jealous of the extravagant parties being thrown by his son. The King, his entourage and guests were on one barge, and Handel and fifty musicians were on another on a concert trip from Westminster to Chelsea. The King liked the music so much that he requested a repeat performance for the trip back later that evening.

17 JULY 1717

BUCKINGHAM PALACE BECOMES THE PRIMARY ROYAL RESIDENCE IN LONDON WHEN QUEEN VICTORIA AND HER MOTHER MOVE IN.

Originally known as Buckingham House, the building at the core of today's palace was a large townhouse built for the Duke of Buckingham in 1703. It was acquired by King George III in 1761 as a private residence for Queen Charlotte and became known as the Queen's House, although Victoria was the first ruling monarch to live there.

The palace has 775 rooms, and the garden, where the Queen hosts her annual garden party every summer, is the largest private garden in London. The staterooms, used for official and state entertaining, are open to the public each year for most of August and September and the odd day in the winter and spring.

ACTOR BENEDICT CUMBERBATCH
IS BORN IN HAMMERSMITH.

After training at the London Academy of Music and Dramatic Arts, Cumberbatch has worked constantly on stage, film, television and radio. He has received numerous awards and nominations, as well as universal praise for work in series such as *Sherlock*.

FENCHURCH STREET STATION IN THE CITY OF LONDON OPENS.

Fenchurch Street is one of the smallest railway termini in London and the only one without a link to the Underground.

It is also one of the four stations (along with Liverpool Street, King's Cross and Marylebone) to feature on the British Monopoly board.

THE *MAYFLOWER* SHIP SETS OFF FROM ROTHERHITHE TO PLYMOUTH FROM WHERE SHE SAILS TO THE NEW WORLD.

The Mayflower sailed from near a pub called the Shippe on Rotherhithe Street, which has since changed its name to the Mayflower. There were 102 pilgrims on that ship and only half survived their first harsh New England winter. Curiously, there are literally millions of Americans who trace their ancestry back to those 51 pilgrims.

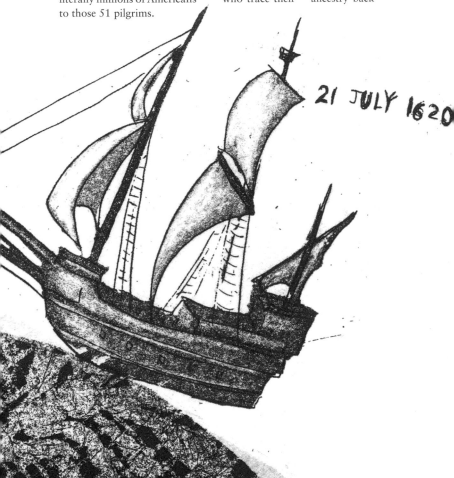

21 JULY 1620

22 JULY 1972

CHI CHI THE GIANT PANDA DIES AT LONDON ZOO.

Chi Chi was caught in China in 1955 and brought to Beijing Zoo in 1957. After travelling between a number of other zoos, she arrived at London Zoo on 5 September 1958. She was not the zoo's first giant panda, with Ming being one of four that arrived in 1938. Chi Chi did become the most beloved animal in the zoo's history, however, and when she died, was mourned by the nation. She was the inspiration for Sir Peter Scott's simple but distinctive black and white design used as the logo for the World Wildlife Fund.

THE WEDDING OF PRINCE ANDREW, DUKE OF YORK, TO SARAH FERGUSON TAKES PLACE AT WESTMINSTER ABBEY.

The BBC estimated that 500 million people tuned in to watch this on television and 100,000 turned up at Buckingham Palace to see them kiss on the balcony. They had two daughters, Beatrice and Eugenie, before divorcing in 1996. The couple remain on friendly terms and rumours persist of a reconciliation.

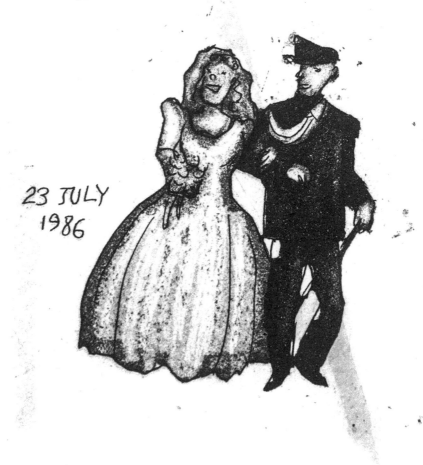

23 JULY
1986

24 JULY 1622

JOHN TAYLOR, DUBBED THE WATER POET, TRAVELS FROM LONDON TO QUEENBOROUGH IN KENT IN A PAPER BOAT WITH TWO STOCKFISH TIED TO CANES FOR OARS.

The eccentric episode was recounted in 'The Praise of Hemp-Seed'.

THE COOKE AND WHEATSTONE TELEGRAPH, THE WORLD'S FIRST COMMERCIAL ELECTRICAL TELEGRAPH, IS SUCCESSFULLY DEMONSTRATED BETWEEN EUSTON AND CAMDEN TOWN.

The receiver consisted of a number of needles moved by electromagnetic coils, which could spell out words by pointing to letters on a board. This was popular with early users, as they needed no codes and little training. It played a part in the arrest of the murderer John Tawell. Once it was known he was on a London bound train, the telegraph signalled ahead to have him apprehended at Paddington.

25 JULY 1837

26 -JULY 1803

THE FIRST PUBLIC RAILWAY COMPANY, THE SURREY IRON RAILWAY, OPENS BETWEEN WANDSWORTH AND CROYDON VIA MITCHAM.

This railway was a horse-drawn plateway where carriages were pulled along iron rails. It was a toll railway mainly used for the transport of coal, building materials, lime, manure, corn and seeds.

DANNY BOYLE'S OPENING CEREMONY FOR THE 2012 OLYMPICS.

The ceremony was titled 'Isles of Wonder' and combined dramatic narrative sequences about the Industrial Revolution and the NHS with the presentation of the athletes and a film that featured a short cameo by the Queen. All of the apprehension that had been whipped up about Britain's inability to host such a major event disappeared during that four-hour spectacle, leaving us a very proud and impassioned nation.

The detail features the Industrial Revolution sequence, where giant smokestacks emerged from the floor and Kenneth Branagh appeared as Isambard Kingdom Brunel. Branagh was brought in as a late replacement for Mark Rylance, who was in mourning following the tragic death of his daughter.

27 JULY 2012

28 JULY 1866

AUTHOR AND ILLUSTRATOR BEATRIX POTTER IS BORN IN KENSINGTON.

Born into a privileged household, Potter was educated by governesses and grew up in isolation from other children. She loved painting and became highly respected for her observational studies in watercolour of fungi found at the family's home in the Lake District.

In her thirties, she published *The Tale of Peter Rabbit*. This was highly successful and led her to publish a further 23 illustrated children's books.

When she died, she left her home in Near Sawrey to the National Trust, preserving much of the land that now constitutes the Lake District National Park.

THE MARRIAGE OF PRINCE CHARLES TO LADY DIANA SPENCER AT ST PAUL'S CATHEDRAL.

The ceremony was watched by 750 million people worldwide and was widely regarded as a fairytale wedding. Hindsight has given us a different impression of the marriage, but it was a lovely ceremony. My daily detail is of one of the plethora of souvenir jugs, mugs, plates and cups that were produced to mark the occasion.

ENGLAND BEATS GERMANY 4-2 TO WIN THE WORLD CUP AT WEMBLEY STADIUM.

The match is famous for being the only time that England has won, for producing the first hat trick in a World Cup final (by Geoff Hurst), and for Kenneth Wolstenholme's famous remark towards the closing moments: 'They think it's all over – it is now.'

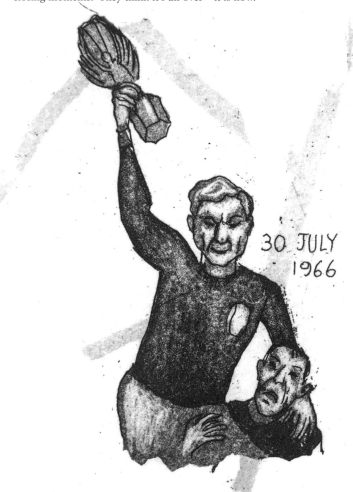

30 JULY 1966

31 JULY 1895

THE MAIDEN TEST FLIGHT OF HIRAM MAXIM'S FLYING MACHINE AT SYDENHAM.

The machine never worked well enough to pursue but did help Maxim to create fairground attractions.

AUGUST

OPENING OF THE MAIN SECTION OF THE REGENT'S CANAL BETWEEN CAMDEN AND LIMEHOUSE.

The canal was first proposed by Thomas Homer in 1802 and became part of an entire redevelopment of that area of North London. The masterplan was produced by noted architect and town planner John Nash, and included Regent's Park and a number of terraces of houses. The first section, between Paddington and Camden, opened in 1816 but was completely eclipsed by the main section that included Regent's Canal dock on the Thames, used for transferring cargo from seafaring vessels to canal barges, and the 886 m-long tunnel at Islington.

1 AUGUST 1820

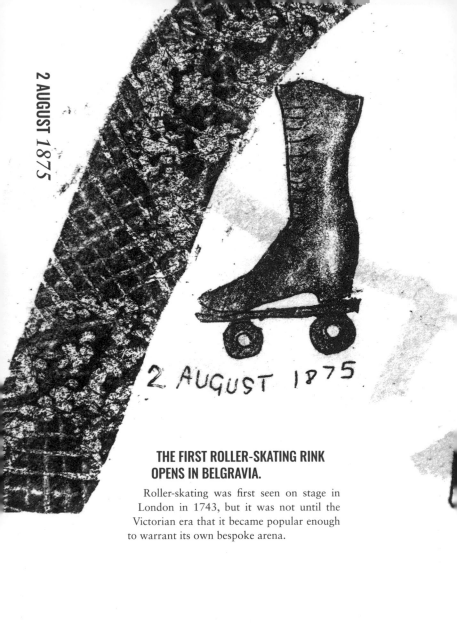

2 AUGUST 1875

THE FIRST ROLLER-SKATING RINK OPENS IN BELGRAVIA.

Roller-skating was first seen on stage in London in 1743, but it was not until the Victorian era that it became popular enough to warrant its own bespoke arena.

SAMUEL BECKETT'S PLAY *WAITING FOR GODOT*, DIRECTED BY 24-YEAR-OLD PETER HALL, HAS ITS LONDON PREMIERE AT THE ARTS THEATRE.

It tells the story of two characters Vladimir and Estragon who engage in conversation and encounter a number of characters while waiting for the arrival of someone named Godot, who never arrives.

The play was originally performed in French as *En attendant Godot* and translated by the author with the added subtitle 'a tragicomedy in two acts'. It is recognised as one of the most significant plays of the 20th century.

3 AUGUST 1955

SUPER SATURDAY AT THE SUMMER OLYMPICS 2012. ON THIS DAY, TEAM GB WINS SIX GOLD MEDALS, INCLUDING THREE TRACK AND FIELD EVENTS, WITHIN THE SPACE OF A MAGICAL HOUR IN THE LONDON STADIUM.

The medal winners were in cycling, where Dani King, Laura Trott and Joanna Rowsell won the women's team pursuit; rowing, where Andrew Triggs Hodge, Peter Reed, Tom James and Alex Gregory won the men's coxless four; rowing again, where Katherine Copeland and Sophie Hosking won the women's lightweight double sculls; and track and field, where Greg Rutherford won the long jump, Jessica Ennis won the women's heptathlon and Mo Farah won the men's 10,000 metres. We were fortunate to be in the London Stadium that night, and it remains the greatest event of any kind that I have ever attended.

4 AUGUST 2012

BRITAIN'S FIRST CINEMA OPENS IN ISLINGTON.

The cinema was converted from part of the Beaux-Arts style Agricultural Hall, designed by Frederick Peck and built in 1869. It was used as a concert hall and then the base for the American minstrel show, the 'Mohawk Minstrels', and had been renamed Mohawk Hall to reflect this. The first film was shown there on 3 August and was so successful that it was dedicated solely to cinema two days later.

5 AUGUST 1901

6 AUGUST 1991

COMPUTER SCIENTIST TIM BERNERS-LEE, INVENTOR OF THE WORLD WIDE WEB, BUILDS THE FIRST WEBSITE AND PUTS IT ONLINE.

Berners-Lee first made a proposal for an information management system in 1989 and implemented the first successful communication between a Hypertext Transfer Protocol (HTTP) client and server via the Internet that same year. The first website built was at CERN, the European Organisation for Nuclear Research, and had the address info.cern.ch. Berners-Lee refused to patent the invention as he felt that it should be made free for all to use.

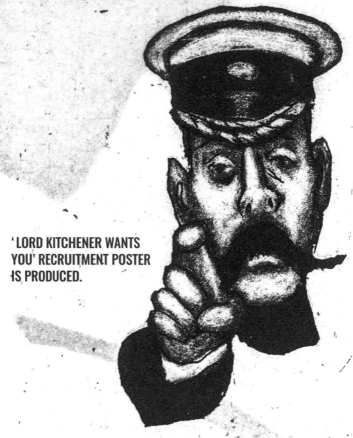

'LORD KITCHENER WANTS YOU' RECRUITMENT POSTER IS PRODUCED.

7 AUGUST 1914

This was an advertisement by Alfred Leete depicting Lord Kitchener, the British Secretary of State for War, wearing the cap of a British Field Marshal, pointing at the viewers, calling them to enlist in the British Army against the Central Powers. The poster is one of the most iconic and enduring images of the 20th century and inspired imitations in many other nations.

ERNEST SHACKLETON LAUNCHES THE IMPERIAL TRANS-ANTARCTIC EXPEDITION.

Even though war had broken out five days earlier, the First Lord of the Admiralty, Winston Churchill, directed Shackleton and his team to proceed with their plans. The expedition was five months in when, just off the coast of Antarctica, their ship, *The Endurance*, became caught in ice and was eventually crushed.

The men spent a total of 15 months camping on ice flows before launching lifeboats that took them to the uninhabited Elephant Island. They christened the largest lifeboat the James Baird, and Shackleton and five others set off to find help. This precarious journey eventually reached land on South Georgia Island, but Shackleton and two others had to cross 32 miles of mountainous terrain to reach a whaling station and relative safety. Ships were immediately sent to rescue the three men on the other side of the island and the 22 on Elephant Island.

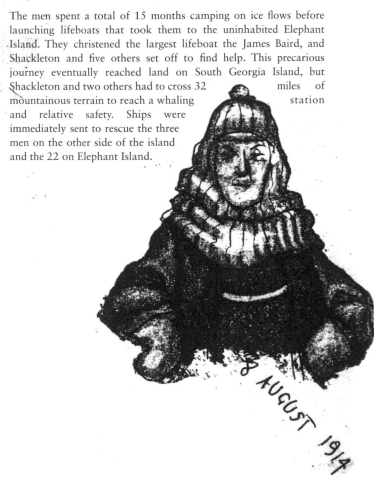

PLAYWRIGHT AND AUTHOR JOE ORTON IS MURDERED BY HIS BOYFRIEND KENNETH HALLIWELL IN THEIR FLAT ON NOEL ROAD, ISLINGTON.

Orton had a meteoric rise to success and fame, writing a string of black comedies for radio and stage over a three-year period. Halliwell, also a writer, had become increasingly jealous of Orton's fame and, probably accurately, did not trust the future of their relationship. After bludgeoning Orton with a hammer, he killed himself with an overdose of Nembutal tablets. Referred to as 'a bloody marvellous writer' by Harold Pinter in his eulogy, Orton wrote work that has continued to be staged. It remains curiously both quintessentially a product of the 60s yet wonderfully relevant and funny.

10 AUGUST 1866

THE FIRST DURABLE AND PERMANENT TRANS-ATLANTIC TELEGRAPHIC CABLE IS TESTED BY QUEEN VICTORIA.

The very first use was with a cable laid in 1858, although it lasted virtually no time at all. The cable reduced the time necessary to communicate between the continents from 10 days to a few minutes.

11 AUGUST 1897

CHILDREN'S AUTHOR ENID BLYTON IS BORN IN EAST DULWICH.

Blyton produced a staggering number of books that have been translated into virtually every language on the planet and have sold 600 million copies. Her books have been consistently criticised by educationalists and critics from as early as the 1930s. There are undeniably some questionable elements in many of her books; however, when my daughters were young, we all adored *The Wishing Chair* and *The Faraway Tree* series.

LEGENDARY CRICKETER W.G. GRACE SCORES 170 AGAINST AUSTRALIA AT THE OVAL, THE HIGHEST TEST SCORE OF HIS CAREER.

England went on to win the match with an inning to spare.

12 AUGUST 1886

FILM DIRECTOR AND PRODUCER SIR ALFRED HITCHCOCK IS BORN IN LEYTONSTONE.

Hitchcock was dubbed 'The Master of Suspense' and pioneered many elements of the suspense and psychological thriller genres. His films bridged the transition in film-making from silent to talkies, and he is regarded as one of Britain's best directors. *Rear Window* has never drifted out of my own personal top three films.

13 AUGUST 1899

SELF-TAUGHT SCULPTOR JOHN KAUFMAN ERECTS *THE DIVER IN THE THAMES* AT RAINHAM.

Kaufman's sculpture is made of galvinised steel and is partially submerged whenever the tide comes in but is totally covered by spring and neap tides. The piece was inspired by Kaufman's family history, as his grandfather was a diver in the London Docks.

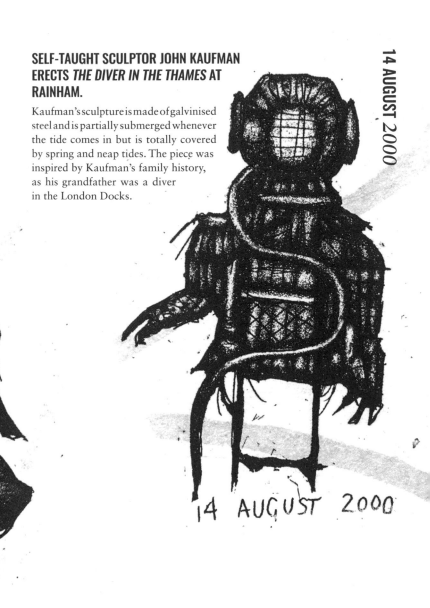

14 AUGUST 2000

BOB DYLAN VISITS
THE WRONG DAVE IN CROUCH END.

The story goes that Bob Dylan was heading to Crouch End to work in musician and producer Dave Stewart's Church Studios on Crouch Hill. Bob got his addresses muddled, however, and went to Crouch End Hill instead. When he turned up at the wrong house and asked for Dave, the woman who lived there asked him to come in to wait, as her husband, also called Dave, was out. Dave and Bob were both surprised when the former returned home to see Bob Dylan in his kitchen, drinking a cup of tea.

That day, Bob also had dinner at Banners Restaurant on Park Road and was seen checking out house prices in the window of a local estate agent (it was thanks to an article in the *Hornsey Journal* with the headline 'Is Bob Dylan moving to Crouch End?' that I found out this date).

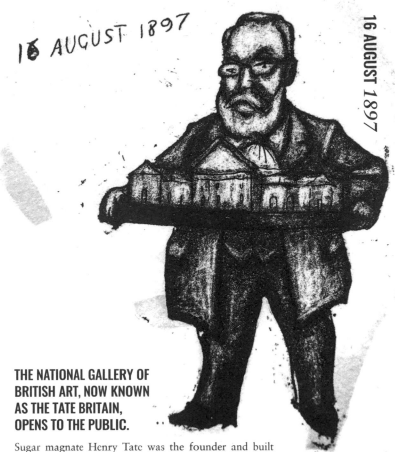

THE NATIONAL GALLERY OF BRITISH ART, NOW KNOWN AS THE TATE BRITAIN, OPENS TO THE PUBLIC.

Sugar magnate Henry Tate was the founder and built the gallery on the site of the former Millbank Prison. It was intended to showcase contemporary and historical British art and artists, and still boasts the world's foremost collection of works by J.W.M. Turner. It was commonly referred to as the Tate Gallery from the beginning but officially changed its name in 1932 and then changed it to Tate Britain once the Tate Modern opened in 2000.

BRIDGET DRISCOLL IS THE FIRST PERSON IN THE UK TO BE KILLED BY A CAR.

The maximum driving speed had just been increased from 2 mph to 14 mph, but Driscoll was hit by a car in Crystal Palace that had a maximum possible speed of 8 mph, although the driver stated that he was not doing more than 4 mph.

17 AUGUST 189

GEORGE ORWELL'S DYSTOPIAN ALLEGORICAL NOVELLA, *ANIMAL FARM: A FAIRY STORY*, IS PUBLISHED.

According to Orwell, the book reflects events leading up to the Russian Revolution in 1917 and the Stalinist era of the Soviet Union. Orwell wrote the book between November 1943 and February 1944, when the UK was at the height of its wartime alliance with the Soviet Union. By the time the book was published, the war was over and international relations were transformed as the alliance gave way to the Cold War.

GINGER BAKER, DRUMMER WITH THE ROCK BAND CREAM, IS BORN IN LEWISHAM.

Baker was as famous for his mercurial and unpredictable personality as the style and showmanship of his playing. He pioneered the use of two bass drums as well as the drum solo, most notably in the Cream song *Toad*.

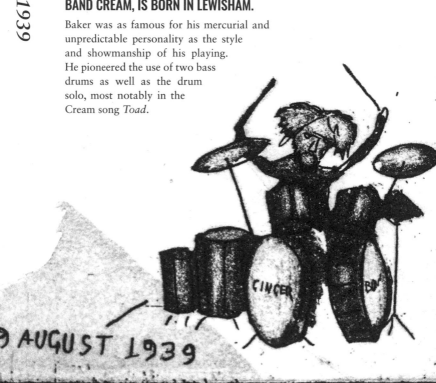

20 AUGUST 1929

THE FIRST TRANSMISSION OF JOHN LOGIE BAIRD'S EXPERIMENTAL 30-LINE TELEVISION SYSTEM FOR THE BBC.

Baird was a Scottish engineer and innovator who is renowned for being one of the inventors of the mechanical television.

Baird's early technological successes and his role in the practical introduction of broadcast television for home entertainment have earned him a prominent place in television's history.

21 AUGUST 1996

SHAKESPEARE'S GLOBE THEATRE ON BANKSIDE OPENS WITH A PERFORMANCE OF *THE TWO GENTLEMEN OF VERONA*.

Actor and director Sam Wanamaker founded the theatre after 26 years of planning and fundraising. The plan had always been to recreate the theatre as it was originally built, but detractors protested that modern fire regulations would make that impossible. Fire inspectors examined the almost completed building, and it was ultimately deemed so safe that they were allowed to proceed with the final sticking point: to give it a thatched roof. The design has been faithfully based on the foundations of the original theatre found nearby, but the scale was increased by 12% to allow for the fact that modern visitors are larger than Elizabethans.

A DUEL TAKES PLACE IN A FIELD BETWEEN HIGHGATE AND HAMPSTEAD HEATH BETWEEN TWO HIBERNIANS ARMED WITH CUDGELS, THEIR NATIONAL WEAPONS.

The fight lasted 65 minutes before one finally collapsed and conceded.

SIR WILLIAM WALLACE, THE SCOTTISH KNIGHT WHO BECAME THE MAIN LEADER OF THE SCOTTISH WARS OF INDEPENDENCE, IS EXECUTED IN SMITHFIELD.

Wallace defeated an English army at the Battle of Stirling Bridge in 1297 and was appointed Guardian of Scotland. He was captured in Robroyston near Glasgow and handed over to King Edward I of England, who had him hanged, drawn and quartered for high treason. His preserved head (dipped in tar) was placed on a pike on London Bridge, and his four limbs were displayed separately in Newcastle, Berwick, Stirling and Perth. He is now considered a national hero, and there is a plaque on the wall of St Bartholomew's Hospital close to the site of his execution.

23 AUGUST 1305

24 AUGUST 1770

POET THOMAS CHATTERTON COMMITS SUICIDE IN HOLBORN.

Although extremely poor, Chatterton was becoming quite well known, not only through his own works but also through the poems of his adopted persona, Thomas Rowley, a 15th-century monk. Never properly paid or rewarded for his work, the 17-year-old poet retired to his attic and drank a bottle of arsenic. He became famous to poets of the Romantic era and inspired many poems and the wonderful painting *Death of Chatterton* by Henry Wallis.

THE FIRST PASSENGER AIR SERVICE BETWEEN LONDON AND PARIS IS INAUGURATED.

25 AUGUST 1919

The service was run by Airco de Havilland in its biplane the DH 16, which had an enclosed cabin seating four passengers plus the pilot in an open cockpit. One of their aircrafts was sold to the River Plate Aviation Company in Argentina for a cross-river service between Buenos Aires and Montevideo.

THE BEATLES MEET THE TRANSCENDENTAL MEDITATION GURU MAHARISHI MAHESH YOGI AT THE HILTON HOTEL ON PARK LANE.

The Maharishi's fame increased and his movement gained greater prominence when he became known as 'the spiritual advisor to The Beatles'. They went to study with him, first in Wales and then in India, although they later formally renounced their association as a 'public mistake'.

VERONICA AND COLIN SCARGILL COMPLETE A ROUND-THE-WORLD TANDEM BICYCLE RIDE.

The couple cycled 18,020 miles in 18 months and were reportedly still on speaking terms at the end.

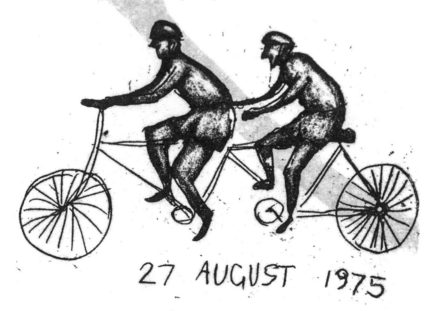

27 AUGUST 1975

THE ARTIST RICHARD DADD EXPERIENCES BOUTS OF MENTAL HEALTH PROBLEMS, SO HE AND HIS FATHER SET OFF ON A RECUPERATIVE JOURNEY TO FRANCE.

On the way, Dadd became convinced that his father was the devil and killed him. He fled to France and was arrested after trying to kill someone else. He was committed to Bethlem (also know as Bedlam) Hospital, where he was encouraged to keep painting. He created most of the work for which he is famous while there, painting in obsessively minute detail. *The Fairy-feller's Master-Stroke* in the Tate Britain is the most well-known and inspired Queen to create a song of the same name, that makes *Bohemian Rhapsody* seem conventional in comparison.

28 AUGUST 1843

SCIENTIST MICHAEL FARADAY CREATES THE FIRST TRANSFORMER AND CONDUCTS AN EXPERIMENT INVESTIGATING THE PHENOMENON KNOWN AS ELECTRO-MAGNETISM.

I have depicted Faraday's first dynamo rather than his first transformer. Albert Einstein kept a picture of Faraday on his study wall, alongside pictures of Isaac Newton and James Clerk Maxwell.

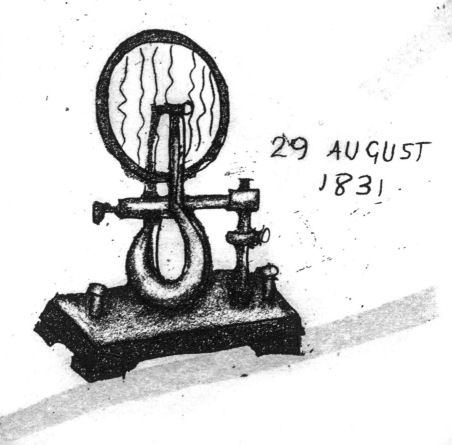

29 AUGUST
1831

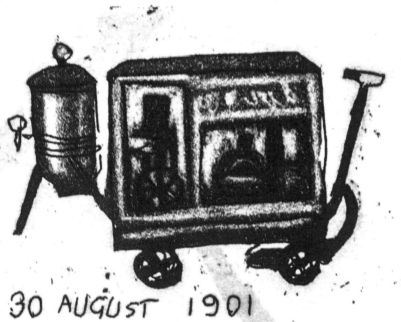

30 AUGUST 1901

HUBERT CECIL BOOTH PATENTS HIS INVENTION, THE FIRST POWERED VACUUM CLEANER.

Booth later became the Chairman and Managing Director of the British Vacuum Cleaner and Engineering Company. Before Booth, all cleaning machines blew or brushed dirt away instead of sucking it in. All vacuum cleaners after Booth are based on his principles.

MARY ANN NICHOLS BECOMES THE FIRST VICTIM MURDERED BY SERIAL KILLER JACK THE RIPPER IN WHITECHAPEL.

Nichols had been married to a printer's machinist and had five children before the couple divorced and she left home and fell on hard times. She had allegedly taken up prostitution to pay for her lodgings and drinking habits and was out drinking on the night she was killed. The name 'Jack the Ripper' was spread by the press after the signature on a letter from someone alleging to be the killer was received. There were many possibly related murders at the time, but Nichols was the first of what they refer to as 'the canonical five' that were undisputedly committed by the same person.

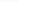

31 AUGUST 1888

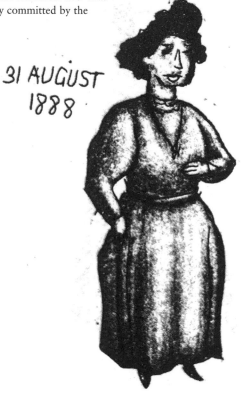

SEPTEMBER

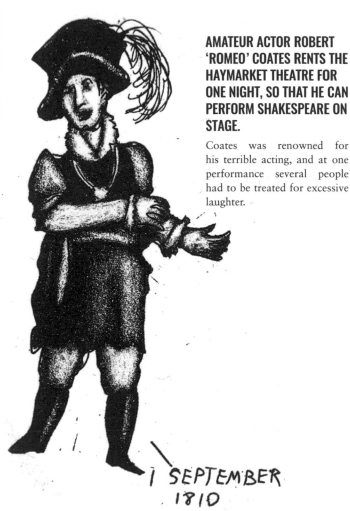

AMATEUR ACTOR ROBERT 'ROMEO' COATES RENTS THE HAYMARKET THEATRE FOR ONE NIGHT, SO THAT HE CAN PERFORM SHAKESPEARE ON STAGE.

Coates was renowned for his terrible acting, and at one performance several people had to be treated for excessive laughter.

1 SEPTEMBER 1810

THE GREAT FIRE OF LONDON STARTS IN THOMAS FARRINER'S BAKERY ON PUDDING LANE.

Firebreaks could have been created to halt the progress of the fire, but the Lord Mayor of London, Sir Thomas Bloodworth, was indecisive and delayed it for too long. The fire destroyed much of the medieval city, consuming 13,200 houses, 87 parish churches, St Paul's Cathedral and most of the buildings of the city's authorities.

Death tolls have been recorded as surprisingly low, but this seems to be because they didn't record the deaths of poor or middle class people.

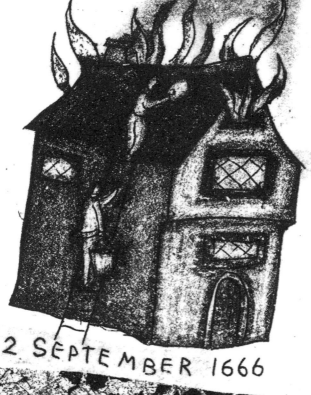

2 SEPTEMBER 1666

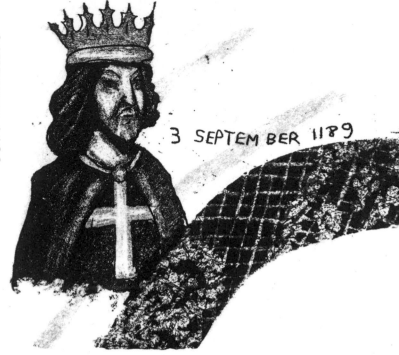

3 SEPTEMBER 1189

RICHARD I IS CROWNED IN WESTMINSTER.

The King was also known as Richard Coeur de Lion or Richard Lionheart because of his reputation as a great military leader and warrior. He is regarded as one of the most popular English monarchs, although throughout his ten-year reign he spent as little as six months in the country. He used England primarily as a source of revenue to fund his military crusade in the holy lands.

Whilst walking around the perimeter walls of a small chateau he had recently captured in Normandy, he was struck in the shoulder by an arrow shot by a young boy. The arrow was removed incompetently, and he ended up dying from the resulting infection.

EDMUND HALLEY, THE SECOND ASTRONOMER ROYAL IN BRITAIN, OBSERVES THE COMET THAT WOULD BEAR HIS NAME.

Halley accurately calculated the orbital period of 75-76 years when all subsequent sightings would occur. The next sighting was in 1758, and even though he did not live to see the comet's return, it was named Halley's Comet when it did.

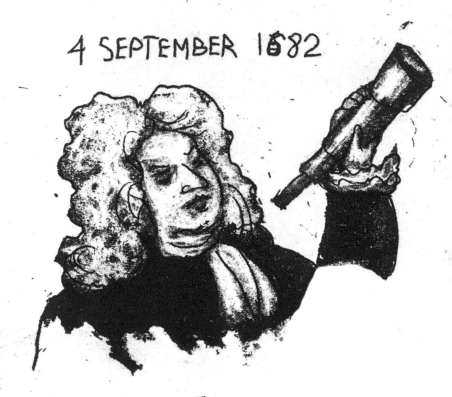

4 SEPTEMBER 1682

THE GREAT FIRE OF LONDON ENDS.

The Golden Boy at Pye Corner is a small monument on the corner of Giltspur Street and Cock Lane marking the furthest extent of the fire before it was finally stopped. It bears the following inscription below it: 'This Boy is in Memmory Put up for the LATE FIRE OF LONDON Occasion'd by the Sin of Gluttony.'

After the fire, architect Christopher Wren created 54 new churches and a new St Paul's Cathedral. He also designed a hugely ambitious masterplan for the complete rebuilding of the City of London. However, the owners of the original plots of land refused to concede anything, resulting in what you still see today: a majestic English Baroque city built on a Medieval grid.

5 SEPTEMBER 1666

WILLIAM WORDSWORTH COMPOSES THE POEM
UPON WESTMINSTER BRIDGE.

The poem describes London and the River Thames, viewed from Westminster Bridge in the early morning. Inspiration for the poem came on a journey made by Wordsworth and his sister Dorothy through London, en route to France.

This date is the most glaring erratum in this project as I somehow managed to get the wrong date (the poem was actually composed on 3 September 1802) and etched it into the plate incorrectly (as 6 July 1840, a date accidentally included twice) on the first handful of maps before it was amended! However I am hopeful that like a misprinted Penny Black stamp, these few maps will be seen as rare and desirable commodities rather than unfortunate examples of negligent cartography. Happy birthday to my friend Jeremy who first spotted this error.

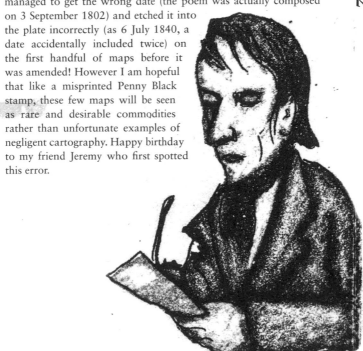

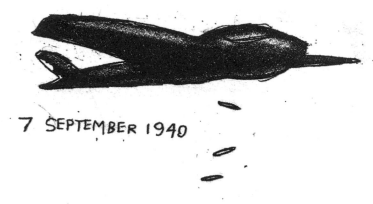

7 SEPTEMBER 1940

THE BLITZ (SHORTENED FROM THE GERMAN WORD *BLITZKRIEG*, MEANING 'LIGHTNING WAR') STARTS IN LONDON.

The German air offensive concentrated on bombing industrial targets and civilian centres in what became known as 'The Battle of Britain'. The Luftwaffe bombed London for 56 of the following 57 nights, dropping more than 100 tons of explosives. These aerial attacks continued intermittently until 21 May 1941, when the plan to demoralise the British into surrender and significantly damage the war economy was deemed to have failed. Hitler abandoned plans to invade Britain and changed his focus to the eastern front, in order to invade Russia.

THE CORONATION OF KING WILLIAM IV, WHO AT 64 IS THE OLDEST PERSON TO ASSUME THE BRITISH THRONE.

William died in 1837, leaving no legitimate children, so the crown went to his niece, Victoria. He did have eight illegitimate children with the actress Dorothea Jordan, with whom he lived for 20 years.

8 SEPTEMBER 1831

ACTOR HUGH GRANT IS BORN IN HAMMERSMITH.

Grant approaches his roles like a character actor, with performances that appear spontaneous and nonchalant. Famous for his collaborations with writer/director Richard Curtis, he has repeatedly claimed that acting was not his true calling but rather a career that unintentionally developed by happenstance.

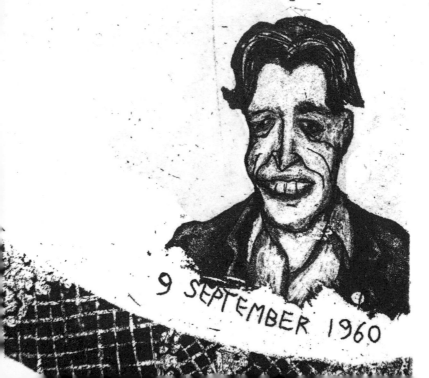

9 SEPTEMBER 1960

BRAM STOKER'S *DRACULA* IS PUBLISHED.

It is an epistolary novel written in the form of fictional but realistic diary entries, telegrams, letters and ships' logs. The book was possibly inspired by Hungarian author Armin Vambery's dark tales of the Carpathian Mountains, as Stoker met him whilst doing research into European folklore.

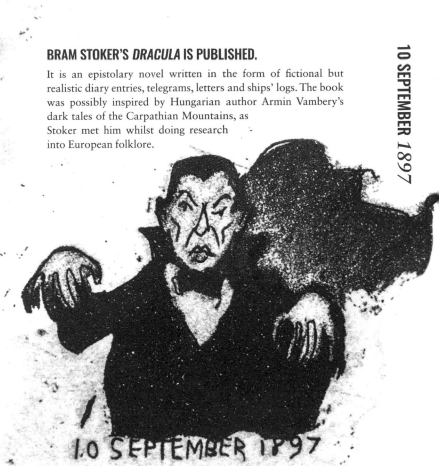

1.0 SEPTEMBER 1897

11 SEPTEMBER 1897

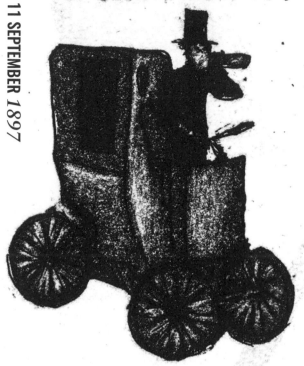

A 25-YEAR-OLD LONDON TAXI DRIVER NAMED GEORGE SMITH BECOMES THE FIRST PERSON EVER ARRESTED FOR DRINK-DRIVING, AFTER SLAMMING HIS CAB INTO A BUILDING.

Smith later pleaded guilty and was fined 25 shillings.

CORNELIUS DREBBEL DEMONSTRATES HIS NAVIGABLE SUBMARINE TO KING JAMES I AND SEVERAL THOUSAND LONDONERS.

This model, Drebbel's third, last and most successful, had six oars and could carry 16 passengers. It stayed submerged for three hours as it travelled between Westminster and Greenwich and back. Drebbel actually took the King on a test dive, giving him the honour of being the first monarch to travel underwater. The craft, called a 'drebbel' after its maker, did not catch on and was never used in combat.

12 SEPTEMBER 1624

ILLUSTRATOR AND CARTOONIST W. HEATH ROBINSON DIES IN PINNER, AGED 72.

Heath Robinson was famous for his drawings of unnecessarily complex and implausible inventions for performing simple tasks. The term 'Heath Robinson' has entered the lexicon to describe any overly elaborate and complicated device. In fact, the predecessor to Colossus, the first digital programmable computer made at Bletchley Park during World War II, was named 'Heath Robinson' in his honour.

13 SEPTEMBER
1944

TALENTED, ACCLAIMED AND UNIQUE SINGER-SONGWRITER AMY WINEHOUSE IS BORN IN SOUTHGATE.

In her brief, meteoric career, her first album, *Frank*, was nominated for the Mercury Prize, and the follow up, *Back to Black*, won five Grammys and three Ivor Novellos.

I sadly never saw her perform but did see her on a street in East Finchley once. My wife and I were going for a coffee at 9 am when Amy and her driver pulled up in a huge black 4 x 4 and popped into a shop. Amy left the shop carrying a tin of lager, and I was walking just behind them after collecting a ticket to park our car. As I passed them, I said, 'I love you Amy', and she turned and said, 'I love you too'. Still a very sweet memory for me, even if my wife was slightly mortified.

A great talent, much missed.

14 SEPTEMBER 1983

GLOBAL FINANCIAL SERVICES FIRM LEHMANN BROTHERS FILE CHAPTER 11 BANKRUPTCY PROTECTION FOLLOWING THE MASSIVE EXODUS OF MOST OF ITS CLIENTS, DRASTIC LOSSES IN ITS STOCK AND DEVALUATION OF ASSETS BY CREDIT RATING AGENCIES.

This was sparked by Lehmann Borthers' involvement in the subprime mortgage crisis and subsequent allegations of negligence and malfeasance. The firm filed for bankruptcy the following day, sparking a global market collapse.

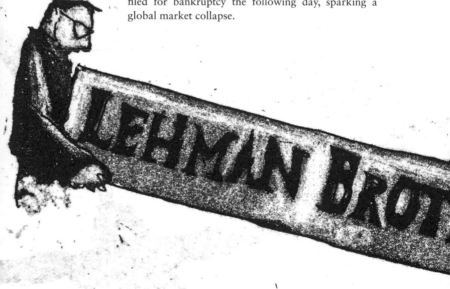

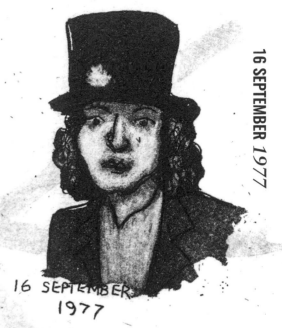

16 SEPTEMBER 1977

SINGER-SONGWRITER MARC BOLAN, FRONT MAN OF GLAM ROCK BAND T-REX, DIES IN A CAR CRASH IN BARNES.

Bolan's girlfriend, Gloria Jones, was driving the car, as Bolan had never learned to drive, fearing premature death. Born Mark Feld, he apparently created the stage name Bolan as a contraction of his favourite singer Bob Dylan.

A TORNADO WITH UP TO 200 MPH WINDS HITS LONDON.

The tornado levelled the medieval church St Mary le Bow and severely damaged London Bridge but miraculously killed only two people.

LEGENDARY SINGER-SONGWRITER AND GUITARIST JIMI HENDRIX DIES IN THE SAMARKAND HOTEL IN NOTTING HILL.

Hendrix had spent two days partying with his German girlfriend, Monika Dannemann, and took nine of her prescription sleeping tablets (18 times the recommended dose). She woke to find him breathing but unresponsive and called for an ambulance, but he was pronounced dead at St Mary's Hospital.

18 SEPTEMBER 1970

His legend has continued to grow with his winning many posthumous Grammys and other awards, and topping countless polls as both a songwriter and a guitarist. It was not until 1983 that Hendrix was honoured with a memorial in his hometown of Seattle, but this was curiously at the Woodland Park Zoo. His blue plaque on Brook Street was the first ever given to a rock musician.

THE GREAT PLAGUE OF LONDON REACHES ITS HEIGHT.

In a two-year period, the bubonic plague claimed an estimated 100,000 Londoners, approximately a quarter of the city's population. At the time, they had no idea that the plague was being spread by rats but suspected a connection with animals and so started getting rid of cats and dogs. This of course exacerbated the problem.

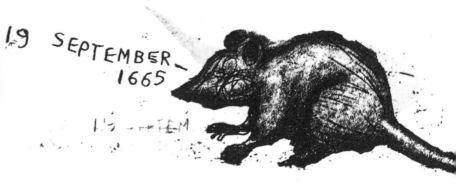

20 SEPTEMBER 1976

100 CLUB PUNK SPECIAL FEATURING SIOUXSIE AND THE BANSHEES, THE CLASH AND THE SEX PISTOLS.

This was the first day of a two-day concert organised by Malcolm MacLaren, the manager of The Sex Pistols. It was a watershed event that shifted punk from being part of an underground music scene to being mainstream.

Although I have depicted Johnny Rotten from The Sex Pistols, the most notable point about that evening was that it was the first public performance by The Clash.

THE HOBBIT OR THERE AND BACK AGAIN, BY J.R.R. TOLKEIN, IS PUBLISHED IN BLOOMSBURY BY ALLEN & UNWIN.

Tolkein was Rawlinson and Bosworth Professor of Anglo-Saxon at Pembroke College, Oxford, and drew heavily from his studies to write his books. The greatest influence on *The Hobbit* was the Old English epic poem *Beowulf*, from which he borrowed many themes. Early drafts were read and critiqued by his friend C.S. Lewis, who was also a professor at Oxford and a fellow member of the literary discussion group called The Inklings.

SIR ROBERT WALPOLE, GREAT BRITAIN'S FIRST PRIME MINISTER, MOVES INTO NO.10 DOWNING STREET.

No. 10 was converted from three houses, which were given to Walpole by George II. Walpole accepted the offer only on the basis that once he left office, the house would pass to the next First Lord of the Treasury.

The street, a cul-de-sac adjacent to St James Park, was a property speculation built by Sir George Downing, a notorious spy for Oliver Cromwell and then George II. Although Downing ensured the houses were designed by Sir Christopher Wren, he built them quickly out of poor materials on soft land. Sir Winston Churchill said that the street was 'shaky and lightly built by the profiteering contractor whose name they bear'.

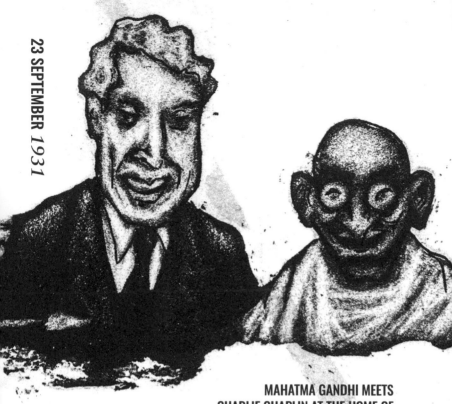

MAHATMA GANDHI MEETS CHARLIE CHAPLIN AT THE HOME OF DR KATIAL IN BECKTON ROAD, CANNING TOWN.

Gandhi was in London to speak about Indian independence at the Round Table Conference. He was staying at Kingsley Hall Community Centre in Bow, as he refused offers to be put up at either a smart West End hotel or a royal residence, such as Kensington or St James Palace. Charlie Chaplin was making a rare visit back to his homeland and asked if he could meet the famous Indian leader. Gandhi was initially reluctant, as he thought that Chaplin was not a serious man, but was convinced otherwise, and the two had a lovely tea together in a private home away from the media.

SAMUEL PEPYS WRITES THE FIRST EVER ACCOUNT OF A CUP OF TEA BEING DRUNK IN LONDON.

Although tea had arrived in the capital earlier, Samuel Pepys, who was always keen for novel experiences, was the first to record drinking it. He wrote in his diary: "I did send for a cup of tee (a China drink) of which I had never drunk before."

24 SEPTEMBER 1660

PHYLLIS PEARSALL, CREATOR OF THE FAMOUS *LONDON A-Z*, IS BORN IN EAST DULWICH.

One day, whilst working as a portrait painter, Pearsall set off to the West End to meet a potential client. She used the only available map of the day to find her way and was frustrated by its inaccuracy. She decided to create a proper map and so began the task of walking the streets of London.

25 SEPTEMBER 1906

26

Pearsall would rise at 5 am and work an 18-hour day mapping the city. In the end she had walked 3,000 miles, recording over 23,000 streets, 9,000 more streets than any previous map. Hers was the first one ever to include house numbers.

THE BEATLES RELEASE THEIR ELEVENTH AND PENULTIMATE STUDIO ALBUM, *ABBEY ROAD*.

The iconic photo shoot was on done on 8 August 1969, when a policeman briefly stopped the traffic so that photographer Iain Macmillan could climb a stepladder to take six photos of The Beatles crossing the street, walking away from their famous studio. They chose photo no. 5, in which they were all walking in step except for Paul McCartney, who was also barefooted (he was not in all of the photos). These clues added weight to a growing conspiracy theory that this man was an imposter and that the real Paul McCartney was dead. Their clothing added to the myth as the four were said to have dressed to represent the guardian angel (John), the undertaker (Ringo), the deceased (Paul) and the gravedigger (George). Further clues were that McCartney is holding a cigarette in his right hand but was left handed; he is walking with his right foot leading while the others are all leading with their left; and there is a VW in the background with the license plate '28 IF', which was said to be code for the fact that Paul would have been 28 if he had lived.

HAIR, THE MUSICAL OPENS AT THE SHAFTESBURY THEATRE.

The opening had to be delayed until the Theatre Act 1968, which abolished theatre censorship, came into effect. This was vital as the play included levels of both profanity and nudity that would have been unacceptable even a month earlier.

27 SEPTEMBER
1968

28 SEPTEMBER 1928

A FORTUITOUS ACCIDENT LEADS ALEXANDER FLEMING TO DISCOVER PENICILLIN.

Before departing for a two-week holiday from his research position at St Mary's Hospital in Paddington, Fleming had piled up several Petri dishes containing a strain of staphylococcus bacteria. He had neglected to seal them properly, and they became contaminated by airborne Penicillium notatum mould that had travelled from the floor below. He noted that there was a halo of inhibited bacterial growth around the Penicillium mould and coined the word 'penicillin'.

Fleming would later say, 'I certainly didn't plan to revolutionise all medicine by discovering the world's first antibiotic or bacteria killer, but I suppose that is exactly what I did.' He made an announcement and published a paper on his findings but was apparently such a poor communicator and speaker that it was years before he could get the scientific community to acknowledge the scale and importance of his discovery.

SIR ROBERT PEEL ESTABLISHES THE METROPOLITAN POLICE AT SCOTLAND YARD.

In his honour, the new officers were nicknamed 'bobbies' and, somewhat less affectionately, 'peelers'. They wanted to have uniforms to distinguish them from the public but decided on the naval blue instead of the military red due to the popularity of the navy. The metal buttons were said to be responsible for yet another of their nicknames, 'copper'. The force started with 1,000 officers and although initially unpopular, they quickly proved to be very successful in cutting down crime in London. By 1857 all cities in the country were obliged to set up their own police forces.

STRAND STATION ON THE LONDON
UNDERGROUND PERMANENTLY CLOSES.

The Station was built on the site of the Royal Strand Theatre and was an underused station almost from its inception. However, its central location made it very useful during both world wars as both an air-raid shelter and for the storage of precious artefacts. In 1917 it was used to store paintings from the National Gallery and just after the Blitz it was used to house the Elgin Marbles.

Since closing it has become a Grade II listed building and is primarily used for filming when an underground platformis required. Famous uses include *Atonement*, *Mr Selfridge* and *Sherlock*.

OCTOBER

ACTOR STANLEY HOLLOWAY IS BORN IN MANOR PARK IN THE EAST END OF LONDON (ALTHOUGH THEN IT WAS TECHNICALLY STILL IN ESSEX).

Holloway was a great comic actor who appeared in many Ealing comedies. He was most famous for his role as Alfred P. Doolittle in *My Fair Lady* that he performed on Broadway, the West End and in the 1964 film. Interestingly, he was the paternal grandfather to writer and former model Sophie Dahl whose other grandfather was writer Roald Dahl.

THE FIRST RUGBY MATCH AT TWICKENHAM STADIUM IS PLAYED BETWEEN HARLEQUINS AND RICHMOND.

Twickenham stadium is the largest in the world devoted to rugby and because it was built on the site of a huge market garden where cabbages were grown, it is affectionately known as 'the Cabbage Patch'.

Although versions of rugby were played for hundreds of years, three boys from Rugby school wrote up rules for it in 1845. It is rumoured that the origin of the game was when one student named William Webb Ellis showed a flagrant disregard for the football played in his day, picked up the ball and ran with it. The story is a bit of an urban myth but the cup for the Rugby World Cup is called the Webb Ellis Trophy in his honour.

2 OCTOBER 1909

THE BOLSHOI BALLET DEBUTS AT COVENT GARDEN ON ITS FIRST TRIP OUTSIDE THE SOVIET UNION.

Amongst their number were two ballerinas whose names are now legendary in the ballet world, Galina Ulanova and Raisa Struchkova. The company is one of the most famous in the world but had very humble beginnings as a dance school set up for a Moscow orphanage in 1773. It was with their trip to London that the Bolshoi's international fame truly began, but it has always been legendarily secretive. For the first time in its history, the company allowed behind the scenes access and complete artistic freedom to a film crew from the west. The result is Nick Read's film *Bolshoi Babylon* that had its world premiere at the Toronto Film Festival in September 2015.

4 OCTOBER 1936

THE BATTLE OF CABLE STREET IN THE EAST END.

Despite many misgivings, the authorities allowed Oswald Mosley and his band of fascists, known as the Blackshirts, to march through the East End of London. They were provided with an escort of 600 policemen, but they found their way blocked by about 100,000 anti-fascist protesters made up of Jewish, Irish, socialist, anarchist and communist groups. The police attempted to clear the way but were attacked by crowds armed with improvised weapons such as rocks, sticks and chair legs, while women along the route pelted the fascists with rotten vegetables, rubbish and the contents of chamber pots.

In the end, those chanting 'they shall not pass' won out as Mosley abandoned the march and his band scattered. Many protesters were arrested and fined for their actions, and the ringleaders were sentenced to three months hard labour. It nevertheless led to the Public Order Act 1936, making it mandatory for the police to consent to political marches and banning the wearing of political uniforms in public. This helped to bring about the demise of the British Union of Fascists before the war. There is a fantastic mural commemorating the event on the side of St George's Town Hall on Cable Street, and my detail of Hitler in his underwear is lifted from it.

THE FIRST JAMES BOND FILM, *DR NO*, HAS ITS WORLD PREMIERE AT THE LONDON PAVILION.

Dr No was actually the second Bond book written by Ian Fleming. The first, *Casino Royale*, introduced the character of James Bond but was not made into a film until the spoof spy film starring David Niven in 1967. David Niven was originally considered for the Bond role in *Dr No*, in addition to Cary Grant, Patrick McGoohan, Roger Moore and Lord Lucan. The producers decided to have a competition to cast the part, but the winner, 28-year-old model Peter Anthony, proved unable to cope with the role. Ultimately, they chose a 30-year-old former milkman named Sean Connery, who swaggered into the audition in crumpled clothes. The director, Terence Young, decided to groom Connery for the role and so took him to his barber and tailor and then out on an extended bender to introduce him to the high life in London.

I have depicted Ursula Andress, whose emergence from the ocean as Honey Ryder is one of the most iconic of the film. Although she looked perfect, her voice was thought to be too heavily accented and was dubbed over in the final film.

JASON LEWIS COMPLETES EXPEDITION 360, THE FIRST CIRCUMNAVIGATION OF THE GLOBE BY PURELY HUMAN POWER.

Lewis started the expedition with fellow adventurer Stevie Smith, although only Lewis completed it, travelling by a combination of mountain bike, kayak, rollerblade and on foot. He roller-bladed thousands of miles across North America but was hit by a drunk driver in Pueblo, Colorado and spent nine months recovering from two broken legs. In addition to this incident, he survived malaria twice, as well as septicaemia, a mild bout of schizophrenia and a crocodile attack near Australia. The journey, which started at Greenwich on 12 July 1994, eventually finished 4,833 days and 74,842 km later.

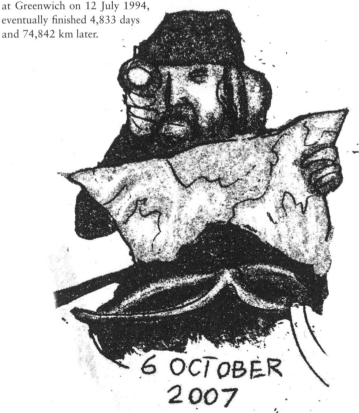

6 OCTOBER 2007

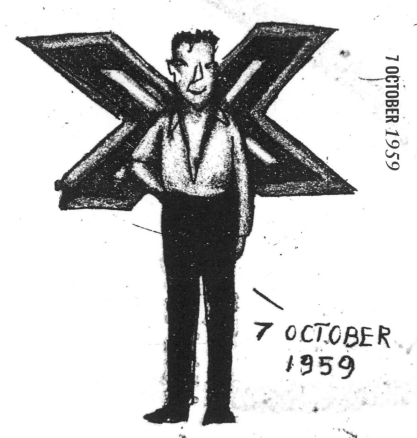

7 OCTOBER 1959

TELEVISION AND MUSIC PRODUCER AND *POP IDOL*, *X FACTOR* AND *BRITAIN'S GOT TALENT* JUDGE, SIMON COWELL, IS BORN IN LAMBETH.

While Cowell is consistently voted one of the most influential men in television, my personal highlight of his career was when he appeared on *The Simpsons* and got beaten up by Homer whilst critiquing Homer's punches.

THE BT TOWER (FORMERLY KNOWN AS THE POST OFFICE TOWER) IS OFFICIALLY OPENED BY PM HAROLD WILSON.

Built to support the enormous microwave aerials necessary to carry telecommunications traffic from London to the rest of the country, the tower was the tallest building in the United Kingdom until 1980, when it was overtaken by the NatWest Tower. There was a rotating restaurant on the 34th floor, which could perform a complete revolution every 22 minutes.

It was temporarily closed after the Provisional IRA exploded a bomb in the men's toilet in 1971 but then permanently closed after the lease, held by the Butlins Group, expired in 1980. Rumours persist about its reopening, but it did this for only two weeks in the summer and then a further three days in the autumn of 2015 to celebrate its 50th anniversary. Lotteries were held for both events; 1,400 lucky people got to dine there in July, and 2,400 went for drinks and snacks in October.

8 OCTOBER 1965

THE FIRST SUMO BASHO (TOURNAMENT) TO BE HELD OUTSIDE JAPAN STARTS AT THE ROYAL ALBERT HALL.

Due to a weekly television program on Channel 4, Sumo had hit a height of popularity in the UK and it was decided that this made for the perfect opportunity to stage a tournament outside Japan for the first time in its 1,500-year history. I went along to see it and will always remember walking past the Royal Garden Hotel on Kensington High Street and seeing these glorious giants lounging in the lobby in their pyjamas and dressing gowns.

The Basho featured all 40 of the main *rikishi* or sumo wrestlers including the two *yokozuma* (grand champions) – Asahifuji and Hokutuomi as well as Konishiki (nicknamed 'The Dump Truck') famous both for being the heaviest sumo wrestler ever (37.5 stone – 238.25 kg) and the first foreigner to become one of the elite wrestlers (he was from Hawaii). My personal favourite Chiyonofuji (The Wolf), who was the eventual champion of the tournament.

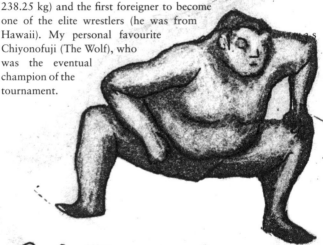

9 OCTOBER 1991

10 OCTOBER

BRITAIN'S FIRST MOSQUE, THE FAZI MOSQUE, IS OPENED TO WORSHIPPERS IN SOUTHFIELDS.

The need for a mosque was recognised as early as 1910 and a house and garden in Southfields were purchased to build one. At a total cost of £6,223 the mosque was completely paid for by contributions by the Ahmadinejad Muslim women of Qadian in India. Although the Fazi Mosque was built and opened first, there is some debate over the claim for it being the first mosque, as the East London Mosque fund was started earlier.

VIVIENNE LEIGH PLAYS BLANCHE DUBOIS IN THE LONDON PREMIERE OF TENNESSEE WILLIAMS' *A STREETCAR NAMED DESIRE* AT THE ALDWYCH THEATRE.

Leigh was chosen for the role by Tennessee Williams himself, and her husband, Laurence Olivier, was chosen to direct it. The play was a huge success, with Leigh's performance predominantly receiving great reviews, although the people who did not like her vehemently slated her. Vivien Leigh had what we would now diagnose as a bipolar disorder and suffered from intermittent attacks of chronic tuberculosis. She claimed to love the character and believed in the importance of the play but said that playing Blanche DuBois had 'tipped her into madness.'

26

II OCTOBER 1949

12 OCTOBER 1979

THE HITCHHIKER'S GUIDE TO THE GALAXY BY DOUGLAS ADAMS IS PUBLISHED IN LONDON BY PAN BOOKS.

The novel is a science fiction romp through space and is based on a series of radio plays the author wrote which had been broadcast the previous year. The book sold 250,000 copies in its first three months and together with the four subsequent books in what Adams called his "trilogy" became part of an international multimedia phenomenon. In addition to being a writer, Adams was a fervent environmentalist and conservationist. He was also responsible for one of my favourite quotes: 'I love deadlines. I like the whooshing sound they make as they fly by.'

RICHARD (DICK) WHITTINGTON IS ELECTED LORD MAYOR OF LONDON FOR THE FIRST OF THREE APPOINTMENTS.

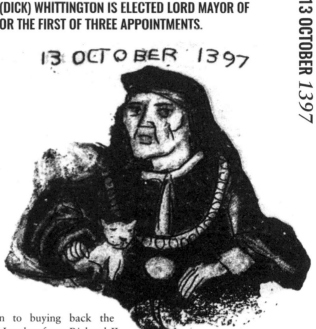

13 OCTOBER 1397

In addition to buying back the liberties of London from Richard II at a cost of £10,000 (about £4 million in today's money), Dick Whittington was also responsible for the rebuilding of the Guildhall, building a ward for unmarried mothers at St Thomas' Hospital, creating drainage systems for areas around Billingsgate and Cripplegate, the rebuilding of his parish church, St Michael Paternoster Royal, creating a public toilet seating 128 that was cleansed by the River Thames at high tide, called Whittington's Longhouse, in the parish of St Martin Vintry, and the creation of Greyfriars library. When he died, he left his considerable fortune to various charitable causes, creating a legendary status that saw him become a beloved fictional hero of pantomimes and stories. There is no record of his ever having owned a pet; however, a mummified cat was found in the tower of the church in which he is buried.

THE CHILDREN'S BOOK *WINNIE-THE-POOH*, BY A.A. MILNE, IS PUBLISHED BY METHUEN BOOKS.

Milne had based the characters in his stories on his son Christopher Robin's collection of stuffed toys, which included Winnie, Piglet, Eeyore, Kanga, Roo and Tigger. He made up the characters of Owl and Rabbit. Winnie-the-Pooh was named after a beloved Canadian brown bear named Winnie who they would often see at London Zoo and a swan called Pooh they met on holiday. The bear had been given to London Zoo by Canadian Lieutenant Harry Colebourn, who had surreptitiously brought it with him to England during World War I. He asked London Zoo to look after Winnie while he was fighting in France, and after the war he donated him to the zoo. He was named after Colebourn's adopted hometown of Winnipeg. I have based my detail on the art of E.H. Shepherd, who created the illustrations for all Milne's books.

14. OCTOBER 1926

THE EXHIBITION OF *REMBRANDT THE LATE WORKS* OPENS AT THE NATIONAL GALLERY.

It was the most major exhibition of the artist's work ever staged outside Holland. The works were revelatory even for such a huge fan of Rembrandt's work as I am. They were also deeply moving, as they coursed the end of a profoundly tragic life. Rembrandt and his wife Saskia had four children, but only one, Titus, survived beyond childhood. After Saskia died from tuberculosis, Rembrandt began a relationship with his maid Hendrickje Stoffels. The two never married but did have a daughter named Cornelia. Rembrandt's early success as a portrait painter had faded, and although he painted constantly and, as the exhibition testified, his work continued to improve, he found it increasingly difficult to sell his work. Rembrandt survived both Hendrickje and his son Titus, and when he died was buried in an unmarked, pauper's grave.

Rembrandt was my first artistic love, and I have a daily reminder of him whenever I look at myself in the mirror. My parents gave me an enormous catalogue raisonné of his work when I was very young, and I carried it around with me everywhere. One day, I was carrying it upstairs when I tripped on the final step landing on the book and broke my nose, which has been decidedly crooked ever since.

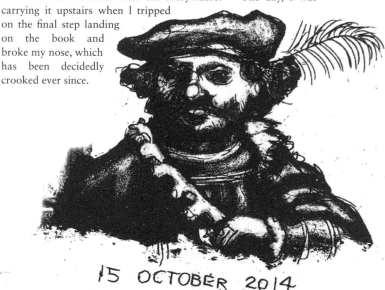

15 OCTOBER 2014

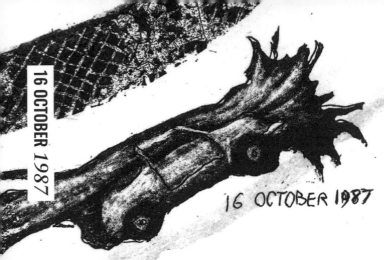

16 OCTOBER 1987

THE GREAT STORM OF 1987 HITS LONDON, THE SOUTHEAST OF ENGLAND, NORTHERN FRANCE AND THE CHANNEL ISLANDS.

The storm was a violent extratropical cyclone with hurricane force winds of up to 122 mph. Twenty-two people were killed in the storm, and there was huge damage to buildings. The most obvious casualties were the trees, as in excess of 15 million were uprooted, including six of the eponymous oaks in Sevenoaks.

I remember clearly walking down to Archway Underground on the morning of the 16th and having to constantly step or climb over the fallen trees that had lined the Archway Road (although I am ashamed to admit I had not really noticed them previously). We got onto a Tube waiting on the platform and got into work only a touch later than usual.

My favourite anecdotal story was from my friend Moira's great aunt, who lived in Shoreham-on-Sea. She had slept through the storm but could clearly see something dramatic had happened when she looked out her window in the morning. She tried to find out more information, but her phone lines and electricity were off. In true Blitz spirit she wrapped up and set off to make inquiries at the local village shop, but when she got there, it was gone.

GENERAL AUGUSTO PINOCHET, THE FORMER DICTATOR OF CHILE, IS ARRESTED IN LONDON FOR HUMAN RIGHTS VIOLATIONS.

The charges included torture, assassination and genocide during his 17-year regime. Pinochet took control of Chile in a coup that deposed President Salvadore Allende and was said to have been responsible for over 3,000 deaths and for the torture of approximately 30,000 people. His arrest was a landmark, as he was the first former leader who was not able to claim diplomatic immunity. He had made himself a lifelong senator in Chile, a role created by him that made him immune to prosecution in his home country. When he travelled to London to have a minor operation on his back, he opened himself up to European courts, and Spain set the works in motion to extradite him. He was held in London for a year and a half before finally being returned to Chile. He was held there pending trial but died without actually being convicted of any crime.

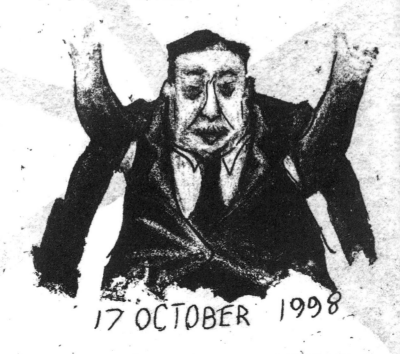

17 OCTOBER 1998

THE CHARLTON HORN FAIR IS HELD ON ST LUKE'S DAY.

The fair was a riotous procession between Rotherhithe and Charlton, said to have been established when King John seduced a miller's wife after a hunting trip and as a concession gave him the fair and a parcel of land in southeast London. The starting point in Rotherhithe was known as Cuckold's Point after a post with horns on it, which were the symbol for cuckoldry. The fair reached its heyday when Charles II came to the throne in 1660 and officially established its date as 18 October to coincide with St Luke's Day. Thousands of people would gather dressed as kings, queens and millers with horns on their heads.

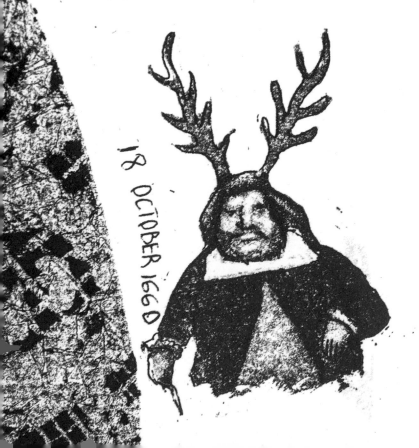

VIRTUOSO CELLIST JACQUELINE DU PRÉ DIES OF MULTIPLE SCLEROSIS.

Du Pré first heard a cello on the radio when she was four and asked her mother for 'one of those'. Her mother started giving her lessons but then enrolled her at the London Violoncello School to study with Alison Dalrymple at the age of five. She was a precociously talented child and won the Guilermina Suggia Award when she was 11. This award allowed her to study at the Guildhall School of Music.

From an early age she began to enter and win competitions with her sister, flautist Hilary du Pré. Her formal debut was at the Wigmore Hall when she was 16. She had a very busy and successful career, performing in many prestigious concerts and recordings alongside many of the renowned musicians of her time.

She started to lose sensitivity in her fingers when she was 26, and her playing noticeably suffered. She was diagnosed with multiple sclerosis two years later, and this coincided with her last public performances. She died at the age of 42, and even though her career was short, she is widely regarded as one of the most gifted cellists of the 20th century.

20 OCTOBER 1708

THE 'TOPPING OUT' (LAYING THE FINAL STONE) OF ST PAUL'S CATHEDRAL TAKES PLACE ON ARCHITECT CHRISTOPHER WREN'S 76TH BIRTHDAY.

The previous St Paul's Cathedral was actually the fourth one to stand on the same spot. It was built between 1087 and 1240, had its spire destroyed by lightning in 1561 and was irreparably damaged by the Great Fire of 1666. Christopher Wren was commissioned to design St Paul's as well as 54 other churches in the City of London. Various designs were submitted before one was agreed to, with the proviso that Wren was permitted to make further changes that he deemed necessary.

The building was covered throughout construction, and legend has it that when Wren's glorious English Baroque masterpiece was revealed, it caused a great deal of commotion as it bore very little resemblance to the approved designs. There is much debate about the date of the completion of the building work, but I love the notion of it falling on Wren's birthday.

FLORENCE NIGHTINGALE AND A STAFF OF 38 WOMEN VOLUNTEER NURSES THAT SHE TRAINED ARE SENT TO THE OTTOMAN EMPIRE DURING THE CRIMEAN WAR.

Nightingale was shocked by the poor conditions in the field hospital and started to tackle the lack of hygiene that was leading to unnecessary infections and deaths. She sent a plea to *The Times* outlining her concerns, and in response Isambard Kingdom Brunel was commissioned to design a prefabricated hospital that could be built in England and then transported to the front line. The result was the Renkioi Hospital, a civilian facility that dramatically improved the mortality rates.

It was through an article in *The Times* that she gained fame and her nickname 'the lady with the lamp', as they wrote about how this ministering angel could be 'observed alone, with a little lamp in her hand, making her solitary rounds'. This epithet was further popularised in *Santa Filomena*, a poem by Longfellow:

'Lo! In that house of misery,
A lady with a lamp I see,
Pass through the
glimmering gloom,
And flit from room to room'.

21 OCTOBER 1854

VEGETARIANS AGAINST THE BOMB

22 OCTOBER 1983

THE CAMPAIGN FOR NUCLEAR DISARMAMENT STAGE A MARCH IN HYDE PARK THAT ATTRACTS OVER A MILLION PROTESTERS.

The CND was formed in 1957 amidst fears of nuclear war after the United Kingdom had become the world's third atomic power. It was very popular from their outset but their support started to wane in the 70s when relations between the superpowers began to thaw.

The UK's decision to adopt cruise missiles in the 80s saw its support surge again and the 1983 march was one of their most successful ever, even though intelligence from within the police had predicted a crowd of 'somewhere between 50,000 to 70,000'. I used this 'Vegetarians against the bomb' image because I loved the way their mushroom cloud actually looked like cauliflower.

PARLIAMENT MEETS AND RECOGNISES THE ACTS OF UNION BETWEEN ENGLAND AND SCOTLAND, WHICH CREATED THE UNITED KINGDOM.

In 1603, James VI of Scotland inherited the English crown from Elizabeth I, his double cousin twice removed, becoming King James I of England. Although they had shared a monarch, it was not until the treaty of 1707 that the union became official.

When the Scottish MPs entered the House of Commons on the morning of the 23rd, they were warmly welcomed by their English counterparts, who stood and applauded. This genial cordiality was short-lived, however, and the Scottish MPs were soon subjected to the cut and thrust of life in the House and the ferocity of the debates.

23 OCTOBER 1707

24 OCTOBER 2003

CONCORDE LANDS IN HEATHROW, COMPLETING ITS LAST COMMERCIAL FLIGHT.

Developed jointly between the UK and French governments, Concorde had its maiden flight 34 years before, on 2 March 1969, and it went into commercial service in April 1974. In its lifetime, the supersonic plane had become an icon, and the three and half hour flying time between London and New York was still attractive enough to warrant the £9,000 fares, even though airfares generally were falling. The planes were getting quite elderly, however, and needed increasing amounts of expensive servicing. The accident in France in 2000 that killed 113 passengers marked the beginning of the end of the era. The final flight carried 100 celebrities and dignitaries and was greeted by a huge weeping crowd of Concorde fans.

THE NATIONAL THEATRE OPENS ON THE SOUTH BANK.

Between 1963 and 1976, the home of the National Theatre was the Old Vic in Waterloo, but a decision was made to build a bespoke building. Architects Denys Lasdun and Peter Softley designed the building in a Brutalist style, using exposed concrete bearing the impression of the wood grain from the moulds into which it was poured. It contains three separate venues: The Olivier, the largest, named after the first creative director, Laurence Olivier, which seats 1,100; the Lyttelton, named after Oliver Lyttelton, the National Theatre's first board chairman, which seats 890; and the Dorfman, named after Lloyd Dorfman, director of the Travelex Group, which seats 400.

The most innovative feature of the Olivier is an ingenious 'drum revolve' (a five-storey revolving stage section) that extends eight metres beneath the stage and is operated by a single staff member. The drum has two rim revolves and two platforms, each of which can carry ten tons, facilitating dramatic and fluid scenery changes. Its

design ensures that the audience's view is not blocked from any seat and that the audience is fully visible to actors from the stage's centre.

To this day, the public remains divided about the aesthetics of the building, but few people doubt that it is a truly wonderful theatre complex.

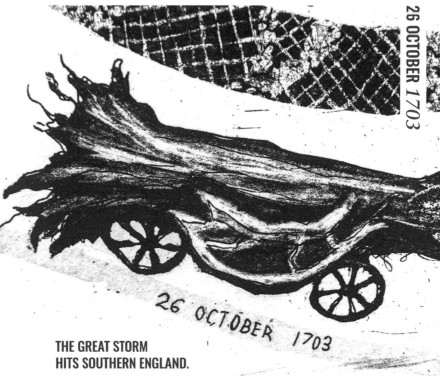

26 OCTOBER 1703

THE GREAT STORM HITS SOUTHERN ENGLAND.

In London 2,000 chimneys collapsed and the
roof was blown off Westminster Abbey. Fearing for her
life, Queen Anne stayed in the cellar of St James' Palace for the
duration of the storm. It coincided with the dramatic increase in
English journalism and was the first natural disaster to be reported.
Printed accounts were widely sold and author Daniel Defoe used
it as inspiration for *The Storm*. Well into the 19th century it was
a frequent theme of sermons, as it was generally accepted that the
storm was retribution by God for 'the crying sins of the nation'.

A SUDDEN DEREGULATION OF THE FINANCIAL MARKETS CREATES THE BIG BANG IN THE CITY OF LONDON.

These changes saw the abolition of fixed commission charges and also charges to the London Stock Exchange, including the cessation of distinction between stockjobbers and stockbrokers and the change from open-outcry to electronic, screen-based trading. This is generally regarded to have cemented London's position as one of the world's most important financial centres but has also been blamed for contributing to the global financial crisis of 2007.

27 OCTOBER 1986

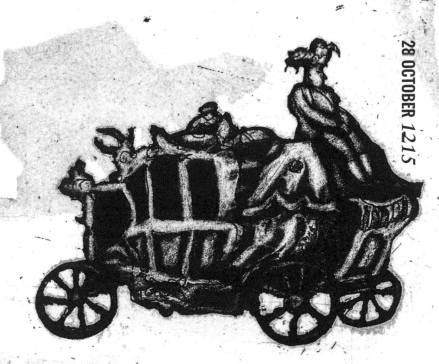

THE FIRST LORD MAYOR'S SHOW, IN WHICH THE MAYOR TRAVELS IN PROCESSION TO THE ROYAL ENCLAVE AT WESTMINSTER.

The office of Lord Mayor was established in 1189, and the charter establishing it required that he must present himself annually to the monarch's representatives. The modern show is a symbolic recreation of that journey and has occurred without fail for the last 477 years, regardless of plague, fire or war. The Lord Mayor has travelled by coach since Gilbert Heathcote broke his leg after being unseated from his horse by a drunken flower girl in 1710. The State Coach still in use today was made in 1757 and has an estimated value of £2 million.

29 OCTOBER
1618

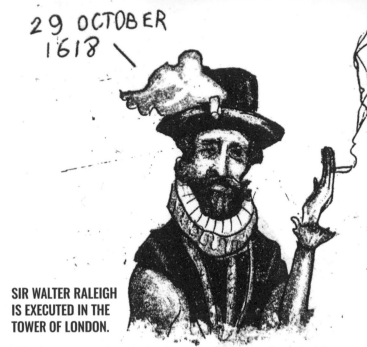

SIR WALTER RALEIGH IS EXECUTED IN THE TOWER OF LONDON.

Raleigh was an explorer and adventurer who was a favourite of Queen Elizabeth I, who knighted him and appointed him captain of the Queen's Guard. He was responsible for establishing two of the first colonies in North America, and although they failed, he was credited with bringing back both potatoes and tobacco to England. When Elizabeth heard that he had secretly married her lady-in-waiting Elizabeth Throckmorton, she was furious and locked them both in the Tower. Upon his release, Raleigh tried to return to her favour by seeking El Dorado, the lost city of gold in South America.

James I disliked Raleigh, and when he was implicated in a plot against the King, he was imprisoned in the Tower for twelve years. When he was released, he tried again to win the favour of his monarch by finding El Dorado but defied the King's express wishes by attacking the Spanish. Upon his return, he was again taken to the Tower, but to appease the Spanish this time was executed.

THE 200 MEN OF THE JARROW CRUSADE MARCH ARRIVE IN LONDON.

The march was organised as a protest against unemployment and poverty suffered in the northeast Tyneside town of Jarrow in the 1930s in the wake of the closure of its main employer, Palmers Shipyards. Two hundred men marched from Jarrow to London over 26 days to deliver a petition to the House of Commons. The petition was received but never debated, and the men went home believing that they had failed. In subsequent years, however, the march has been seen as a defining point of the 1930s; it did much to change attitudes, leading to social reform after World War II. In an aside, Jarrow's earliest claim to fame was as the home of the Venerable Bede, 8th-century saint and author of the *Ecclesiastical History of the English People*.

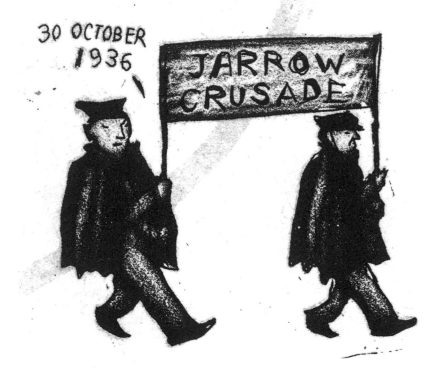

THE POET JOHN KEATS IS BORN IN MOORGATE.

Keats' parents both died by the time he was 14 (his father from falling from a horse and his mother from tuberculosis), and he was sent to live with his grandmother in Edmonton. Keats was left £800 (the equivalent of about £34,000 today) by his grandfather and a share of a legacy from his mother of £8,000 (about £340,000 today) but was apparently never told of either, as he never applied for any of the money. This was particularly unfortunate as money was always a pressing concern for him and living in a series of cold, damp rooms contributed to his poor health.

Keats registered as a medical student at Guy's Hospital and showed such promise that within a month he was accepted as a dresser, assisting surgeons during operations. He spent increasing amounts of time writing, however, and once he had qualified, announced his intentions to be a poet rather than a doctor. He began to show symptoms of tuberculosis, the disease that had taken both his mother and one of his brothers, and moved from Hampstead to the warmer climate of Rome. His condition worsened, and he died there aged 25.

Although the three volumes of his poems published in his lifetime sold only a total of 200 copies, his reputation continued to grow, and by the end of the 19th century he was regarded as one of the great English Romantic Poets.

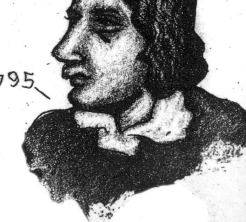

NOVEMBER

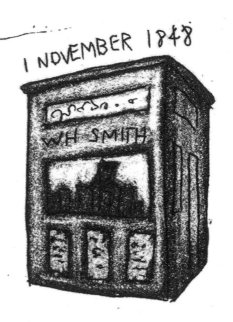

W.H. SMITH OPENS HIS FIRST
RAILWAY NEWS STAND IN EUSTON STATION.

W.H. Smith started his career as a news vendor on Little Grosvenor Street in Mayfair but to take advantage of the railway boom decided to open a series of newsstands in stations. He started with Euston and then other London stations before opening stands in Birmingham, Liverpool and Manchester. These stands flourished and developed into shops, which made W.H. Smith the world's first chain store. In 1966 the chain developed a nine-digit code for uniquely identifying books, called the Standard Book Numbering system. This began to be widely used and was adopted worldwide as the ISBN in 1974.

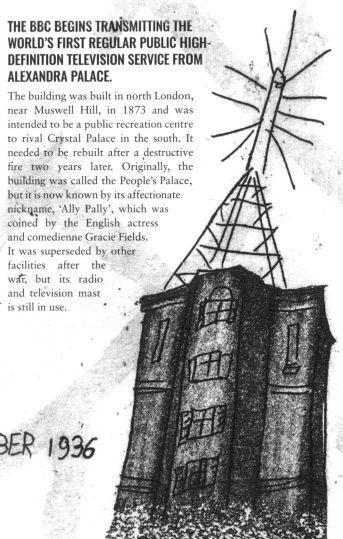

THE BBC BEGINS TRANSMITTING THE WORLD'S FIRST REGULAR PUBLIC HIGH-DEFINITION TELEVISION SERVICE FROM ALEXANDRA PALACE.

The building was built in north London, near Muswell Hill, in 1873 and was intended to be a public recreation centre to rival Crystal Palace in the south. It needed to be rebuilt after a destructive fire two years later. Originally, the building was called the People's Palace, but it is now known by its affectionate nickname, 'Ally Pally', which was coined by the English actress and comedienne Gracie Fields. It was superseded by other facilities after the war, but its radio and television mast is still in use.

VEMBER 1936

JOHN AUSTIN, HIGHWAYMAN AND FOOTPAD,
BECOMES THE LAST MAN TO BE HANGED AT TYBURN.

Austin was found guilty and sentenced to death for murdering labourer John Spicer from Kent. He was brought from Newgate Prison by cart, a journey of 2.5 miles that took three hours. The journey icnluded stops at St Sepulchre Without Newgate church and then two public houses. The convicted man was returned to the cart after having finished his last drink at the second public house and his feet would not touch the ground again, as he was hanged from the cart. This is why we still say someone is 'on the wagon' when he or she has stopped drinking. After that day, executions were moved to just outside Newgate Prison, ending a 600-year tradition.

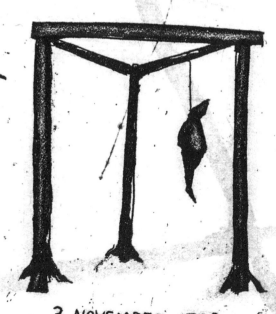

3 NOVEMBER 1783

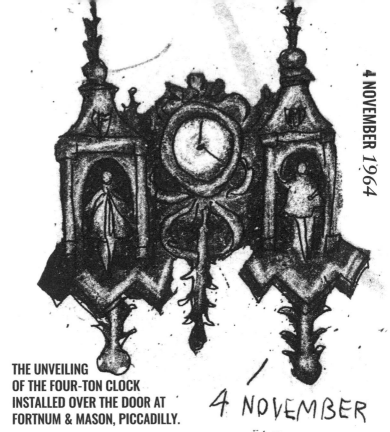

THE UNVEILING
OF THE FOUR-TON CLOCK
INSTALLED OVER THE DOOR AT
FORTNUM & MASON, PICCADILLY.

4 NOVEMBER
1964

The clock was commissioned by the Canadian owner W. Garfield Weston to commemorate the founders, and every hour, two 4 foot models of William Fortnum and Hugh Mason emerge to bow to one other.

Fortnum was originally a footman in the royal household of Queen Anne. She insisted that only new candles be used daily, which allowed him to sell the surplus wax and amass enough money to open his store in 1707 with his landlord, Mason. They invented the Scotch egg in 1738 and were the first people in Britain to sell Heinz Baked Beans, having bought the entire shipment of tins brought over from the USA by their creator in 1886.

THE GUNPOWDER PLOT TO ASSASSINATE KING JAMES I AND DESTROY THE HOUSE OF LORDS IS THWARTED.

The plot was initiated by a group of 12 provincial English Catholics led by Robert Catesby in response to a growing sense of dissatisfaction with how they were being treated by the new monarch, James I. The plan was to plant barrels of gunpowder in the cellar of the House of Lords and ignite them during the State Opening of England's Parliament on 5 November at which the King would be present. The responsibility for guarding and then igniting the gunpowder was given to Guy Fawkes, who had experience of explosives from his ten years' fighting in the Spanish Netherlands during the Dutch Revolt.

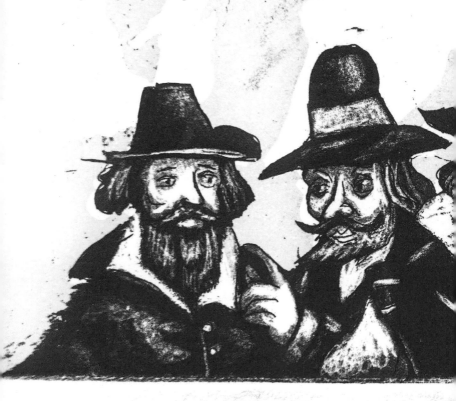

The plot was revealed to the authorities in an anonymous letter sent to William Parker, 4th Baron Monteagle, on 26 October 1605, and when they searched the cellar of the House of Lords the night before, they found Guy Fawkes guarding 36 barrels of gunpowder. The other conspirators fled from London and got as far as Worcester, and in the ensuing battle, Catesby was killed. Fawkes and seven others were convicted and sentenced to be hung, drawn and quartered. The uncovering of the plot has been celebrated ever since with fireworks and bonfires on which an effigy of Fawkes is burnt.

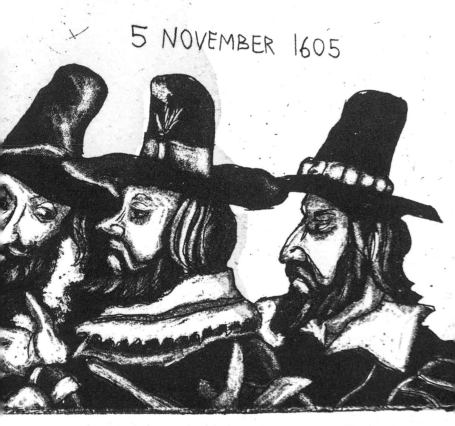

5 NOVEMBER 1605

THE CORONATION OF KING HENRY VI AT WESTMINSTER ABBEY, A MONTH BEFORE HIS EIGHTH BIRTHDAY.

Henry succeeded to the English throne after the death of his father Henry V when he was only nine months old, the youngest person ever to become the monarch. He also inherited the French crown and a long-running conflict with France known as the Hundred Years' War. Charles VII of France contested the crown of France, and Henry married his niece Margaret of Anjou in a failed attempt to make peace. Losing all of France except Calais led to a mental breakdown, with Richard of York taking over as his regent. Civil war, known as the War of the Roses, broke out the following year, and he ultimately lost the crown to Edward IV and died in the Tower of London.

Henry is now remembered mostly as the protagonist of a trilogy of plays about his life by Shakespeare and for his incredible contribution to education, as he founded Eton College, King's College, Cambridge and All Souls College, Cambridge.

6 NOVEMBER 1429

THE FIELD LANE SCHOOL, SAFFRON HILL, OPENS FOR 45 'RAGGED' BOYS AND GIRLS.

The school was founded by Andrew Provan, the newly appointed London City Missionary, in response to what he saw as a deplorable situation in one of the most impoverished areas of the city. The area was a notorious slum and rookery, comprised of narrow and muddy streets with crumbling buildings where, in some cases, there would be three or four families sharing a single attic room. The neighbourhood had such an impact on Charles Dickens that he depicted it as the location of Fagin's den of thieves in *Oliver Twist*. He wrote a letter to the *Daily Times* praising the school, stating that 'children who were too ragged, wretched, filthy and forlorn to enter any other place: who could gain admission into no charity school; and would be driven from any church door are invited to come in here.' The Ragged School Movement had a huge impact on society in the Victorian era.

8 NOVEMBER 1974

LORD LUCAN, THE BRITISH PEER SUSPECTED OF MURDER, DISAPPEARS.

Richard John Bingham, 7th Earl of Lucan, was born into an Anglo-Irish aristocratic family in Marylebone. He served in the army and was a merchant banker before deciding to take up gambling full time. Although not an actor, the suave man about town was once considered for the role of James Bond.

The end of his marriage and the loss of a bitter custody battle for his children had a dramatic effect on his life and personal finances. On 7 November, his children's nanny was found murdered in the basement of their Belgravia home, and his wife, who had also been attacked, identified Lucan as her assailant. Lucan made a final phone call to his mother and then drove a borrowed Ford Corsair to drive to a friend's house in Uckfield, East Sussex, where he was last seen when he left a few hours later. The car was later found in Newhaven complete with incriminating traces of blood and a lead pipe similar to the murder weapon; however, Lord Lucan has never been seen since.

BRIGADIER-GENERAL SIR WILLIAM HORWOOD, THE COMMISSIONER OF THE METROPOLITAN POLICE, RECEIVES A PACKAGE OF POISONED WALNUT WHIPS.

Believing them to have been a present from his daughter Beryl, Sir William tucked into the Walnut Whips after lunch. The poison kicked in very rapidly, and in agony, he got his magnifying glass and investigated the packaging and found that it had been tampered with. The chocolates had been laced with weed killer, and on the same day other members of the Met had been targeted with similarly poisoned chocolate éclairs.

When the culprit, Walter Tatum of Balham, was tracked down and convicted of attempted murder, he claimed that he had received instructions for the attack from 'voices from the hedge'. The Walnut Whip brand has never suffered, with one eaten in the UK every two seconds.

9 NOVEMBER 1922

SCOTLAND YARD

ARTIST WILLIAM HOGARTH IS BORN IN BARTHOLOMEW CLOSE IN THE CITY OF LONDON.

Hogarth was the son of a poor Latin schoolmaster and at a young age became an apprentice to an engraver. He was a remarkably quick learner and before long was an engraver in his own right, designing coats of arms and plates for booksellers, and creating and publishing his own works. A big commission went sour when the client Joshua Morris decided that he was 'an engraver not a painter'. Morris would not accept the works, and Hogarth successfully sued him.

Hogarth developed a style that combined narrative art with biting social commentary, creating some of the most important satirical and moralising pieces of the time, including *The Rake's Progress, The Harlot's Progress, Marriage à la Mode* and of course *Beer Street and Gin Lane*. He had no children of his own but fostered and adopted many and was the founding governor of the Foundling Hospital. Sergeant painter to the King and a hugely important artist, he was my personal nomination for the visual artist to grace the next £20 note.

10 NOVEMBER 1697

11 NOVEMBER 1920

THE UNVEILING OF THE EDWIN LUTYENS-DESIGNED CENOTAPH ON WHITEHALL.

Made of Portland stone, Lutyen's cenotaph replaced a temporary wood and plaster version also designed by Lutyens at the same place. It is the location for the annual National Service of Remembrance each Remembrance Sunday, the closest Sunday to Armistice Day on 11 November. On this day in 1920, King George V laid a wreath to the Unknown Warrior at the base of the Cenotaph, which was draped with Union flags.

IN RESPONSE TO THE DESIRES OF QUEEN MARY I, PARLIAMENT RE-ESTABLISHES CATHOLICISM AS THE RELIGION OF THE CHURCH OF ENGLAND.

Protestantism had been the country's religion since Mary's mother, Catherine of Aragon, had been divorced by her father, Henry VIII. Edward VI had carried on his father's religion, but when he died, aged 16, Mary saw her popularity as an opportunity to return to Catholicism. She died in 1558, and her successor, Elizabeth I, returned the country to Protestantism. Her executions of Protestants led to the posthumous sobriquet 'Bloody Mary'.

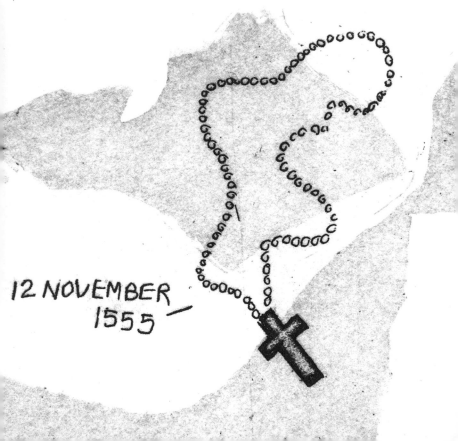

12 NOVEMBER 1555

BLOODY SUNDAY, WHEN A MARCH AGAINST UNEMPLOYMENT AND COERCION IN IRELAND CULMINATES IN A RIOT IN TRAFALGAR SQUARE.

A long depression was creating rural migration as thousands were seeking work in the cities, adding to already growing unemployment and poverty. 30,000 spectators encircled Trafalgar Square, looking on as 10,000 protestors, organised by the Social Democratic Federation, who had marched from the East End of London were met by 10,000 members of the army and the Metropolitan Police, many on horseback.

Amongst those marching were social activists Annie Besant, William Morris and George Bernard Shaw. The worst of the injuries were to the police, as although they were armed with rifles and bayonets and the cavalry with swords, they were strictly ordered to not open fire or draw their swords.

13 NOVEMBER 1887

14 NOVEMBER 1896

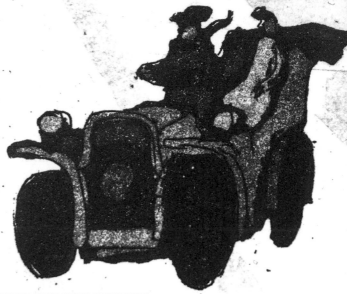

THE FIRST LONDON TO BRIGHTON VETERAN CAR RUN TAKES PLACE.

The event was called The Emancipation Run and was a celebration of the Locomotives on Highways Act that allowed cars to travel at speeds up to 14 mph rather than the previous speed limits of 4 mph in the country and 2 mph in towns and cities. The event was run on a wet Saturday, with 17 of the 33 entrants reaching Brighton. It was not held again until 1927, but since then, except for a break for World War II, it has run most years. Cars must have been built before 1905 to qualify, and the average speed still must not exceed 20 mph. Many celebrities have taken part over the years, and in 1968 one of the cars was driven by Prince Rainier and Princess Grace of Monaco.

THOMAS CROMWELL MARRIES ELIZABETH WYCKES.

Elizabeth was the widow of Thomas Williams, a Yeoman of the Guard, and the daughter of Henry Wykes, who had served as a Gentleman Usher to King Henry VII. Elizabeth and two of their three children tragically died during the epidemic of sweating sickness that swept through the country in 1528. Although remarkably lowly born, Cromwell became a lawyer and statesman and rose to great heights as the chief minister to King Henry VIII between 1532 and 1540. He was one of the most powerful advocates of English Reformation and was responsible for engineering Henry's annulment from Catherine of Aragon. Permission for this was not forthcoming from the Pope, so Cromwell had Parliament form the Church of England, of which the King was the head. Henry annulled his own marriage to allow him to marry Anne Boleyn. Cromwell's fall from power happened after he arranged the marriage to a German princess, Anne of Cleves. Henry found her deeply unattractive and had the marriage annulled six months later. Cromwell was blamed for this and was executed on Tower Hill for heresy and treason on 28 July 1540.

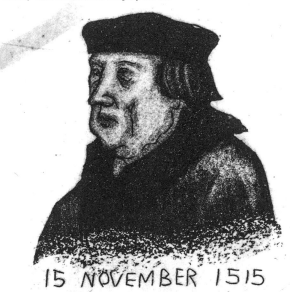

15 NOVEMBER 1515

WILLIAM CAXTON, THE FIRST PERSON TO INTRODUCE PRINTING TO ENGLAND, PUBLISHES *DICTES OR SAYENGIS OF THE PHILOSOPHRES* (SAYINGS OF THE PHILOSOPHERS).

Caxton lived for a time in Bruges, where he set up a press and printed *Recuyell of the Historyes of Troye*, the first book in the English language. He returned to London and established a press in Westminster in 1476. The first book Caxton produced was Chaucer's *The Canterbury Tales*, but the date of this is uncertain. Other notable works were Sir Thomas Mallory's *Le Morte d'Arthur* and the first English translation of Aesop's Fables. English was changing rapidly during his lifetime, and Caxton is credited with standardising the English language through printing.

16 NOVEMBER 1477.

UPON THE DEATH OF MARY I, ELIZABETH I BECOMES QUEEN OF ENGLAND.

Elizabeth was the daughter of Henry VIII and Anne Boleyn, who was executed when she was two and a half, at which point she ruled illegitimately. When her father died, her half-brother became King Edward VI, but his reign was short, as he died aged only 16. In defiance of the statute law to the contrary, he ignored the claims of his sisters Mary and Elizabeth and bequeathed the crown to his cousin Lady Jane Grey. His will was set aside, however, and Mary became Queen, deposing (and then beheading) Lady Jane Grey.

17 NOVEMBER 1558

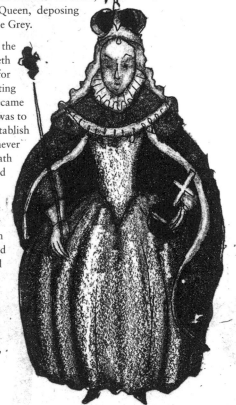

Under Mary, who had returned the country to Catholicism, Elizabeth was imprisoned in the tower for a year for possibly supporting Protestant rebels. When she became queen, one of her first actions was to restore Protestantism and to establish the Church of England. She never married and ruled until her death in 1603, by which time she had become a legend.

She had black teeth from the excessive amounts of sugar she consumed and was known to have commissioned life-sized gingerbread sculptures of royal guests of honour. In addition to a burgeoning empire and the defeat of all enemies, including the Spanish Armada, the Elizabethan era gave us the theatre, Shakespeare, Spenser, Marlowe and the potato.

THE KING'S CROSS FIRE STARTS ON AN ESCALATOR, KILLING 31 PEOPLE AND INJURING 100 MORE.

The fire started from a match being dropped on the then largely wooden Piccadilly Line escalators. The fire was initially deemed to be of a manageable size, but a previously unknown phenomenon called the 'trench effect' saw the flames race up the escalator and then burst into the ticket hall, where most of the victims were located.

Tube trains had designated smoking carriages until they were banned in 1984, and a further ban in 1985 stopped people smoking on the platforms. The platform ban was the less rigorously enforced of the bans, and people would often light up there or on the escalators and in the ticket hall on their way out of the station. This fire completely changed everyone's attitude to smoking on public transport, with smoking bans being rigorously enforced in every part of the underground network from that point. Smoking bans on buses followed, where people had previously been allowed to smoke at the back of the upper deck.

18 NOVEMBER 1987

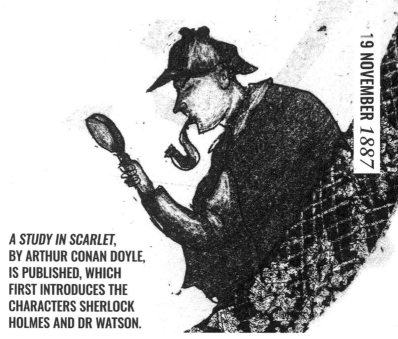

A STUDY IN SCARLET, BY ARTHUR CONAN DOYLE, IS PUBLISHED, WHICH FIRST INTRODUCES THE CHARACTERS SHERLOCK HOLMES AND DR WATSON.

The book was written in three weeks by 27-year-old Arthur Conan Doyle while he was a General Practitioner in Portsmouth. In the original canon it was one of only four full-length novels as the rest were short stories. The book received little attention upon publication, and of the short print run, there are only 11 copies still in existence. These are extremely valuable now, however.

Holmes was possibly based on Francis 'Tanky' Smith, a policeman and master of disguise who went on to become Leicester's first private detective. There is also speculation that he was based on Joseph Bell, a surgeon at the Royal Infirmary of Edinburgh for whom Doyle had worked as a clerk, although Bell himself discounted this, saying, 'he is based on you Doyle, and you know it'. I've depicted Holmes with the detective's magnifying glass that Doyle is credited with inventing.

THE START OF THE BROWN DOG ANTI-VIVISECTION RIOTS, CENTRED ON A BRONZE STATUE OF A DOG IN BATTERSEA.

The controversy was triggered by allegations that in February 1903, William Bayliss of the Department of Physiology at University College London performed an illegal dissection before an audience of 60 medical students on a brown terrier dog, which Swedish activists protested was conscious and struggling. The procedure was condemned as cruel and unlawful by the National Anti-Vivisection Society, which commissioned a bronze statue of the dog as a memorial, unveiled in Battersea in 1906.

Medical students angered by the provocative plaque – 'Men and women of England, how long shall these Things be?' – frequently vandalised the statue until it received a 24-hour police guard. When medical students marched through London carrying effigies of the brown dog on sticks, they clashed with anti-vivisectionists, suffragettes, trade unionists and the police. The riots continued intermittently until they reached a crescendo on 10 December, with proper pitched battles being waged. The statue was then considered too controversial and was removed and destroyed late one night in 1910.

20 NOVEMBER
1907

21 NOVEMBER 1846

SWEENEY TODD, THE DEMON BARBER OF FLEET STREET, IS INTRODUCED AS THE PROTAGONIST IN A VICTORIAN PENNY DREADFUL ENTITLED *THE STRING OF PEARLS*.

Todd dispatches his victims by pulling a lever as they sit in his barber chair, causing them to fall into the basement. The victims are then polished off by Todd with a straight razor and robbed of valuables before being passed to his neighbour Mrs Lovett to be ground up and baked into pies to be sold at her shop.

Sweeney Todd was successfully turned into a Tony Award winning Broadway musical by Stephen Sondheim and Hugh Wheeler. Although the character is a product of pure fiction and urban legend, belief that he was based on a real person persists to this day. Dickens wrote of dubious pie fillings in *The Pickwick Papers*, as the servant Sam Weller talks of a pieman who used cats to make his pies. The advice he gives is that you should only ever eat a pie 'when you know the lady 'as made it, and is quite sure it ain't kitten'.

22 NOVEMBER 1990

MARGARET THATCHER RESIGNS AS PRIME MINISTER WHEN HER CABINET REFUSES TO BACK HER IN A SECOND ROUND OF LEADERSHIP ELECTIONS.

The former Secretary of State for the environment, Michael Heseltine, threw down the gauntlet after a string of disputes over Britain's involvement in the European Union. Thatcher won the subsequent leadership contest but without the necessary majority. The Prime Minister said pressure from colleagues had forced her to conclude that party unity and the prospect of victory in the next general election would be better served if she stepped down. In the next round of votes, John Major, the Chancellor of the Exchequer, succeeded her five days later. My drawing is of the moment when Thatcher and her husband Dennis were driven away from Downing Street for the last time.

HENRY V TRIUMPHANTLY RETURNS TO LONDON AFTER VICTORY OVER THE FRENCH AT AGINCOURT.

The famous battle took place on St Crispin's Day, and estimates say the English were outnumbered six to one. Huge crowds of rejoicing Londoners lined Henry's route from London Bridge to Westminster, and lavish celebrations were created by the Corporation of London along the way. Giant figures bearing the royal coat of arms flanked the bridge, with trumpets and horns blaring in multiple harmony from the ramparts. The entire bridge was decorated with wooden pillars painted to resemble marble and huge murals on fabric hung on the fronts of the houses. At the centre, where there was a small drawbridge, there were large figures of an antelope and a lion made from wood covered in painted to resemble stone. A statue of St George wearing a suit of armour was just beyond, and the first of two choirs of boys sang from above. There was a second choir by Cornhill, and after that, on Cheapside, 12 old men dressed as the apostles sang in perfect harmony, and in an amazing feat of craftsmanship buildings covered in fabric perfectly resembled a wall of marble and ivory. At that point, a flock of small birds was released that swarmed around the King, some landing on his shoulders. The day was capped off by an extraordinary feast at Westminster. This was all pretty amazing preparation and pageantry when you consider that victory was less than a month before, on 25 October.

23 NOVEMBER 1415

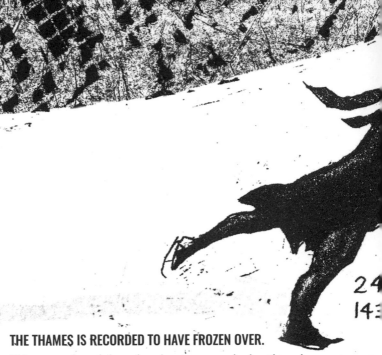

24
14=

THE THAMES IS RECORDED TO HAVE FROZEN OVER.

This occurred much less often than is commonly thought and was due to a combination of properly cold temperatures and the poor flow of the river created by the multiple supports of the medieval London Bridge. Between the year the bridge was built in 1400 and torn down in 1835, the river froze over 24 times. These occasions would inspire impromptu frost fairs, where market stalls would be erected and all manner of games and activities would take place. They were said to be like proper bacchanalian festivals, with the last fair in 1814 lasting four days. An elephant was walked onto the river at Blackfriars, and the printer George Davis set up a printing press where he published and printed a 124-page book called *Frostiana: a History of the Thames* in a frozen state.

AGATHA CHRISTIE'S MYSTERY, *THE MOUSETRAP*, STARTS THE WORLD'S LONGEST THEATRICAL RUN AT THE AMBASSADORS THEATRE IN COVENT GARDEN.

The play ran until Saturday 23 March 1974, when it immediately transferred to the larger St Martins Theatre next door, reopening on Monday 25 March 1974, thus continuing its 'initial run' status. Countless actors have appeared in *The Mousetrap*, including my friend David Semark, in a run that has now exceeded 60 years and 25,000 performances.

)VEMBER
17I5

25 NOVEMBER
1952

THE BRINK'S-MAT ROBBERY, WHERE £26 MILLION IN GOLD, DIAMONDS AND CASH IS STOLEN FROM A WAREHOUSE AT LONDON'S HEATHROW AIRPORT.

Six robbers broke into the warehouse thinking that they would find £3 million in cash but were surprised by the huge volume of gold bullion and diamonds they found instead. Although various arrests have been made over the years, the loot has never been found. A huge amount of the gold bullion was suspected to have been melted down in the garden of a private residence in Bath. The police were called to investigate this house a few days after the heist but curiously never entered the property or properly followed up the lead. Rumours persist about a curse linked to the burglary, which has seen the early demise of many of the protagonists. The most recent of these was the man who allegedly melted down the gold, John 'Goldfinger' Palmer, who was shot dead in June 2015.

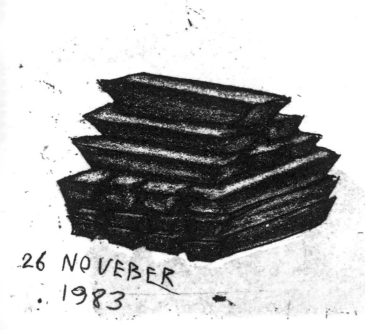

26 NOVEBER
1983

MY GRANDPARENTS FRED BARRATT AND ANNIE GODDARD MEET IN LONDON.

27 NOVEMBER 1918

My grandfather emigrated to Canada when he was very young but was then sent back to Britain as a Canadian soldier in World War I. He was part of a battalion called The Bantams in which there was a height limit of 5'6". The photo I saw of him with his fellow soldiers beside their normal height commanding officer looked like a primary school class photo. My father overheard me once saying that my grandparents were both 4'11", and he corrected me, saying, 'your grandfather wasn't 4'11".' I was disappointed, as I've always loved that fact about them. 'No,' he continued, 'your grandfather was actually only 4'10"!' When my wife Amanda heard this, she said, 'Imagine being a 4'11" woman and still not finding a man taller than you.'

POET, ARTIST AND PRINTMAKER
WILLIAM BLAKE IS BORN IN SOHO.

As a young man, Blake was apprenticed to the engraver James Basire and became a professional engraver at the end of this term, aged 21. Tastes had generally started to move towards the technique of mezzotint rather than the line engraving he had learned, and this made it difficult for him to attain commissions. He created a new technique called 'relief etching', where images were painted onto the surface of a copper plate with varnish and then etched to achieve a raised image area that could be rolled up with ink like a wood engraving. He used this technique to publish illuminated texts and to illustrate his own poems and writings. Blake was a deeply religious man, and his work often had philosophical or mystical undercurrents. He was considered mad by many of his contemporaries but has since been regarded as a 'glorious luminary' and one of the pivotal writers and artists of the Romantic era.

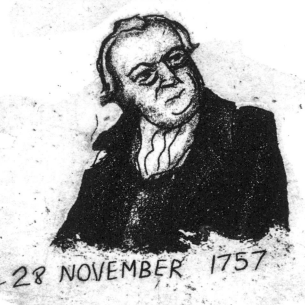

28 NOVEMBER 1757

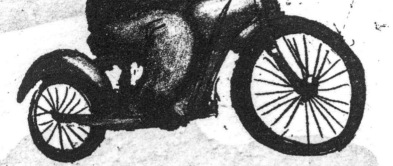

29 NOVEMBER 1897

THE FIRST EVER MOTORCYCLE RACE IS HELD AROUND A TRACK AT SHEEN HOUSE IN RICHMOND.

The course was a mile long, and the winner was Charles Jarrot on a Fournier, with a time of two minutes and eight seconds. Motorcycles were a relatively new invention, as the first prototypes not to be powered by steam were produced in 1884 and the first mass-produced ones made by Hildebrand & Wolfmüller in 1894. In England, Triumph was established in 1898 and Royal Enfield in 1899. The first Harley Davidson was made in 1903.

THE CRYSTAL PALACE IN SYDENHAM BURNS DOWN.

Originally built in Hyde Park, The Crystal Palace was the centrepiece of The Great Exhibition of 1851, more properly known as The Great Exhibition of Works of Industry of All Nations. This was the first of the World's Fair exhibitions of culture and industry that became popular in the 19th century. A committee that included William Cubitt and Isambard Kingdom Brunel had been formed in 1850 to plan the exhibition, and architects were invited to submit proposals for this temporary yet vital building at its heart.

No one came up with a feasible plan that could be built on time and on budget, and time was rapidly running out. Renowned garden designer Joseph Paxton became interested at this point. He was the head gardener for the 6th Duke of Devonshire at Chatsworth House, and his pioneering public gardens at Birkenhead Park had greatly influenced the design of New York's Central Park. He came up with the simple idea that combined a cast-iron structure with ready-made glass panels very much like an enormous greenhouse. This gave a huge exhibition space that had no internal walls to inhibit the displays and needed no artificial lighting during the day.

The Great Exhibition was such a success that it was decided to move the building to Sydenham Hill, where it could become a permanent exhibition space. It cost £150,000 to build but £1,300,000 to move, and as the venue steadily declined over the years, the company never repaid that debt. In the 1920s it was taken over by the state and brought back to something like its original glory. On the fateful night, a small explosion in the women's cloakroom started a small fire that within hours had burned the building to the ground. Standing amongst the onlookers watching the fire, Winston Churchill said it was 'the end of an era'.

30

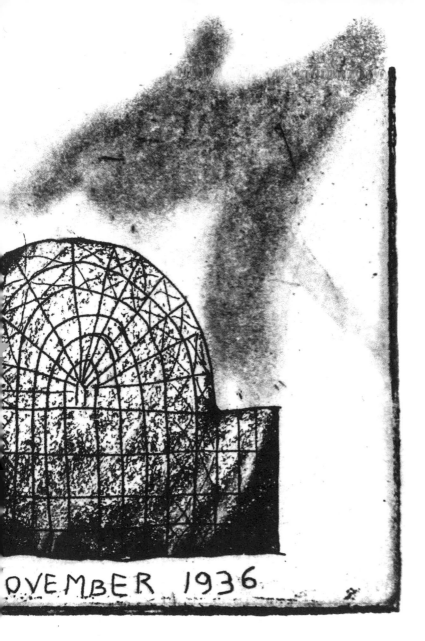

OVEMBER 1936

DECEMBER

I DECEMBER 1967

Pipaluk was the first male polar bear born in captivity in Britain and became a major celebrity at London Zoo. His name came from an Inuit term meaning 'sweet little thing' and is actually one of the most popular girl's names in Greenland. Pipaluk was moved from London to Poland when the Mappin Terraces were closed, and he died in 1990. The Mappin Terraces, now called The Outback, is home to emus, wallabies and red kangaroos.

2 DECEMBER 2014

PROFESSOR STEPHEN HAWKING WARNS OF THE DANGERS ARTIFICIAL INTELLIGENCE (AI) COULD POSE TO MANKIND.

This is the most recent detail in my map of days and came about as I was searching for something to reference on 2 December 2014. I was listening to the news, and Stephen Hawking was in London responding to a question about a revamp of the technology he uses to communicate, which involves a basic form of AI. He said that he felt that the development of full artificial intelligence could spell the end of the human race, as it could supersede humans, who evolve in a slow biological manner. There is something very surreal about hearing these warnings delivered in his vaguely robotic voice.

AN INFLATABLE PIG USED FOR A COVER SHOOT FOR PINK FLOYD'S ALBUM *ANIMALS* BREAKS FREE FROM ITS MOORINGS ON BATTERSEA POWER STATION.

3 DECEMBER 1976

Artist Lucy Sparrow, co-founder of the 1970s art agency Hipgnosis, along with Pink Floyd's Roger Waters, came up with the concept of a 40-ft inflatable pig floating over Britain's iconic Battersea Power Station. Before they completed the photo, however, the cable snapped, and the pig floated away directly into the path of planes landing at Heathrow. All flights were grounded, and Sparrow was arrested. The pig eluded police helicopters and the Royal Air Force until it eventually fell to the ground miles way in a farm in Kent, where it was said to be terrifying the farmer's cows.

The final cover used a photo taken on the morning before the giant balloon was in situ, and the pig was pasted on afterwards. It remains both one of the most iconic album covers of all time as well as one of the most successful accidental publicity stunts.

THE FIRST ENORMOUS CHRISTMAS TREE IS GIVEN BY THE CITY OF OSLO AS A TOKEN OF NORWEGIAN GRATITUDE TO THE PEOPLE OF LONDON FOR THEIR ASSISTANCE DURING THE YEARS 1940–45.

The tree, a 50-60-year-old Norwegian spruce approximately 20 m high, has been an annual feature of Trafalgar Square ever since 1947, attracting huge crowds and seemingly constant Carol singers. It is lit with 500 low wattage white lights and stays up until the Twelfth Night of Christmas, when it is taken down and recycled into mulch.

4 DECEMBER 1947

5 DECEMBER 1766

JAMES CHRISTIE CONDUCTS
HIS FIRST AUCTION OF ART AND ANTIQUES.

The image I have used is of a George III silver cow creamer from their first catalogue. There have been newspaper advertisements of sales dating back to 1759, but the one in 1766 is the first one that Christie's history acknowledges. Christie's soon established a reputation as a leading auction house and took advantage of London's newfound status as the major centre of the international art trade after the French Revolution.

MARTIN LUTHER KING PREACHES TO A CONGREGATION IN ST PAUL'S CATHEDRAL.

King was en route to Oslo to collect the Nobel Peace Prize for his leadership of the civil rights movement when he broke his trip to preach to a 3,000-strong congregation. The Evensong Address that he gave, entitled 'The Three Dimensions of a Complete Life', was repeated every year until his assassination in 1968 and underpinned his theological career.

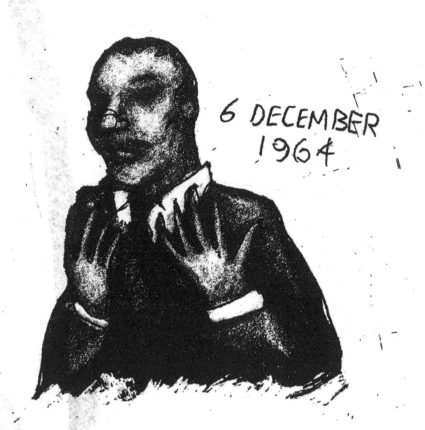

6 DECEMBER
1964

GRAYSON PERRY WINS THE TURNER PRIZE.

Perry beat the heavily favoured Chapman Brothers to the coveted award and its prize money of £20,000 with a collection of decorated vases that were both thought-provoking and extremely beautiful. He accepted the prize in the guise of his alter ego, Claire, wearing high-heeled shoes and a stunning printed dress designed by students studying fashion at Central Saint Martins. In his acceptance speech he said that he thought it was about time that a transvestite potter from Essex won the Turner Prize.

Perry had been wearing women's clothes since his early teens, and the discovery of this put further strain on his already troubled relationship with his mother and stepfather. Encouraged by one of his teachers, he went to art school at Portsmouth to study ceramics. When he left, he was living a hand-to-mouth existence in a series of flats that he shared with milliner Stephen Jones and singer Boy George. They would go out to Blitz, a New Romantic club in Covent Garden, and have competitions to see who could wear the most outrageous costumes.

An articulate and highly intelligent artist, Grayson Perry has gone from strength to strength since the Turner Prize win, with work extending into printmaking, textiles, tapestries and even architecture with his creation of Julie's House, a fantastical narrative building that he designed in Essex.

MARGARET HUGHES BECOMES THE FIRST WOMAN TO PERFORM ON AN ENGLISH STAGE WHEN SHE PLAYS DESDEMONA AT THE VERE STREET THEATRE IN LINCOLN'S INN FIELDS.

After the incredible vibrancy of the theatre during the Elizabethan period, it was banned completely by the Puritans in 1642. When Charles Stuart was restored to the throne, he brought back the theatre, and the Restoration period became famous for its bawdy comedies. All the female roles had been played by boys or men in Shakespeare's day, and even in 1660 it was seen as remarkably audacious to see a woman on stage. Margaret Hughes became a very famous on-stage presence and was mentioned many times in Samuel Pepys' diary.

8 DECEMBER 1660

A RING-TAILED LEMUR IS FOUND IN THE MIDDLE OF TOOTING COMMON.

The lemur was freezing and suffering from hypothermia when he was rushed to the Blue Cross Animal Hospital in Victoria. Staff named him 'King Julien' after the character in the animated film *Madagascar*. He was initially too weak to eat, but staff nursed him back to health by using syringes to drip honey into his mouth until he made a full recovery. It remains a mystery how this native primate from an island off the east coast of Africa was found in Tooting.

9 DECEMBER 2011

MUSICIAN FRANK ZAPPA IS PUSHED FROM THE STAGE BY A DISGRUNTLED FAN AT THE RAINBOW THEATRE.

The band was playing a slightly ironic cover of *I Want to Hold Your Hand* as an encore when disgruntled Beatles fan Trevor Howell jumped onto the stage and pushed the singer into the concrete orchestra pit. The band at first thought that Zappa had been killed. He had such severe fractures to his head, back and legs that he ended up in a wheelchair for six months and also suffered a crushed larynx that resulted in his voice dropping half an octave when he returned to singing. Zappa was not a stranger to disaster, as five days before this occurred he had been performing at a casino in Montreux when a fan let off a flare, which burned the venue to the ground. This incident was immortalised by Deep Purple in their song *Smoke on the Water*.

10 DECEMBER 1971

KING EDWARD VIII ABDICATES THE THRONE
TO MARRY WALLIS SIMPSON.

Edward had been a notorious lothario before meeting and falling in love with American socialite Simpson. She was divorced once and was in the process of divorcing her second husband when Edward announced his intention to marry her. Parliament and the Commonwealth were dramatically opposed to their marriage, as the King is the nominal head of the Church of England, which at the time did not allow remarriage after a divorce. He decided that the love of Wallis Simpson meant more to him than the crown, so he addressed the nation to abdicate after having been King for only 11 months. He married Simpson and stayed married to her until his death 35 years later. Edward remains the only monarch to renounce the throne since Anglo-Saxon times. The crown passed to his brother Albert who took the regnal name George VI.

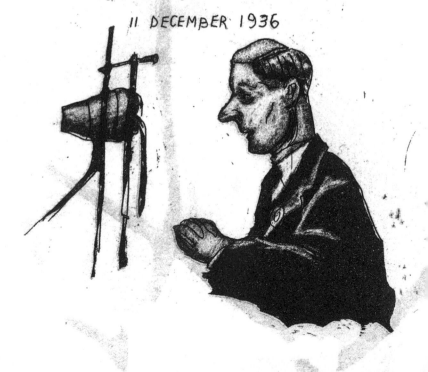

11 DECEMBER 1936

12 DECEMBER 1896

INVENTOR GUGLIELMO MARCONI DEMONSTRATES HIS FIRST RADIO TRANSMITTER.

The 22-year-old Italian had come to England to seek funding for his invention and joined William Preece, chief engineer to the General Post Office, at a public lecture on telegraphy at Toynbee Hall. Preece operated the transmitter, and whenever he created an electric spark, a bell rang on a box Marconi took to any part of the lecture room. There was no visible connection between the two, and the demonstration caused a sensation and made Marconi a celebrity. On the same day in 1901, he became the first person to send a signal across the Atlantic Ocean. His claim has since been challenged to have been impossible under the circumstances. Further controversy hounded him after the *Titanic* disaster, as the outdated Marconi radio system was said to have been partly responsible for the delays in rescue boats reaching the survivors.

CHRISTIE'S SELLS CHARLIE CHAPLIN'S ICONIC HAT AND CANE FOR $154,200 AT ITS LONDON AUCTION HOUSE.

Chaplin wore the hat and cane as trademark features of his Little Tramp persona in films such as *Gold Rush*, *City Lights* and *Modern Times*. They were bought by Jorten Strecker, a Danish entrepreneur, who planned to display them in his cinema and restaurant complex in Copenhagen. Chaplin's oversized, shabby boots were sold to an anonymous telephone bidder for $72,000.

13 DECEMBER 1987

14 DECEMBER 1901

THE FIRST TABLE TENNIS TOURNAMENT
IS HELD AT THE LONDON ROYAL AQUARIUM.

The game, called 'Whiff Waff' in Victorian times, originated as an after-dinner parlour game in which books were stood up along the middle of a table and further books were used as paddles to hit a golf ball back and forth. Although the game was originally patented in 1901 by J. Jacques of London under the name 'Ping Pong', table tennis has now replaced that name internationally except for in North America.

THE PICCADILLY LINE ON THE LONDON UNDERGROUND OPENS BETWEEN FINSBURY PARK AND HAMMERSMITH.

15 DECEMBER 190

The line was extended in the 1930s to the northeast at Cockfosters and west to Hatton Cross in a time when a forward-looking government decided to spend their way out of a dramatic recession. The line is one of the deepest in London, although of its 53 stations, only 25 are below ground. The extension out west to Heathrow Airport was not added until 1977.

OLIVER CROMWELL BECOMES 1ST LORD PROTECTOR OF THE COMMONWEALTH OF ENGLAND, SCOTLAND AND IRELAND.

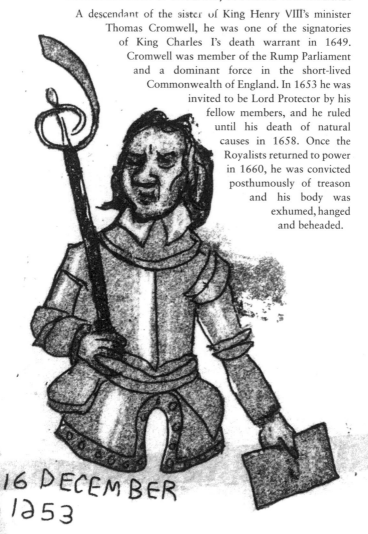

A descendant of the sister of King Henry VIII's minister Thomas Cromwell, he was one of the signatories of King Charles I's death warrant in 1649. Cromwell was member of the Rump Parliament and a dominant force in the short-lived Commonwealth of England. In 1653 he was invited to be Lord Protector by his fellow members, and he ruled until his death of natural causes in 1658. Once the Royalists returned to power in 1660, he was convicted posthumously of treason and his body was exhumed, hanged and beheaded.

16 DECEMBER 1253

THE FIRST BOWLER HAT IS CREATED FOR EDWARD COKE, THE YOUNGER BROTHER OF THE 2ND EARL OF LEICESTER.

The hat was designed by London hatmakers Thomas and William Bowlers for hatters Lock & Co of St James's. The brief was to create a piece of headgear that could be worn by gamekeepers when they were out riding to protect their heads from low-hanging branches. It is thought that before accepting the hat, Coke arrived at the shop in London and stamped on the crown twice to check its robustness. It cost him 12 shillings.

The bowler hat was Winston Churchill's trademark and became a ubiquitous accoutrement of the 1950s city gent. It died out from the 70s but has undergone a recent hipster resurgence.

FOLLOWING THE ESTABLISHMENT OF THE FOOTBALL ASSOCIATION, THE FIRST EVER MATCH OF FOOTBALL IS PLAYED AT MORTLAKE.

Versions of football had been played for centuries, but no official rules had ever been established. The Football Association was formed in a meeting on 26 October 1863 at the Freemasons Tavern in Great Queen Street, and rules were drawn up over six subsequent meetings. It planned to play the inaugural match on 2 January 1864 in Battersea Park, but some enthusiastic members could not resist the temptation to try out an early practice match in Mortlake. The match was between teams from Barnes and Richmond and ended in the first ever goalless draw.

CEMBER
1863

19 DECEMBER 1843

A *CHRISTMAS CAROL*, BY CHARLES DICKENS, IS PUBLISHED IN LONDON BY CHAPMAN AND HALL.

After the disappointing reception of *Martin Chuzzlewit*, Dickens felt that his popularity as a writer was waning and wanted to write something that would turns things around for him. He got the idea for this novella whilst visiting work-worn Manchester, as he had wanted to write a pamphlet to address the problems of poverty, especially in children.

Dickens started writing the book in September, only six weeks before its publication date. He based the character of Scrooge, the incorrigible miser who achieves redemption on Christmas, in part on his complicated relationship with his father who was imprisoned in Marshalsea debtors' prison when Dickens was a boy. Although not reaping quite the level of royalties that Dickens had hoped for, the book was very popular critically and has never been out of print.

There have been countless versions of the story produced for radio, stage and screen, but I have never been swayed by any beyond the 1951 film starring Alistair Sim.

CO-REGENTS DUTCH PRINCE OF ORANGE-NASSAU KING WILLIAM III AND HIS SPOUSE QUEEN MARY II (KNOWN AS WILLIAM AND MARY) ARRIVE IN LONDON.

The Convention Parliament offered them the throne following the Dutch victory in the Glorious Revolution. For more detail please see 23 December.

20 DECEMBER 1688

21 DECEMBER 1842

HM PRISON PENTONVILLE
OPENS ON THE CALEDONIAN ROAD.

Pentonville was a modern prison that was necessitated by the rapid increase in prisoner numbers brought about by the ending of capital punishment for many crimes and a steady reduction in transportation to Australia. It was deemed to have been such a success that it was used as the model for a further 54 prisons built throughout the British Empire over the next six years. It became the major execution site after Newgate Prison was closed in 1916 and until capital punishment was abolished in 1964. Famous inmates include Oscar Wilde, Dr Crippen, Boy George and George Michael.

THE CORONATION OF KING STEPHEN IN WESTMINSTER ABBEY.

Also known as Stephen of Blois, he was the grandson of William the Conqueror, and his reign was marked by unrest and civil strife. When King Henry I's only legitimate son and successor, William Adelin, died aboard the White Ship in 1120, it sparked a dispute over the line of succession. Henry wanted the next ruler to be his daughter the Empress Matilda, but after his death, Stephen seized the throne. This caused a twenty-year-long civil war known as The Anarchy that was only resolved when Stephen agreed to allow Matilda's son, Henry, to become King after his death.

22 DECEMBER 1135

JAMES II FLEES TO FRANCE AFTER BEING DEPOSED BY THE GLORIOUS REVOLUTION OF WILLIAM AND MARY.

James was the second son of Charles I and ascended to the throne upon the death of his brother Charles II. He was suspected by members of Britain's political elite of being both pro-French and pro-Catholic and of having designs on becoming an absolute monarch. When he produced a Catholic heir to the throne, tensions exploded, and his daughter Mary and Protestant son-in-law William of Orange were invited by English Parliamentarians to bring an army from Holland to overthrow him. William III and Mary II ruled jointly from this point onwards and drew up the country's first bill of rights.

The Bill of Rights 1689 outlined for the first time the limitations of the monarch, the role of Parliament and the basic human rights of the individual citizen.

23 DECEMBER 1688

THE LONDON COLISEUM COMES INTO BEING AS A VARIETY THEATRE.

Unusual in its day, the Coliseum was designed without a pit, as Oswald Stoll, the man who commissioned it, wanted it to be a smart and respectable venue. This was not an orchestral pit, but the type common to all London theatres of the day, which housed the rowdy working classes. The building was designed by renowned theatre architect Frank Matcham and had 2,359 seats, making it the largest theatre in London. It went on to become the home of the Sadler's Wells Opera Company, who changed their name to the English National Opera in 1974. The theatre is also now the home of the English National Ballet.

WILLIAM THE CONQUEROR IS CROWNED AT WESTMINSTER ABBEY ON CHRISTMAS DAY.

William I, Duke of Normandy, was born to the unmarried Robert I and his mistress Herleva, leading to his other, less flattering, nickname, William the Bastard. He was the first cousin once removed of the childless monarch Edward the Confessor and claimed that Edward had promised him the English throne. When Edward died, however, he passed the crown on his deathbed to the powerful English earl Harold Godwinson.

William had consolidated his rule of Normandy and so decided to invade England. He built a large fleet and landed in England in September 1066. He won the decisive Battle of Hastings on 14 October, when he defeated and killed Harold with an arrow through his eye. Harold's mother offered her son's weight in gold for the return of his body, but William refused and ordered that it be taken and dumped into the sea. It is not known what actually happened to Harold, although it is claimed that his remains were secretly buried in Waltham Abbey.

The English did not meekly accept William, but he conquered them at Dover, Canterbury and then Winchester, where the royal treasury was located, before marching to London. He captured London and was crowned at Westminster Abbey on Christmas Day. Amongst his lasting impact is the White Tower of London, which he built as his London residence, the Domesday Book, which detailed all of the inhabitants and lands of his empire, and the prevalence of French words in our language.

25 DECEMB
- 1066

26 DECEMBER 1871

WRITING DUO GILBERT AND SULLIVAN'S FIRST COMIC OPERA COLLABORATION, *THESPIS*, OPENS AT THE GAIETY THEATRE FOR 63 PERFORMANCES.

The piece was an extravaganza in which the classical Greek gods, grown elderly, are temporarily replaced by a troupe of 19th-century actors and actresses, one of whom is the eponymous Thespis, the Greek father of the drama. Its humour was very broad and risqué, and the music has since been lost, although one song made it into *The Pirates of Penzance*. Richard D'Oyly Carte brought together W.S. Gilbert, who wrote the libretto, and Arthur Sullivan, who wrote the scores. The two created a total of 14 comic operas, the most famous of which are *The Mikado*, *HMS Pinafore* and *The Pirates of Penzance*. D'Oyly Carte built the Savoy Theatre on The Strand to stage their plays and founded the D'Oyly Carte Opera Company, which performed their joint works for over a century.

HARRISON WEIR ORGANISES THE FIRST MAJOR CAT SHOW AT CRYSTAL PALACE.

Due to his obsession with cats, Weir came to be known as 'The Father of the Cat Fancy'. He staged a much smaller cat show in July, but the one in December was on a grand scale. Weir was an artist, and beyond the drawings and paintings that he produced, his greatest achievement was the work he did on Warleigh, his Victorian gothic home in Matlock, Kent. This house was bought by the Sassoon family and was the birthplace of poet Sigfried Sassoon.

27 DECEMBER 1871

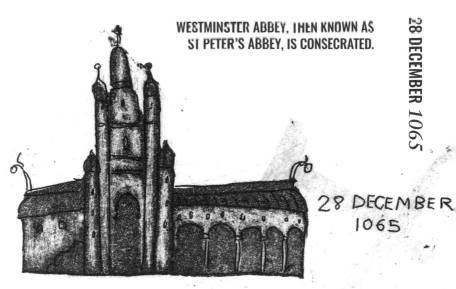

WESTMINSTER ABBEY, THEN KNOWN AS ST PETER'S ABBEY, IS CONSECRATED.

28 DECEMBER 1065

Legend has it that the site of the original church was chosen by a young fisherman named Aldrich, who had a vision of St Peter there, and to commemorate this, the Worshipful Company of Fishmongers still gives the Abbey a gift of a salmon annually in his honour. Edward the Confessor began rebuilding the church between 1042 and 1052 to provide himself with a royal burial church. He died on 5 January 1066, a week after it was consecrated. He was buried there as per his wishes, and his Queen Edith was buried alongside him nine years later. Harold II was believed to have been the first king crowned there, but William the Conqueror's was the first properly documented coronation (see 25 December 1066). Parts of Edward's building still remain, but the only existing depiction of what it looked like, and the one I have used for my drawing, is from the Bayeux Tapestry.

JAMES JOYCE'S FIRST NOVEL, *A PORTRAIT OF THE ARTIST AS A YOUNG MAN*, IS PUBLISHED AS A SERIAL.

Joyce planned to write a 63-chapter autobiographical novel called *Stephen Hero*, but after writing 25 chapters, he abandoned his project and set fire to the manuscript. His sister saved the burning papers, and he was later grateful for this as much of it found its way into *A Portrait*, although heavily condensed into five chapters. American modernist poet, Ezra Pound serialised the novel in the London literary magazine *The Egoist*.

29 DECEMBER 1914

30 DECEMBER
1919

THE FIRST WOMEN ARE CALLED TO THE BAR
BY THE HONOURABLE SOCIETY OF LINCOLN'S INN.

Lincoln's Inn is one of four Inns of Court in London (along with Middle Temple, Inner Temple and Gray's Inn) to which lawyers belong once they are called to the bar. It is not known when any of the Inns of Court were established; however, the first existing minutes of Lincoln's Inn, named after Henry de Lacy, 3rd Earl of Lincoln, date back to 1422, when it was already a well organised institution. Women had never been allowed to sit the examinations to become solicitors, and even the landmark case of Miss Gwyneth Bebb against the Law Society in 1914 failed to overturn this. It would be another five years before the Sex Disqualification (Removal) Act 1919 finally admitted women to the legal profession.

THE LONDON EYE IS COMPLETED AND TESTED FOR THE FIRST TIME, ALTHOUGH WITHOUT PASSENGERS.

The London Eye would not properly open to the public until March 2000 but was finished in time for the millennium, as promised. It is currently Europe's tallest Ferris wheel and offered the highest viewing point in London until the Shard's 72nd floor observation deck opened in 2013.

The Eye was initially built as a temporary structure but has now had its status changed to permanent (like the Eiffel Tower). It is both loved and iconic, and is London's most popular tourist attraction, with over 3.75 million visitors annually.

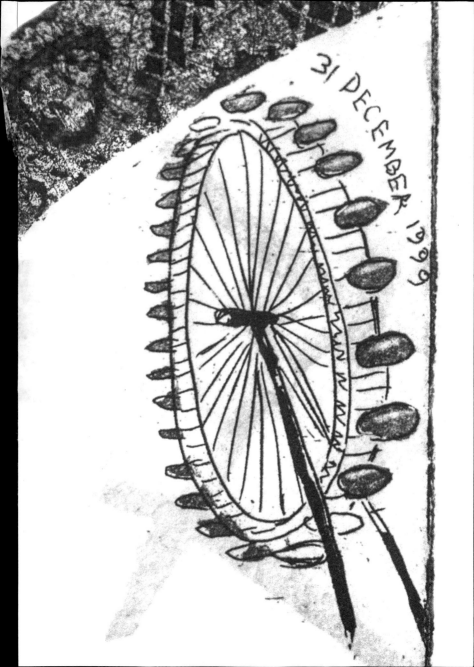

31 DECEMBER 1999

Published in 2017 by Unicorn
An imprint of Unicorn Publishing Group
101 Wardour Street
London
W1F 0UG
www.unicornpublishing.org

ISBN 978-1-910787-75-5

10 9 8 7 6 5 4 3 2 1

Photography by Brandon Few
Proofreading by Kelly St Jacques
Design by Felicity Price-Smith
Printed in India by Imprint Press